|ah

Common Sense Survival Guides

The Lost Science Series:
The Free-Energy Device Handbook
The Fantastic Inventions of Nikola Tesla
The Anti-Gravity Handbook
Anti-Gravity & the World Grid
Anti-Gravity & the Unified Field
Man-Made UFOs: 1944-1994
The Cosmic Conspiracy

The Lost Cities Series:
Lost Cities of Atlantis, Ancient Europe & the Mediterranean
Lost Cities of North & Central America
Lost Cities & Ancient Mysteries of South America
Lost Cities of Ancient Lemuria & the Pacific
Lost Cities & Ancient Mysteries of Africa & Arabia
Lost Cities of China, Central Asia & India

The Mystic Traveller Series:
In Secret Mongolia by Henning Haslund (1934)
Men & Gods In Mongolia by Henning Haslund (1935)
In Secret Tibet by Theodore Illion (1937)
Darkness Over Tibet by Theodore Illion (1938)
Danger My Ally by F.A. Mitchell-Hedges (1954)
Mystery Cities of the Maya by Thomas Gann (1925)
In Quest of Lost Worlds by Byron de Prorok (1937)

The Atlantis Reprint Series:
Vimana Aircraft of Ancient India & Atlantis
The History of Atlantis by Col. Brahgine (1926)
Riddle of the Pacific by J.M. Brown (1924)
The Shadow of Atlantis by Col. A. Braghine (1940)
Secret Cities of Old South America by H.P. Wilkins (1952)
Atlantis In Spain by Elena Whishaw (1928)

Write for our free catalog of exciting books and tapes.

COMMON SENSE SURVIVAL GUIDES

Edited by Albert E. Sindlinger

For Further information on Albert Sindlinger and
Common Sense Survival Guides please write to:

Albert Sindlinger
AU Specialty Publications
P.O. Box 687
Elko, Nevada 89801 USA
702-753-2150

ISBN 0-932813-32-1

I dedicate this book to the saving of lives and to the people of
the world who must endure disasters. The will to survive against
all odds makes the earth a very interesting place to live.

Published by
Adventures Unlimited Press
303 Main Street
P.O. Box 74
Kempton. Illinois 60946 USA

Cover Photos by Scott Anger
Cover Designed by Harry G. Osaff
Cover photos of disasters along I-5 in California.

Thanks to the Creator, Ursula, Edward, Enella, Josanne, Chris, Janeane, Joshua, Jonathan, Jordan, David H. Childress, Dan Jolley, Harry G. Osaff, Rick Holloway, Ty Carrillo, and Johannah Schumacher.

Acknowledgements: Many thanks to the process of life and the experiences that made this book possible. The material in this book was collected over a long period of time. Many of the original sources are unknown or lost to the writer. Sources are appropriately cited. I wish to thank all the original authors, whoever they may be, and with the confidence that they urge, " Do not inquire as to who said this, but pay attention to what is said." I would like to especially thank the American Medical Association, Random House, Federal Emergency Management Authority, United States Geological Survey, United States Forest Service, Elko County Library, Elko County School District, R.E. McMaster Jr., Julian Snyder, and Scott Anger.

Preface: The guides included within this publication are in no way intended as legal, financial, professional, or medical advise. Read these guides and use your own power of choice to make the best common sense decision suitable to your own belief system. You, the reader, must take responsibility and this writer specifically disclaims any loss or liability resulting from the use or non-use of this information. As intelligent human beings, we need to take responsibilty for our own actions or non-actions and quit the blame game. Use at your own risk. Become a response-able being!

THE
AZTEC COSMOS

CONTENTS

INTRODUCTION

The intent of this guide is to offer helpful information to weather the storming earth changes that are increasing in intensity. This is part of the cycle of living on planet earth at this time. Whether you look at it in terms of scientific predictions, future trends, or prophecies; it does not matter. The point is, intense changes are taking place. Ancient calendars forecasting the end of this age will be brought about by earthquakes just as the age of Noah was altered by floods. This is part of the rythmn of life. Is there any reason to fear this change? The answer may be yes or no depending on your point of view. This is what change is all about, making us alter our thoughts and beliefs.

Fear can be an asset. But panic is fear out of control and should be avoided. These guides will aid in preparing and eliminating the panic stage. Think of the ant and the grasshopper story. One prepares and the other reacts to the environment. This will help you prepare so when the environment reacts, the changes will be a little less rough. Developing your skills will aid your reactions to all types of changes. If you do face the threat of earthquakes, floods, hurricanes, and other disasters you must take the time to prepare for them. It may mean you have to evacuate or make the best of it. Like everything else in life, awareness, knowledge, confidence, training and experience will set you up to be a good survivor. Where there is a will, there is a way.

In developing this guide I have tried to compile a series of plans that will aid the individual/ family in surviving in the physical environment. Your number one guide should be your own **common sense.** Rely upon that first because you know what is best for you and your family. The information contained in these pages draws upon experts and people who have experienced difficult situations. Take it as advice and make the best choice that will fit for your particular situation. I have tried to include as many situations as possible and you can use it to aid in your planning. Select and use the guides that make sense to you. Adapt these guides to meet your local needs. Remember it is better to plan ahead than to react to a situation. It can make the difference in a survival situation. The actions in the first few hours after a disaster are vitally important. Disaster can bring out the best or worst in people.

The preparation plans presented in this guide are to be put into hands-on use. Take this guide apart and apply the parts that you need to ensure your own personal survival. It starts with individuals and expands out to include families who make up the community. Do not rely totally on the government. As the magnitude of the changes increase the government may be unable to cope, even though it may have the best of intentions. Become as self sufficient as possible. If you want it done right, do it yourself. The key is to act by taking this guide and make plans and preparations. Have emergncy supplies ready to go. Get the contact phone numbers to all family members. Know what to do in the event of an earthquake. Apply these guides to your life. Do not read this guide and put it on your book shelf. Use it. Take action! Cut it up and post the different plans. Discuss and post on the refrigerator the actions each family member should take in the event of an earthquake. Be a response-able person by acting in advance. Survival planning is being prepared. Remember the story of the ant and the grasshopper.

This guide book is designed so that a page or two of it can stand on its own. Sources are cited at the end to avoid too much congestion. Use it to make your plans and actions. Preparedness is the key. I have tried to put together a balanced approach to the topic of survival. I believe that a middle of the road approach is the best. Best to avoid extremist movements as far as survival goes. Civilization changes in response to outside stressors. The stress of the earth changes will change things and it may mean the death of things as we now know it. But always remember the words of Chief Seattle who said, "There is no death, there is but a change of worlds." That world may mean a better place to live and the choices that we make now could shape it.

"Each day should be passed as though it were our last." Publilius Syrus

**<u>Preparedness,
Awareness,
Prevention
Guides</u>**

"If you want something done, ask a busy person." Benjamin Franklin

" A peck of common sense is worth a bushel of learning."

" Don't wait for George to do it, because he won't." Anonymous

" There is no use whatever trying to help people who do not help themselves. You cannot push anyone up a ladder unless he is willing to climb himself." Andrew Carnegie

" Everyone is ignorant, only on different subjects." Will Rogers

" Experience is a hard teacher. She gives the test first, the lesson afterwards. " Anonymous

SURVIVAL THOUGHTS

Size up the situation.

Undue haste makes waste.

Remember where you are.

Vanquish fear and panic.

Improvise.

Value living.

Act like the natives.

Live by your wits... but for now, learn basic skills.

PERSONAL QUALITIES

- Being as self sufficient as possible.
- Having and making good use of common sense.
- Being able to make up your mind and make a choice.
- Being able to improvise.
- Being able to live with yourself.
- Being adaptable to the situation; to make a good thing out of a bad thing.
- Remaining cool, calm, and collected.
- Hoping for the best, but preparing for the worst.
- Have patience.
- Being prepared to meet the worst that can happen.
- Being able to "figure out" other people; to understand and predict what other people will do.
- Understanding where your special fears and worries come from and know what to do to control them.
- Being aware and understand yourself and the environment.
- Being response-able for actions and non-actions.

EMERGENCY PREPAREDNESS

☐ Schedule quarterly family conferences to discuss prodedures to follow in different kinds of emergencies.
☐ Hold practice drills.
☐ Post and memorize emergency telephone numbers.
☐ Assemble and store a survival kit containing:
 ☐ Flashlights and portable radio with extra batteries.
 ☐ First Aid Kit with manual.
 ☐ Crescent and pipe wrenches for turning off utilities.
 ☐ Emergency food and beverage, 3-day supply (nonperishable food, juices, and one gallon of water per person per day).
 ☐ Chlorine bleach for water purification.
 ☐ Fire extinguisher.
 ☐ Spare eyeglasses, prescribed medications, baby food, pet food, and special dietary foods.
 ☐ Manual can opener.
 ☐ Sanitation supplies; large plastic trash bags, soap, toothbrush and paste, feminine supplies, infant care items, toilet paper, newspaper and a camp shovel.
 ☐ Camping equipment; blankets, sleeping and cooking gear.
 ☐ Complete change of clothes for each person in the family.
☐ Learn First Aid.
☐ Establish a location for the family to reunite if members become separated.
☐ Arrange for a friend or relative in another town to be a communication contact for the extended family.
☐ Learn the emergency plan of the family's school, day care centers, workplaces, and clubs.
☐ Make a habit of tuning in to daily weather forecasts and be aware of changing conditions. The Emergency Broadcast System on commercial radio and TV stations will announce a **WATCH** if an emergency situation is expected and a **WARNING** if it is imminent or in progress.
☐ Learn Emergency Food and Water Procedures.
 ☐ Be prepared to take care of yourself and your family for up to five days.
 ☐ Take emergency drinking water from melting ice cubes, toilet tanks (not bowls) water heater, and canned fruits and vegetables.
 ☐ Don't drink municipal tap water, or water from any questionable sources, until it has been strained with a clean cloth and treated. To treat water add 10 drops of chlorine bleach to each gallon of water, mix well, and let stand for about 30 minutes.
 ☐ Freezer foods will last from 48-to 72-hours if the freezer is full and the door always stays closed.
 ☐ Discard all open food and beverages that could be contaminated.
 ☐ Eat perishable foods first. Cook on portable grills, only outdoors.
☐ Determine an evacuation route and with alternatives.
☐ Find out where main utility switches are and learn how to turn them off if they rupture and trained technicians aren't available.

"What we anticipate seldom occurs; what we least expect generally happens." Benjamin Disraili

EMERGENCY PREPAREDNESS CHECKLIST

When a disaster strikes it is usually sudden and swift. **The key to survival is preparation.** There are steps you can take to protect yourselves and help cope with disaster if you plan ahead. Using this checklist will assist in the planning and preparation. Use these ideas and prepare a personal emergency plan that is suited to your area. Make the plan visible and known to all family members. If you need additional information contact your local fire department, American Red Cross, or local emergency management offices.

GET EDUCATED AND INFORMED
☐ Find out which disasters could happen in your area.
☐ Learn how to prepare for each disaster.
☐ Learn how the local warning system works for emergencies in your area. If necessary, create your own.
☐ Learn the escape and evacuation routes in your community.
☐ Learn the emergency plans of the school districts, day care centers, and your place of employment.

CREATE AN EMERGENCY PLAN
☐ Meet and discuss with your family the dangers of fire, crime, severe weather, earthquakes, and other emergencies.
☐ Discuss appropriate action and response to each type of disaster that could occur in your area.
☐ Teach the children how to dial 911 for the police and fire.
☐ Make sure emergency numbers are posted near the telephone.
☐ Make sure to teach children how to make long distance phone calls.
☐ Select one local and one out of state contact for family members to call if separated by a disaster. Often it is easier to call out of state than locally when a disaster strikes.
☐ Draw out a floor plan of your house. Mark at least 2 escape routes from each room and make known.
☐ Learn how to turn off the main switches for electricity, water, and gas.
☐ All family members should be aware of the local radio station for emergency broadcast information.
☐ Select two meeting places. One near your home in case of fire and a second place outside of your neighbor hood in case you cannot return home after a disaster.
☐ Learn basic first aid. Take a CPR class and stay current. Include all family members in this.
☐ Keep important papers and records in a water and fireproof container.
☐ Check and see if you have enough and adequate insurance coverage. If not, get insured.

PREPARE A DISASTER SUPPLIES KIT
Put together supplies needed in the event of an evacuation and store in an easy-to-carry bag or pack:
☐ Have a supply of one gallon of water per person per day. Store and change water every three months.
☐ A supply of nonperishable food and hand can opener.
☐ A change of clothing, rain gear and some sturdy shoes.
☐ Sleeping bags, space blanket, and blankets.
☐ A first aid kit and any prescriptions medications.
☐ An extra pair of glasses.
☐ A battery or solar powered radio, flashlight, and extra batteries.
☐ Cash, coin, credit cards and an extra set of car keys.
☐ A list for family doctors, important information, serial numbers of important property.
☐ Special items for infants, elderly of disabled family members

EMERGENCY PLAN: IMPORTANT INFORMATION

Local Contact
Name: _____
Telephone (Day):_____ (Evening): _____

Out-of-State Contact
Name: _____ City: _____
Telephone (Day): _____ (Evening): _____

Nearest Relative
Name: _____ City: _____
Telephone (Day): _____ (Evening): _____

Family Work Numbers
Father: _____ Mother: _____
Other: _____ Other: _____

Emergency Telephone Numbers
In a life threatening emergency, dial 911 or the local EMS number.
Police Department: _____
Fire Department: _____
Hospital: _____

Family Doctors
Name: _____ Telephone: _____
Name: _____ Telephone: _____
Name: _____ Telephone: _____

Reunion Locations
• Right outside your home: _____

• Away from your neighborhood, in case you can't return home: _____

Address: _____
Telephone: _____
Route to try first: _____

Evacuation Plan: _____

DECLARATION OF PREPARATION
BEFORE AN EARTHQUAKE
CHECKLIST

Awareness: Create a plan and make known to all family members including procedures for before, during , and after an earthquake. Drill and practice with all members and neighbors. Conduct a hazard hunt of the home and surrounding environment for potential problems. Reduce risks where possible. Purchase earthquake insurance.

Location: Know the location of electric, water, and gas shut-off valves and supplies.

- ☐ First Aid Kit
- ☐ Gas Valve
- ☐ Main Fuse Box
- ☐ Water Valve
- ☐ Flashlight
- ☐ Fire Extinguisher
- ☐ Supplies (gloves, shoes, clothes, pry bar)
- ☐ Wrenches
- ☐ Food
- ☐ Radio
- ☐ Water
- ☐ Medication
- ☐ Special Items
- ☐ Organized in survival kits

Emergency Procedures: Educate for proper actions: first aid treatment, exiting, staying, evacuation, and an out of state phone contact (family/friend).

- ☐ Contact Phone #()
- ☐ Know indoor and outdoor procedures during a quake.
- ☐ Determine safety zones and escape routes.
- ☐ Stay alert. Ensure the emergency plan is understood.
- ☐ Retain control at all times.
- ☐ Keep calm, think clearly, and act decisively.

Responsibilities: Be ready and able to respond. All family members and neighbors must be responsible for their actions. Your actions before are important. Preparedness is the key to survival.

Treatment: Be adaptable and flexible. Activate your plan. Follow procedures from practice and drill. Check for hazards and treat the emergency accordingly. Expect aftershocks to occur. Be part of the solution. "I know and understand this plan. I declare that I am prepared for an earthquake!"

Signed : (family, neighbors, friends) _____

_____ _____

_____ _____

_____ _____

_____ _____

FIRE PREVENTION

ELECTRICAL SAFETY: If electrical systems and equipment are not well maintained, they become dangerous fire hazards. Prevent electrical fires by following these safety tips:
•Don't overload electrical outlets or extension cords.
•If appliances aren't working right, have them repaired. Be sure that all electrical appliances and tools have been listed or labeled by a reputable testing laboratory.
•If a fuse blows in your home, try to determine the cause. Be sure the new fuse is the correct size and amperage.
•If small children are around the house, insert plastic covers (available at hardware stores) into unused outlets.
•Combined, water and electricity can give you a shock. When using appliances, such as hair dryers, have dry hands and do not stand in water. If the inside of an appliance gets wet, have it serviced. Unplug when not in use.

KITCHEN: Because hot stove burners and ovens can catch things on fire--and burn you-- it is very important to be alert and attentive while cooking. Practice these safety tips in the kitchen:
•Wear tight sleeves when you cook. Loose-fitting garments can catch fire more easily.
•Do not store things on or over the stove. People get burned reaching over hot burners.
•Turn pot handles in so they can't get knocked off the stove or pulled down by small children.
•Be careful when deep-frying or cooking with grease. If a grease fire starts, cover the pan with a lid to smother the flames, and turn off the burner. Do not pour water on a grease fire. Baking soda also works as an extinguisher.
•Never leave pot holders on the stove. Never leave cooking unattended as fires can start quickly and become serious.

LIVING & FAMILY ROOMS: Every family member needs to be alert for fire hazards in the communal areas of the home. Here are fire safety rules for everybody to follow:
•Use extreme caution with cigarettes! Provide large, deep ashtrays for smoker and check under couch and chair cushions for smoldering cigarettes before you go to bed.
•Use a metal fireplace screen on your hearth. Have the chimney checked and cleaned regularly.
•Be sure to use only the correct fuel source in fireplace, woodstove, and kerosene heaters. Refuel cool appliance only.
•Keep portable heaters at least 3 feet away from combustibles: paper, bedding, clothes, or curtains. Always turn heaters off when you go to sleep or leave the house.
•Make sure televisions and stereos have space around them to prevent overheating. If your TV isn't working properly, have it checked, as it could be a fire hazard.
•Store lighters and matches up high, out of the reach of young children.

WORKSHOPS, STORAGE AREAS & OUTDOORS: Basements and garages are often full of flammable materials not found in other areas of the home. Exercise fire safety inside and out as follows:
•Store gasoline and other flammable liquids, such as paint, outside in tight, labelled metal containers. Never use or store flammable liquids near appliances, heat, a pilot light, or while smoking. Do not store gasoline in your home or basement.
•Move your lawnmower, snowblower, or motorcycle away from gasoline fumes before starting. Cool the motor before you refuel.
•Have your furnace checked every year.
•Never use gasoline on a grill fire. Once the fire has started, use only dry kindling to revive it; not charcoal lighter fluid.
•Keep your work area clean. Sort and remove trash from the house. Don't store anything near a furnace or heater.
•Install a lightning rod or lighting protection system on your roof. Check to see if your roof is fire retardant. If it is not made of slate or tile, the roofing should be labeled Class C.

BEDROOMS: Most fatal home fires occur at night when people are sleeping. That's why it is extremely important to install smoke detectors outside every bedroom to wake you up in case of a fire. When you practice family escape drills, be sure you know two ways out of your bedroom, so you can escape even if one route is blocked by smoke and flames. Remember these fire safety rules:
•Never smoke in bed.
•Install smoke detectors outside every bedroom and put an extra one inside if you smoke or sleep with the door closed. Test and clean your detectors regularly.
•Plan two escape routes from your bedroom. If one way out is a window and you're above the ground floor, make sure you have a way to get to the ground safely. Ask your fire department for advice.
•Be sure everyone in your family is familiar with the home escape plan, the meeting place, and the fire department phone number.

"Iron rusts from disuse, stagnant water loses its purity and in cold weather becomes frozen; so does inaction sap the vigors of the mind." Leonardo da Vinci

CHECKLISTS

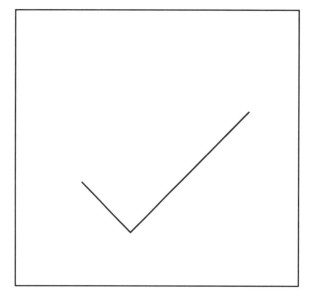

"When I saw something that needed doing, I did it." Nellie Cashman

THE 72-HOUR SURVIVAL KIT

This survival kit should be ready in the event that it is needed. Place it in a safe spot away from the house in a shed or the trunk of a vehicle. It contains the essential things that you will need to live for 3 days. You can design it to fit your needs but it should contain the following as a minimum:

☐ Bottled water (3 gallons per person)
☐ Water filter and purification tablets
☐ Food (non-perishable) little or no cooking required
☐ Camping plates and utensils
☐ Vitamins and energy food bars, salt, honey
☐ Backpacker's cooking stove and fuel
☐ Flashlight, spare batteries and spare bulb
☐ Candles and matches
☐ First aid kit, drugs, extra eyeglasses
☐ Emergency medical book
☐ Seasonal clothing (rain gear, jacket, boots, etc.)
☐ Tool box, pry bar, pliers, screwdriver, hatchet, etc.
☐ Folding camp shovel (for latrine and garbage)
☐ Pocket knife/leather man (multipurpose, sharp)
☐ ABC fire extinguisher
☐ Road flares
☐ Local area maps
☐ Tissues, toilet paper, sanitary napkins
☐ Soap, toothbrushes, personal care kit
☐ Plastic, foil, emergency space/wool blanket
☐ Sleeping bag
☐ Battery or solar powered radio
☐ Cash
☐ Plastic tubing for siphoning gasoline
☐ Keep all in a plastic container with a tight lid

CHECKLISTS

The following checklists are general guides to help you organize your own larger survival kits. The design and makeup of these kits must be made to fit your own survival plans and family needs. Proper storage of the items is essential to avoid loss. Water should be changed every couple of months and food should be rotated to prevent spoilage. Storing food for a year is a good investment. When times are good and food is plentiful the prudent thing to do is to save for lean times. Being self reliant may make a difference especially if emergency services are extended beyond their designed capacities. It will also offer some security and peace of mind. Your family may be the ones taking a leadership role to help support other who are not as well prepared.

WATER

Water is the number one concern. Have a minimum of 1 gallon per person per day. The body can go without food for a lot longer than water (3 to 4 days). In an emergency situation it may be even less time especially if one is sweating heavily. Try to conserve water as much as possible but drink enough to maintain your basic bodily functions.

- ☐ Storage containers: Use the size best suited to your storage needs. 50, 5 ,or 1 gallon containers will work fine. You can buy them specially designed for this or old soda, milk, or beverage containers.
- ☐ Also use smaller sizes such as canteens. Also change the water every three months at a minimum.
- ☐ Chemical agents: Chlorine bleach or hydrogen peroxide (food grade), halazone & iodine tablets can be added to the water to prevent unwanted growth of algae or bacteria.
- ☐ Water purifier: There are many different systems available which use a filter or similar device to purify any source of water.
- ☐ Pail or bucket, clear plastic sheets, hose or tubing to make a solar water still.
- ☐ Cups or small containers for drinking.
- ☐ Cooking pot for boiling water.
- ☐ Salt, salt tablets, or special sports drinks to replace essential minerals lost from sweating.
- ☐ Garbage, plastic, and ziplock bags to help store water.
- ☐ Filter or straining material: cheesecloth, rags, nylons,

FOOD

Food would be the second most important item after water. A year's supply would be ideal. It would be very valuable in an emergency situation. You should have a good supply of food that is prepared and needs no cooking or refrigeration. It should be well balanced and high in calories. An emergency situation is very stressful and a balanced diet is very important. Make sure the foods you include store well and have a long storage life. Keep track and rotate the food when necessary. Mark and label the food. Store food that your family will eat. Have any special foods for the specific situations where a different diet is required such as diabetics, allergies, and infants.

- ☐ Meat: Canned or dried
- ☐ Vegetables: Canned, dried, or freeze-dried
- ☐ Fruits: Canned or dried
- ☐ Juices/Beverages: Bottled, canned, packaged, or powered
- ☐ Herbs and spices
- ☐ Staples: Sugars, flours, honey, pasta, grains, legumes, cereals, oils
- ☐ High energy foods: Candy, snacks, cookies, peanut butter, etc.
- ☐ Supplements: Vitamin and mineral

EQUIPMENT FOR FOOD
- ☐ Pots, pans & forks, knives, and spoons
- ☐ Cook stove and fuel
- ☐ Cups, bowls, plates (paper/foam)
- ☐ Wire, string, rat/mice traps
- ☐ Can openers
- ☐ Plastic bags, aluminum foil
- ☐ Ice chest, water jug containers
- ☐ Misc. utensils, napkins, etc..

SHELTER

Depending on the type of emergency situation you may need alternative housing. Protection from the elements is of vital concern. The wind, rain, heat, cold, and snow can become life threatening when the primary means of shelter is destroyed or damaged. Always prepare for the worst possible elements.

- ☐ Camper, trailer, motorhome, boat
- ☐ Small tent, large plastic tarp
- ☐ Tube tent/emergency tent
- ☐ Plastic, space blanket
- ☐ Rain jacket, poncho, umbrella
- ☐ Stakes, pegs, grommets
- ☐ Fiber, duct, or strapping tape
- ☐ Hats/caps: cool & hot, rain, hard
- ☐ Gloves: leather, rubber, mittens
- ☐ Heavy coat, jacket, windbreaker
- ☐ Shirts, sweaters, thermal underwear
- ☐ Wash rags, towels
- ☐ Backpacks-large & small, fanny pack
- ☐ Large garbage cans
- ☐ Trunks, large storage boxes, ammmo boxes

- ☐ Large tent
- ☐ Sleeping bags
- ☐ Ground cloths
- ☐ Blankets (wool & cotton), sheets, pillows
- ☐ Pad, air mattress, foam
- ☐ Garbage bags (large & small)
- ☐ Rope, cord, or shroud line
- ☐ Eye protection: glasses, goggles
- ☐ Boots (rubber, work, walking), shoes
- ☐ Socks
- ☐ Pants (long & short)
- ☐ Outdoor clothesline
- ☐ Bags-duffle, tote
- ☐ Suitcases, briefcases
- ☐ 5-gallon buckets

ENERGY/FUEL/LIGHT

Utilities such as electricity and natural gas may be unavailable due to disruptions or breakdown in the system. You will need to figure out alternatives for heating and cooking food and water.

- ☐ Matches/lighters: waterproof, regular
- ☐ Candles-light
- ☐ Magnifying glass
- ☐ Canned fuel-sterno type
- ☐ Portable heater & fuel
- ☐ Wood stove/Firewood
- ☐ Newspapers
- ☐ Flashlight & batteries
- ☐ Flares or fusees

- ☐ Warming candles
- ☐ Tinder: steel wool, cotton, paper
- ☐ Stove & fuel-butane, propane, white gas
- ☐ Lantern & fuel
- ☐ Coleman stove and fuel
- ☐ Charcoal and fuel
- ☐ Fire Extinguisher
- ☐ Light sticks, chemical type
- ☐ Generator & fuel

SANITATION/PERSONAL

- ☐ Toilet garbage can, 5-gallon container
- ☐ Soap, shampoo
- ☐ Bug repellant
- ☐ Shaving supplies: razor, cream
- ☐ Mouthwash
- ☐ Feminine hygiene needs
- ☐ Washcloth & towel
- ☐ Mirror
- ☐ Bleach
- ☐ Disinfectant & deodorizers
- ☐ Wash basin
- ☐ Portable toilet

- ☐ Toilet paper/kleenex
- ☐ Dental care: brush, paste, floss
- ☐ Deodorant
- ☐ Foot powder
- ☐ Contact lens solution
- ☐ Handy wipes or towelettes
- ☐ Hairbrush, comb
- ☐ Paper towels
- ☐ Large & small garbage bags with ties
- ☐ Shovel
- ☐ Detergent: laundry & dish
- ☐ Zip-loc bags

"Opportunity passes like a cloud." Chinese proverb

MISCELLANEOUS ITEMS

- ☐ AM/FM radio & extra batteries
- ☐ 2-way radios/CB radio
- ☐ Ham radio
- ☐ Scanner/ emergency bands
- ☐ Whistles
- ☐ Aersol spray-mace, pepper
- ☐ Survival cards(instruction guides)
- ☐ Watch/clock
- ☐ Children book & games
- ☐ Cellular telephone
- ☐ Emergency signal/road flare
- ☐ Signalling mirror
- ☐ Solar powered electrical panel
- ☐ Pen & paper
- ☐ Guns, rifles or pistols/ammo
- ☐ Maps
- ☐ Compass
- ☐ Phone numbers
- ☐ Pet food & leash

IMPORTANT PAPERS

- ☐ Insurance papers, proof and phone #
- ☐ Checking/Savings account #'s
- ☐ Video/photo inventory of home & valuables
- ☐ Birth certificates
- ☐ Important papers-deeds, wills, legal papers
- ☐ Driver's license
- ☐ Immunization records
- ☐ Investment papers-stocks, account #'s
- ☐ Charge card account #'s & phone #'s
- ☐ Degrees-high school & college
- ☐ Social security #'s
- ☐ Passports
- ☐ Contract copies
- ☐ Important photos

CURRENCY/MONEY

- ☐ Cash-$100, $20, $10, $5, $1's
- ☐ Silver- coins or bars
- ☐ Checkbook
- ☐ Stamps
- ☐ Coins-change (several rolls of each)
- ☐ Traveler's checks
- ☐ Credit cards
- ☐ Jewelry-gold, silver, diamonds

TRANSPORTATION

- ☐ Automobile
- ☐ Motorcycle/moped
- ☐ Wagon/handcart
- ☐ Hand trucks/dollies
- ☐ Rollerblades, skateboard, skates
- ☐ Keep a full tank of gasoline
- ☐ Camper, mobile home, trailer
- ☐ Bicycle(s)
- ☐ Wheelbarrow
- ☐ Raft/air mattress/boat/canoe
- ☐ Walking boots/shoes

LONG-TERM SURVIVAL

- ☐ One-year food supply
- ☐ Retreat location
- ☐ Large storage of water
- ☐ Vegetable garden seeds & tools
- ☐ Checklists & survival plans
- ☐ Sources of heat/cooking & fuel(wood,propane)
- ☐ Gas for travel
- ☐ Important papers box
- ☐ Clothing for all seasons
- ☐ Evacuation plans

"Mankind consists of two men: one who takes heed, the other of whom heed is taken." Chinese proverb

HARDWARE/RESCUE TOOLS

- Wrenches-assorted sizes & crescents
- Hammers-regular, sledge
- Nails (16, 8, roofing)
- Hose clamps (various sizes)
- Knifes-pocket, hunting
- Sandpaper
- Work gloves, hard hat, & goggles
- String/twine
- Spool of fishing line
- 10- 8' 2x4's
- Plywood and screws (nails)
- Vise-grips
- Ratchet & socket set
- Rope (200 ' nylon)
- Tire patch repair kit
- Sharpening stone & oil
- Bow & arrow/crossbow
- Grommets
- Scissors
- Sewing kit
- Glue-super, wood,
- Laces-shoe & boot
- Leatherman multipurpose tool
- Tow cable, chains, rope
- Pressure gauge
- Radiator sealant
- Fluids-power steering, brake, transmission
- Belts (spare fan, other)
- Safety pin (various sizes)
- Siphon hoses/tubing
- Razor blades
- Jack
- Tire pump
- Extra fuel/emergency rescue fuel
- Fire extinguisher(s)
- Tape-duct, masking, fiber & electrical
- Rags
- Anti-freeze/coolant
- Ax (long & pick)/hatchet
- Shovels (dirt, snow)
- Cross cut saw
- Hack saw & blades
- Saws-hand, bow, saws all
- Pliers-various type
- Chain saw, fuel, oil, ear plugs, chain, file
- Lubricants-oil & WD-40
- Assorted bolts, nuts, & washers
- Come-a-long, winch & chain
- Assorted jacks, house & car
- Tape measure
- Pry, wrecking, & crow bars
- Pick
- Assorted nails & screws
- Rifle & ammo
- Fishing pole/equipment
- Files-large, small, round, square
- Stapler & staples
- Rubber bands
- Tool kit (assorted tools)
- Bolt, wire, & fence cutters
- Velcro
- Extra hoses & clamps
- Jumper/battery cables
- Battery terminal cleaners
- Oil
- Oil spout/funnel
- Thumbtacks
- Tire sealant (flats)
- Pipe wrenches, pipe cutters
- Wire-(light & heavy), baling
- Snow chains
- Extra air & oil filters
- Emergency reflectors/flares
- Screwdriver sets-standard & phillips
- Paper towels

"Common sense consists in not letting oneself be dazzled by a sentiment or an idea, however excellent they may be, to the point of losing sight of everything else." Andre Gide

FIRST AID KIT

KNOWLEDGE:
- ☐ ABC instructions
- ☐ CPR instructions
- ☐ General first aid instructions
- ☐ Medical manuals
- ☐ Medical histories
- ☐ Emergency numbers

SUPPLIES:
- ☐ Gauze pads (assorted sizes)
- ☐ Compressed gauze pads
- ☐ Bed sheet
- ☐ Band-Aids (assorted sizes)
- ☐ Post-op sponges
- ☐ Oval sterile eye pads
- ☐ Muslin triangular bandages/pin
- ☐ Maternity OB pads
- ☐ Abdominal pad
- ☐ Moleskin
- ☐ Tourniquet
- ☐ Cervical collar
- ☐ Splints (assorted sizes)
- ☐ Coldpacks & hotpacks
- ☐ Airway opening devices
- ☐ Ispropyl alcohol
- ☐ Saline solution
- ☐ Sterile latex gloves
- ☐ Cotton balls & applicators
- ☐ Snake bite kit
- ☐ Maglite or small flashlight
- ☐ Soap-liquid or bar
- ☐ Safety pins (assorted sizes)
- ☐ Scalpel
- ☐ Plastic measuring cup-ounce type
- ☐ Syringes
- ☐ Aspirin
- ☐ Antacids
- ☐ Cough drops/throat lozengers
- ☐ Salt-epsom & sea
- ☐ Cough syrup
- ☐ Decongestants & antihistamines
- ☐ Nasal spray
- ☐ Allergy reaction kit
- ☐ Bug repellent
- ☐ Camphophenique
- ☐ Antiseptic pads
- ☐ Sugar, salt, baking soda
- ☐ Suncreen/sunblock
- ☐ Nonsticking pads
- ☐ Tape-sugrical,adhesive, cloth
- ☐ Butterfly bandages (assorted sizes)
- ☐ Ace bandages
- ☐ Petroleum jelly
- ☐ Gauze dressing (sterile)
- ☐ Gauze rolls
- ☐ Conforming gauze bandages
- ☐ Scissors
- ☐ Paper & pencil
- ☐ Hearing protectors
- ☐ Tongue depressors
- ☐ Bulb aspirator
- ☐ Masks-dust & surgical
- ☐ Hydrogen peroxide
- ☐ Sterile liquid soap
- ☐ Thermometers
- ☐ Towels
- ☐ Blankets
- ☐ K-Y Gel
- ☐ Knife or razor
- ☐ Forceps & tweezers
- ☐ Drinking cups
- ☐ Measuring spoon
- ☐ Eye dropper
- ☐ Tylenol
- ☐ Laxatives
- ☐ Lomitil
- ☐ Antibiotics-Penicillin, Amoxicillin, Ampicillin
- ☐ Hydrocortisone cream
- ☐ Sutures & needle
- ☐ Lotions-hand & calamine
- ☐ Syrup of ipecac/activated charcoal
- ☐ Cornstarch
- ☐ Anitbacterial ointment
- ☐ Eye & ear drops
- ☐ Chapstick
- ☐ Inhaler

NATURAL DISASTERS

AVALANCHES

In an avalanche, never give up in terror. Keep fighting. They usually happen in fresh snow or recent snows. Be aware, prevention is your best defense. Certain areas are more prone than others. If a slope does avalanche there will be a fracture suddenly working its way across the slope with muffled detonation and a whole layer of snow peeling away. In response you should:
- Get rid of ice axe, poles, skiis, or any object that you are holding immediately by throwing it away from you.
- Quickly check if at top, center, side, or bottom end of fall.
- Dive for the best escape at top or sides if possible.
- At all costs try to delay downhill slide. You can do this by leaping upwards if avalanche breaks off by ankles, or to one side if you are near solid snow, or by clinging to some bush or rock horn sticking out of the snow. The less snow above you, the less to bury you later.
- Keep mouth tightly shut.
- Swim. Try swimming for side. Use a sort of double-action back stroke with back to force of avalanche and head up. If in danger of being clobbered by solid slabs of snow try rolling into a ball. There is no cut and dried answer. Ride it out as best you can. But keep your mouth shut (many avalanche victims die from drowning with snow melting into lungs).
- Reserve greatest effort for last few seconds.
- Bring arm up in front of nose and mouth.
- When avalanche stops make one huge effort to break out. As avalanche loses momentum and starts to settle, two things are paramount; an air space in front of face and being as near as possible to the surface. In that last final effort, if you don't know which way up you are ...spit. Then follow the direction of the saliva, backwards.
- Don't panic when trapped. Easier said than done. Fear uses up oxygen by faster breathing rate and you want to conserve as much oxygen as possible. Try hard to keep calm. You can survive underground for hours until rescuers arrive.

DROUGHT

- **Do not** waste water. A hose ban means exactly that, and could signal the start of severe water shortages.
- **Do not** drink tap water if local authorities issue warnings to that effect. Shrinking water levels can result in contamination and, in extreme drought, dead animal may pollute water sources. Boil, purify, or buy bottled water.
- If your water supply is cut off and mobile water tanks or standpipes are installed in streets, this is designed for drinking water **only.** The situation is too severe to waste water on other uses.
- **Do not** use the toilet, but leave enough water in the bowl to act as a barrier to prevent smells and possible disease spreading from sewers up the pipes.
- Buy a camping chemical toilet. Alternately, you may have to face making an outdoor latrine.
- Re-use water as much as possible.
- Ensure food is always covered. Flies could prove a problem.
- Try to practice good hygiene, despite lack of water, especially when preparing food. Hot unsanitary conditions are a breeding ground for germs.
- **Never** throw cigarette ends casually out of cars or anywhere else. Grass could be tinder-dry and fire-fighting services severely hampered.
- If driving any distance, carry your own water in case the engine overheats.
- Watch out for structural damage to house, particularly those built on clay. You may have to fell trees located too close to the house to prevent the roots from causing damage to foundations.
- Watch out for bug infested or diseased trees which could cause potential bug and fire problems.
- Plant drought resistant vegetation.

During the Dust Bowl (1932-1937) some storms piled dust drifts 30-feet high and deposited a film of dust on Franklin D. Roosevelt's desk in Washington DC over a thousand miles away.

THE BIG FREEZE

Getting Prepared:
• Ensure your house is well-insulated, especially the loft. Insulate pipes to prevent freezing and insulate the hot water heater to prevent heat loss. Don't continue loft insulation under a cold water cistern; the small amount of heat beneath it may keep it from freezing.
• Check for drafts around exterior doors and windows. A heavy curtain over the front door can make halls warmer. Plastic sheeting taped over windows is a simple, cheap alternative to double glazing.
• Service central heating; it has a habit of going wrong when it's most needed.
• Kitchen foil, fixed shiny side out on walls behind radiators, will reflect heat.
• Check electrical wires are in good working order. Many winter deaths are caused through occasionally used electrical wires which prove to be faulty.
• Electric blanket should be serviced annually.
• If you have an unused fireplace, get it cleaned and unblocked and stock up on fuel. It could prove a last resort heat source when nothing else is available.
• Check emergency kit and supplies. A camp stove could be vital, especially if you have an electric heater or oven.
• Food is fuel for the body. Ensure you have enough supplies for at least three days, but resist the temptation to stockpile. You don't really need 15 loaves of bread to see you through a winter emergency in a town or city and you could cause hardship for other people.
• Make sure you have enough winter clothing.

During Bad Weather:
• Listen to radio/TV for weather reports and emergency information. Call social services if you need help for yourself or a relative living alone.
• Have emergency supplies at hand in case of power failure.
• Live in one room if you can't keep the whole house heated.
• Do not block all ventilation; avoid build-up of potentially toxic fumes from fires and heater.
• Drink pleny of hot drinks to make you feel warmer.
• If your pipes freeze, shut off water at the mains and turn on all taps to drain the system in case of burst pipes. Drain water into containers to ensure an adequate supply.
• If there is power failure, do not open freezer. A closed freezer should stay frozen for up to 48-hours.
• If central heating does fail, turn it off as a safety measure.

If You Must Go Outside:
• Dress accordingly. Several thin layers are warmer than one thick layer. Mittens are warmer than gloves, and hats will prevent heat loss. Frostbite and hypothermia are **serious** hazards.
• Avoid over-exertion. The combination of excessive physical activity and cold can **KILL**.
• Do not drink alcohol. It lowers the body temperature.
• Do not dry wet clothes on or too close to heaters as it's a major fire risk.

1816 was a year without a summer because of the volcano Tambora eruption in 1815. In the northeastern United States it snowed in heavy amounts in June, July, August, and September.

EARTHQUAKE SAFETY MEASURES

HAZARD HUNT- Identify potential dangers in the home using common sense, foresight, and your imagination to reduce risk in the event of an earthquake. Take active security measures, surveying the home for possible hazards. Take steps to correct and secure these hazards, reducing risk.

HAZARD-RISK REDUCTION

- Tall heavy furniture which could fall; fix it to a wall.
- Hot water heaters that can fall away from pipes and rupture need to be anchored to a wall. Use flexible gas line connectors.
- Appliances that can be moved can break electrical or gas lines and must be anchored to a stable location with flexible connections.
- Be sure heavy mirrors or picture frames are placed away from beds and mounted securely to the wall.
- Cabinets containing breakable items should have latches and heavy objects should be placed low to the ground.
- Flammable liquids must be stored securely away from flame.
- Masonry chimneys need bricks checked. Firmly support the roof.
- Beds should not be placed near windows.
- Glass bottles should not be placed on high shelves.

FAMILY EARTHQUAKE DRILLS will help you and your family plan and react; remembering where to seek shelter and how to protect yourselves.

- Identify safe spots and places in each room.
 - -Under a doorway, sturdy table, desk, or kitchen counter.
 - -Against an inside corner or wall; cover head with hands.
 - -Know and reinforce these locations by practice.
- Beware of danger zones and stay clear of:
 - -Windows that may shatter, including mirrors and picture frames.
 - -Heating units, fireplace, stove, and area around chimneys.
 - -Cabinets, refrigerators, and bookcases that may topple.
- Practice safe quake actions:
 - -Conduct drills, check reactions and choices.
- Discuss what to expect following a major earthquake and be prepared:
 - -To treat and take care of injuries.
 - -To check for gas leaks and learn where and how to turn off the gas, power, and water at main switches and valves.
 - -For aftershocks and exiting the building.
 - -To deal with family members' emotional needs.
 - -Remember to stay close and if separated to activate the emergency communication plan.

DURING AN EARTHQUAKE
EMERGENCY PROCEDURES

- REACT INSTANTLY
 - -Stay Calm!
 - -Think clearly and use common sense.
 - -Duck and cover!

- AT HOME
 - -Stay indoors.
 - -Turn off the stove and douse fires.
 - -Crouch under a heavy table or desk and hang onto it.
 - -If there is no protective furniture; crouch and brace yourself against an inside doorway, inside corner, or wall.

- OFFICE BUILDING OR IN A STORE
 - -Don't run for the exit; there may be a stampede. Stay on the same floor.
 - -Move away from windows.
 - -Crouch under a desk, bench, or table.
 - -Do not use the elevator.
 - -Expect the fire alarm and sprinkler to activate.

- ON FOOT
 - -Stay outside, in the open, away from trees, signs, utility poles and lines, and buildings.
 - -If you are near a building, duck into a doorway to avoid falling debris. Do not enter the building.

- IN A VEHICLE
 - -Quickly pull to the side of the road.
 - -Keep away from buildings, trees, bridges, signs, overpasses, and utility lines and poles.
 - -Stay in the vehicle until it stops shaking.

AFTER AN EARTHQUAKE
EMERGENCY PROCEDFURES

- Check for injuries and treat the injured with first aid. Take steps to stop bleeding and call for medical assistance if there is an emergency. Don't attempt to move severely injured persons unless they are in immediate danger of further injury. Cover them with blankets.
- Stay calm and use common sense.
- Use the telephone only to report severe emergencies.
- Put out fires. Don't use matches, lighters, candles, electrical switches or appliances in case there is a gas leak; use flashlights.
- Check gas, water and electrical lines and check appliances for damage. If you smell gas or see a broken line, shut off the main valve.
- Wear heavy shoes and gloves in areas near fallen debris and broken glass.
- Do not touch downed power lines or broken appliances.
- Clean up dangerous spills such as glass, bleach or medicines.
- Turn on a battery-powered or car radio for instructions and information.
- Check to see that sewage lines are intact before using toilet.
- Check water and food supplies. If water is cut off, use emergency supplies found in toilet tanks and water heater.
- Check the building for damage and cracks. Do not use the fireplace until it is in-spected.
- Check cabinets and closets. Open carefully and beware of falling objects.
- Watch for falling objects when you enter or leave buildings. Do not enter severely damaged structures.
- Do not use your vehicle, unless there is an emergency. Do not go sight-seeing to view damage. You may hamper the relief effort. Keep streets clear for passing emergency vehicles.
- Render aid and assistance to your community as needed.
- Be prepared for aftershocks. They can cause added damage. If near large body of water, evacuate to higher safe ground.
- If evacuation is necessary, post a message of where you can be found in clear view. Have designated reunion points. Have a 72-hour survival kit ready to take with you that includes: medicines, first aid kit, flashlight, radio batteries, important papers, cash, food, water, sleeping bags, blankets, and extra clothes.

<u>FLOODS</u>

BEFORE A FLOOD:

- Create an evacuation plan with a retreat to higher ground.
- Purchase flood insurance.
- Know what has happened on local properties during past floods and take appropriate precautions. Place survival items in high and dry locations with easy access.
- Estimate the danger from rising water versus a sudden deluge (tsunami, high tides, or dam breaks).
- Consult a local licensed insurance agent for the availability of flood insurance through the federally sponsored National Flood Insurance Program. Usually there is a five day waiting period.
- Own a raft or small boat.
- Obtain sandbags, plastic sheeting, lumber, and towels.
- Have survival kits available and ready.
- Install check valves in sewer traps to prevent floodwaters from backing up in sewer drains, or buy large corks or stoppers to plug sinks, showers, and bath tubs.
- Fuel vehicles in case evacuation becomes necessary along with survival items.
- Monitor rapidly changing weather conditions.

Hurricane-caused, giant wind-driven waves and floods National Oceanic and Atmospheric Administration

"Nature to be commanded, must be obeyed." Francis Bacon

<u>FLOODS</u>

DURING A FLOOD

IF THERE IS TIME
• Disconnect all electrical and gas appliances. Shut off the water main to keep contaminated water from the water heater (a source of emergency water).
• Bring outdoor possessions inside.
• Move valuables and essential items to upper floors.
• Sandbags should be stacked well away from the building to avoid damaging walls. If major flooding is expected, flood the basement with clean water to equalize the water pressure on the outside of the basement walls and floors. This is to help prevent structural damage.
• Round up pets.

EVACUATION
• Use travel routes recommended by local emergency authorities.
• Keep a radio on for news and information updates.
• Watch for flooding at bridges, viaducts, and low lying areas.
• Be alert for thunder and lightning that may signify rain and more flooding ahead.
• Don't drive over flooded roads. It is impossible to tell how deep the water is, or if portions of the roadway have been washed out. Vehicles may be swept away.
• Never try to cross flowing water above your knees.
• All passengers should abandon a stalled vehicle immediately and move as a group to higher ground.

FLOODS

AFTER A FLOOD

• Return home only when authorities say it is safe.
• If there is major structural damage or there are utility breaks, have qualified specialists inspect your home and make repairs before you re-enter.
• Be very careful when inspecting your home on your own for the first time.
• Use a flashlight, not a torch or lantern.
• Check for gas leaks (use your nose).
• Wear rubber-soled shoes and rubber gloves in case of severed electrical lines.
• Don't turn on electrical switches.
• Check electrical circuits only when electricity has been shut off.
• Don't use flooded electrical appliances until they have been repaired.
• Don't drink municipal water until the health department has declared it as safe for human consumption.
• Don't rush to pump out a flooded basement. If the water is removed all at once, the walls may cave in because of the sudden pressure change. Pump out about a third of the water a day. Mud is easier to shovel while it is still moist.

HEAT WAVE

- Slow down. Your body can't do its best in high temperatures and humidities; it might do its worst.
- Heed your body's early warnings that heat syndrome is on the way. Reduce your level of activity immediately and get to a cooler environment.
- Dress for summer. Lightweight, light colors reflect heat and sunlight and helps your thermoregulatory system maintain normal body temperature.
- Put less fuel on your inner fires. Foods (like proteins) that increase metabolic heat production also increase water loss.
- Don't dry out. Heat wave weather can wring you out before you know it. Drink plenty of water while the hot spell lasts.
- Stay salty. Unless you're on a salt-restricted diet, take an occasional salt water tablet or some salt solution when you've worked up a sweat.
- Avoid thermal shock. Acclimatize yourself gradually to warm weather. Treat yourself extra gently for those first critical two or three hot days.
- Vary your thermal environment. Physical stress increases with exposure time in heat wave weather. Try to get out of the heat for at least a few hours each day. If you can't do this at home, drop in on a cool store, restaurant, or theater--- anything to keep your exposure time down.
- Don't get too much sun. Sunburn makes the job of heat dissipation much more difficult.
- Know the heat syndrome symptoms and first aid.

HURRICANES

PREPARATION: Your 72-hour survival kit should include: a supply of boards, tools, batteries, non-perishable foods, and the other equipment you will need when a hurricane strikes. Continue normal activities and stay tuned to the weather service or storm warnings for advice, keep alert. Purchase wind storm insurance.

WHEN YOUR AREA RECEIVES A HURRICANE WARNING:

• Keep calm until the emergency has ended.
• Plan your time before the storm arrives and avoid the last-minute hurry which might leave you unprepared or marooned.
• If you are driving and have no warning, drive perpendicular to its path and try to outrun it.
• Leave low-lying areas that may be swept by high tides or storm waves.
• Moor your boat securely before the storm arrives, or evacuate it to a designated safe area. When your boat is moored, leave it, and don't return once the wind and waves are up.
• Board up windows or protect them with storm shutters or tape. Danger to small windows is mainly from wind-driven debris. Larger windows may be broken by wind pressure.
• Secure outdoor objects that might be uprooted or blown away. Garbage cans, garden tools, toys, signs, porch furniture, and a number of other harmless items become missiles of destruction in hurricane winds. Anchor them or store them inside before the storm strikes.
• Store drinking water in clean bathtubs, jugs, bottles, and cooking utensils: your town's water supply may be contaminated by flooding or damaged by hurricane floods.
• Keep your car fueled. Service stations may be inoperable for several days after the storm strikes, due to flooding or interrupted electrical power.
• Stay at home if it is sturdy and on high ground. If it is not, move to a designated shelter and stay there until the storm is over or seek refuge in a basement. Avoid mobile homes. If in a tall building move to the center or interior halls.
• Remain indoors during the hurricane. Travel is extremely dangerous when winds and tides are whipping through your area.
• Monitor the storm's position though weather reports and advisories.
• Beware of the eye of the hurricane. If the calm storm center passes directly overhead, there will be a lull in the wind lasting from a few minutes to a half an hour or more. Stay in a safe place unless emergency repairs are absolutely necessary. But remember, at the other side of the eye, the winds rise very rapidly to hurricane force, and come from the opposite direction.

WHEN THE HURRICANE HAS PASSED:

• Avoid loose or dangling wires, and report them immediately to your power company or the nearest law enforcement officer.
• Seek necessary medical care Red Cross disaster stations or hospitals.
• Stay out of disaster areas. Unless you are qualified to help, your presence might hamper first-aid and rescue work.
• Drive carefully along debris-filled streets. Roads may be undermined and may collapse under the weight of a car. Slides along cuts are also a hazard.
• Report broken sewer or water mains to the water department.
• Prevent fires. Lowered water pressure may make firefighting difficult.
• Check refrigerated food for spoilage if power has been cut off during the storm.
• Remember that hurricanes moving inland can cause severe flooding. Stay away from the river banks and streams.

"Plan your year in spring, your day at dawn." Chinese proverb

SEVERE THUNDERSTORMS

One of the most common natural hazards is the severe thunderstorm. WATCH for the conditions that may accompany this disturbance.

HAIL: Large hail can cause serious injury, so avoid the outdoors while a storm is in progress. Protect gardens and shelter vehicles to prevent costly damage.

LIGHTNING: Lightning kills more people in the United States than any other natural hazard. It may strike several miles from the parent cloud. These safety rules will help you save your life when lightning threatens.
 • Stay indoors, and don't venture outside, unless absolutely necessary.
 • Stay away from open doors and windows, fireplaces, radiators, stoves, metal pipes, sinks, and plug-in electrical appliances.
 • Do not use plug-in electrical equipment like hair dryers, electric tooth brushes, or electric razors during the storm.
 • Do not use the telephone during the storm.
 • Avoid being the highest object in any area. Stay away from hilltops, lone trees, or telephone poles. In a forest, move under a thick growth of small trees.
 • Do not take laundry off the clothesline.
 • Do not enter a small structure in an open area.
 • If suitable shelter is not available, seek a ravine or valley, and drop to the ground in a crouched position, hands on knees. Do not lie flat.
 • Abandon metal equipment (tractors, golf carts, bicycles). Drop golf clubs and remove golf shoes. Keep several yards away from other people.
 • Do not handle flammable materials in open containers.
 • Get out of the water and off small boats.
 • Stay in your automobile if you are traveling. Automobiles offer excellent lightning protection.
 • When you feel the electrical charge-if your hair stands on end or your skin tingles-lightning may be about to strike you. Drop to the ground immediately.

FLASH FLOODS: Flash floods often occur without warning following upstream heavy rainfall. Drainage canals, streambeds, canyons, or areas downstream from a dam are potential flood areas. Monitor current weather conditions and make evacuation plans. Roads and trails that parallel existing drainage systems may be swept away by flood water. When a flash flood warning is issued, or you realize a flash flood is coming, act quickly to save lives. Seconds count!
 • Go to high ground immediately.
 • Do not drive through already flooded areas. Shallow, swiftly flowing water can sweep a car from the road and disguise a washed out road bed.
 • Do not attempt to cross a flowing stream on foot where the water is above your knees.

"The voice of thunder was in the heaven: The lightnings lightened the world: The earth trembled and shook." PSALM LXXVII

TORNADOES

SHELTER

Seek inside shelter, if possible. If in the open, move away from a tornado's path at a right angle. If there is no time to escape, lie flat in the nearest depression, such as a ditch or ravine.

• IN OFFICE BUILDINGS: The basement or an interior hallway on a lower floor is the safest. Upper stories are unsafe. If there is no time to descend, a closet or small room with stout walls, or an inside hallway will give some protection against flying debris. Otherwise, under heavy furniture must do.

• IN HOMES WITH BASEMENTS: Seek refuge near the basement wall in the most sheltered and deepest below the ground part of the basement. Additional protection is afforded by taking cover under heavy furniture or a workbench. Other basement possibilities are the smallest rooms with stout walls, or under a stairway.

• IN HOMES WITHOUT BASEMENTS: Take cover in the smallest room with stout walls, or under heavy furniture, or a tipped-over upholstered couch or chair in the center part of the house. The first floor is safer than the second. If there is time, open windows partly on the side away from the direction of the storm's approach but stay away from windows when the storm strikes.

• MOBILE HOMES: Are particularly vulnerable to overturning and destruction during strong winds, and should be abandoned in favor of a preselected shelter, or even a ditch in the open.

• FACTORIES, AUDITORIUMS, AND OTHER LARGE BUILDINGS: With wide, freespan roofs, should have preselected, marked shelter areas in their basements, smaller rooms, or nearby.

• PARKED CARS: Are unsafe as shelter during a tornado or severe windstorm. However, as a last resort, if no ravine or ditch is nearby, they may provide some shelter from flying debris to those who crawl under them.

 PERSONAL PREPARATIONS: Should include availability of a battery operated radio, in case of power loss; knowledge of safety rules and how to tell if a tornado or severe thunderstorm is approaching; and change of family plans in order to remain near shelter during a severe local storm threat.

"In Southern China on 4-22-95 a tornado and hailstones the size of basketballs(some weighing 33 pounds) killed 37 people and injured 453 and collapsed 2,000 homes." Earth Changes Report

TSUNAMI

• Sooner or later, tsunamis visit every coastline in the Pacific. Warnings apply to you if you live in any Pacific coastal area.

• Not all earthquakes cause tsunamis, but many do. When you hear that an earthquake has occurred, stand by for a tsunami emergency.

• An earthquake in your area is a natural tsunami warning. Do not stay in low-lying coastal areas after a local earthquake.

• A tsunami is not a single wave, but a series of waves. Stay out of danger areas until an "all clear" is issued by a competent authority.

• Approaching tsunamis are sometimes heralded by a noticeable rise or fall of coastal water. This is nature's tsunami warning and it should be heeded.

• A small tsunami at one beach can be a giant a few miles away. Don't let the modest size of one make you lose respect for all.

• The National Tsunami Warning Center does not issue false alarms. When a warning is issued, a tsunami exists.

• All tsunami-like hurricanes are potentially dangerous, even though they may not damage every coastline they strike.

• Never go down to the beach to watch for a tsunami. When you can see the wave, you are too close to escape it.

• During a tsunami emergency, your local Civil Defense, police, and other emergency organizations will try to save your life. Give them your fullest cooperation.

VOLCANIC ERUPTIONS

Advance Warnings: A volcano may show signs of life for years before actually erupting. It also can erupt in a few hours or days. Don't take any chances. Stay away from it and don't climb it for a closer look. Pay attention to the following:
• Audible rumblings from the volcano or the ground.
• Ash and gases appearing from the cone, the sides or around the volcano. This gas can be killing vegetation around the area.
• Earth movement, whether faint harmonic tremors or earthquakes.
• Presence of pumice dust in the air.
• Acid rain fall.
• Steam in clouds over the mouth of the volcano.
• Rotten egg smell near rivers, betraying the presence of sulphur.

Emergency Procedure
• Stay out of harms way-be alert for possible warning signals of imminent eruptions.
• Leave the area immediately. Do not waste time trying to save possessions.
• Be prepared for difficult travelling conditions. If vehicles get bogged in deep ash you may have no choice but to abandon them, in which case run for the nearest road out of the area. You may be able to hitch a ride.
• Avoid areas downwind from the eruption if ash is being expelled.
• Cover face with scarf or dust mask to keep any ash and volcanic dust out of the mouth. The combination of ash and acidic gas can cause lung damage. You might try wetting the mask with water, vinegar, or urine.
• Protect the eyes with any snug-fitting goggles, safety glasses, or eye wear.
• Beware of flying debris-wear any helmet or hat to protect the head. Also wear thick padded clothing for body protection.
• Always check for mudflows when approaching a stream channel. A mudflow can move faster than anyone can run and even buildings may not stop one.
• Shelter in buildings (other than emergency refuges) ONLY as a last resort. Walls can be crushed by rocks and lava. Roofs are subject to collapse, even from just the weight of ash and debris.
• For a fast moving cloud of gas, ash, rock fragments that accompany an eruption you may have only a couple of choices. Either shelter in an underground emergency refuge or hold you breath and submerge yourself underwater in a river, a lake, or the sea. The danger may pass in 30 second or so.
• If you are within the fallout area of an eruption keep your activity to a minimum. Evacuate if necessary. Keep posted by local Emergency authorities. Avoid using equipment since fine ash is very abrasive and damaging. Keep a supply of extra air filters for vehicles and homes.
• If you are miles away from the volcanic eruption, you may still be effected by the ash fallout due to wind. If your area is blanketed by volcanic ash, stay insided until notified through emergency services that it is safe to come out. Do not drive vehicles through ash as damage can occur to the engine and ash will enter the vehicle. Until ash is safely cleaned up, wear a scarf across the face or a dust or surgical mask.

When Krakatoa erupted in 1883 the blast could be heard 2900 miles away, along with tsunamis between 50 and 120 feet high.

WINTER STORMS

Severe winter storms with high winds and drifting snow often occur with little warning. Follow these instructions:
- Recognize current weather conditions and obtain forecasts.
- Be prepared for isolation at home with necessary survival items.
- Use lights for heat if the furnace goes out. Don't use gas stoves.
- Prevent fire hazards due to overheated wood or oil burning stoves, fireplaces, or electric heaters
- Stay indoors. Overexertion such as snow shoveling is a major cause of winter storm deaths.
- Dress in warm layers of clothes.
- Travel only if necessary, and then only in daylight on major roads.
- Do not travel alone. Let someone know your destination and schedule.
- Travel in a convoy with another vehicle if possible.

If you are caught in a vehicle:
- Do not panic.
- Do not leave the vehicle unless help is in sight.
- If stuck in snow, remain in car and run motor for 10 minutes of every hour for heat.
- Ensure proper ventilation while running the engine.
- Signal trouble by raising the hood, tying a cloth on the antenna, or turning on the flashers.
- Wear many layers of clothing to protect from the cold.
- Don't burn anything in the vehicle.
- Carry winter survival items: blanket, sleeping bags, flashlight, batteries, first aid kit, knife, high calorie/nonperishables food, extra clothing, large empty can with plastic cover and tissues, drinking water, sack of sand, shovel, windshield scraper and brush, tool kit tow rope, and booster cables.
- Keep a full tank of gas.
- Don't travel alone and let someone know about your route and timetable.
- Avoid overexertion and exposure.
- Keep fresh air in your car.
- Exercise by clapping hands and moving arms and legs vigorously from time to time, and do not stay in one position for long.
- Turn on the dome light at night to make the vehicle visible to work crews.
- Keep watch. Do not permit all occupants of the car to sleep at once.

WILDFIRES

PREPARATION:

Fire plays a natural role in the ecology of forests and rangelands. Homes located on the fringes of these areas are in danger of wildfire. To reduce the risk of fire destruction take steps to landscape the grounds properly and fireproof all buildings. Contact the local fire protection agency for home safety guidelines and information on brush and tree clearance. Before hiking in the back country, consult the public or private agency that manages the area for tips on fire survival.

IF FIRE THREATENS YOUR HOME:

During a major conflagration, fire protection agencies may not have enough equipment and manpower to be at every home. If a house is already in flames, firefighters may have to pass it by to save others in the fire's path.

Law enforcement or fire officials may advise you to evacuate. If you are not notified in time, or decide to stay with your home, the following suggestions will help you defend your property.

- Evacuate pets and all family members not essential to protecting the home. But don't risk your own life.
- Dress in natural fibers, not synthetics. Wear long pants and boots.
- Remove combustible items from around the house.
- Close outside attic, eave and basement vents, and shutters.
- Place large plastic trash cans or buckets around the outside of the house and fill them with water. Soak burlap sacks, rugs, and rags to beat out burning embers or small fires. Inside, fill bathtubs and storage containers with water.
- Locate garden hoses so they will reach any exterior surface of the house. Use a spray gun type of nozzle.
- Use a portable gasoline-powered pump to take water from a swimming pool or tank.
- Place a ladder against the roof of the house opposite the side of the advancing fire. Soak the roof.
- Back cars into the garage and roll up the windows. Disconnect the door opener. Close all garage doors.
- Place valuable papers and mementos inside a car in the garage in case a quick departure is necessary.

IF YOU ARE CAUGHT IN THE OPEN:

The best temporary shelter is in a sparse fuel area.

- When in an automobile, move it to the barest possible ground. Close all windows and doors. Lie on the floor and cover yourself with a jacket or blanket. Keep calm and let the fire pass.
- If a road is nearby, lie face down along the road cut or the ditch on the uphill side. Cover yourself with anything that will shield you from the fire's heat.
- When hiking in the back country, seek a depression with sparse fuel. Clear fuel from the area while the fire is approaching and then lie face down in the depression and cover yourself.
- On a steep mountaintop, the back side is safer.

AVOID:

- Canyons: They form natural chimneys and concentrate heat, gases, and updrafts.
- Saddles: Vegetation normally ignites first in these wide, natural paths that are ideal for fire storms and winds.

"The pine stays green in winter ...wisdom in hardship." Chinese proverb

AFTER A DISASTER

- Be extremely careful and excercise caution in working or entering buildings that may have been damaged by the disaster. They could collapse without warning. There may also be gas leaks or electrical short circuits.
- Steer clear of fallen or damaged electrical wires which may still pose a problem.
- Keep any lighted items such as cigarettes, torches, or lanterns away from damaged buildings because they may be leaking gas lines or other material that might be flammable.
- Check for leaking gas lines in your building. This should be done by smell only. Do not use candles or matches. If gas odor is present, ventilate the building as well as possible. Make sure the gas main valve is shut off. Notify the proper authorities such as the gas company or fire department. Do not reenter the house until the problem is taken care of.
- If any electrical appliances are wet, first turn off the main power switch in the house, then unplug the wet appliance, dry it out thoroughly. When completely dry, reconnect and turn on the main power switch. Make sure you do not do any of these things while you are standing in water or are wet. If a fuse blows when the power is turned back on , turn off the main power switch again and then reinspect for short circuits in the house appliances, equipment, and wiring.
- Check any food and water supplies before using them. Refrigerated foods may be spoiled due to an interruption in power. Don't eat any food that came in contact with flood waters. Be sure to check with local authorities concerning the use of food and water supplies.
- Be as self sufficient as possible. If needed, get food, clothing, medical care and shelter at the Red Cross or from local government authorities.
- Keep away form disaster areas. Your curiosity could get in the way of rescue efforts and interfere with first aid or rescue work and may be dangerous as well.
- Don't drive unless it is absolutely necessary and drive with caution. Be careful and watch for hazards to others and yourself. Report any hazards to the local emergency authorities.
- Commicate with relatives by phone, writing, or telegraph after the emergency is over so they will know you are safe.

Volcanic eruptions alter the climate of the earth.

"An optimist sees an opportunity in every calamity; a pessimist sees a calamity in every opportunity." Winston Churchill

FIRST AID GUIDES

"Health has become a laughing matter. Good humor is an integral part of wellness and health."
Director of Nursing at CSUFullerton

FIRST AID

Major goals of first aid are to save lives and prevent further injury. To accomplish these goals, first:
- Call 911, your local emergency medical services system, or a physician.
- Maintain breathing.
- Maintain circulation.
- Stop any loss of blood.
- Prevent shock.

Persons giving first aid should follow these steps and use good common sense:
- First determine if the scene is safe to enter; don't become a second victim.
- Stay calm.
- Reassure the victim.
- Do only what is necessary to keep the victim alive and minimize the injury until emergency help arrives. Do not move the victim unless there is imminent danger of further injury; for example, from a fire or flood.
- If the victim is unconscious, look for an emergency medical identification bracelet, signal device, or a card to learn about the victim's needs or any necessary precautions.

Your emergency medical services system: After you call 911 or your local emergency medical services system, stay with the person until help arrives. Be prepared to tell the paramedics the following:
- What has happened.
- What the victim's injuries or symptoms are.
- When the accident occurred or symptoms or signs began.
- If known, what medications the victim has taken.
- If poisoning has occurred, what has been swallowed, and when.
- Where you and/or the victim are.
- The phone number of your location.
- Ask what more you can do to help.

Federal Emergency
Management Agency

American
Red Cross

EARTHQUAKE • TORNADO • WINTER STORM • FIRE

ABCs : AIRWAY, BREATHING, CIRCULATION

The term "ABCs" is a simple way to remember the order of actions to take in an emergency if the victim is not breathing or if his/her heart is not beating. These letters stand for airways, breathing, and circulation. They are the three basic steps in a procedure known as cardiopulmonary resuscitation (CPR). Before you begin these steps, call 911 or your emergency medical services system, so that help will arrive promptly.

Warning: If you suspect a back or neck injury, do not move the person's head. Any movement can cause paralysis or death. Always keep the person's head, neck, and body in alignment.

(A) Airway: The victim's airway must be clear and open in order to restore breathing.
To clear an adult's airway:
 • Place the person face-up on the floor or on the ground.
 • If the person is unconscious, check his/her mouth for any obstructing object and remove it. Sweep the mouth with your finger even if no foreign object is visible.
To open the person's airway:
 • Chin lift technique: lift jaw by hooking two fingers underneath the chin and gently pulling foreward.
 • Jaw-thrust technique: Use both hands to grasp at the back of the jaw and push jaw gently forward.
To clear an infant's airway:
 • Place the infant face-up on your forearm, braced against your thigh, with his/her head cradled in your palm.
 • Look in the infant's mouth for any obstructing object and remove it. Do not sweep the mouth with your fingers.
 • Gently tilt the infant's head back only slightly, so that the airway does not become closed off.

If the victim is choking perform the Heimlich maneuver.

(B) Breathing: To restore breathing in an adult perform rescue breathing.

(C) Circulation: To restore blood circulation, give CPR if you have completed expert training in the procedure. CPR must be performed along with mouth-to-mouth resuscitation.

"The only way to keep your health is to eat what you don't want, drink what you don't like, and do what you'd rather not." Mark Twain

ALLERGIC REACTIONS

Signs of allergic reaction include difficult breathing (wheezing or choking): swollen lips, tongue, or ears; or hives and skin swelling with itching. If the reaction is severe, victims may go into anaphylactic shock, which may be life-threatening.

TREATMENT
- If the signs are severe or if they rapidly get worse, call (or have someone call) 911 or your local emergency medical services system.
- Keep the victim quiet in whatever position is most comfortable.
- If the victim stops breathing, give mouth-to-mouth resuscitation.
- If the victim feels dizzy, nauseated, is sweating, or faints, keep him/her lying down with the feet slightly elevated.
- If the victim is in a remote area, take him/her to the nearest hospital as quickly as possible. Severe allergic reactions can cause death in minutes to hours.

ALTITUDE SICKNESS

This illness is caused by a lack of oxygen in the air and decreased barometric pressure at high altitudes (above 10,000 feet).

SYMPTOMS
 Any or all of the following may be present: headaches, extreme tiredness, light-headedness, feeling of not being able to catch one's breath, pain in the chest or tightness in the throat, restlessness or inability to sleep, nausea and vomiting, fainting, hallucinations, and panic.

TREATMENT
- ABCs: Maintain an open airway. Restore breathing and circulation, if necessary.
- If the victim is breathing on his/her own, do not give mouth-to-mouth resuscitation.
- Keep the victim quiet, to conserve oxygen and energy, until he/she can catch his/her breath. Have the victim breathe air from an auxiliary oxygen source, if available.
- It is very important for you and others to remain calm, so that the victim will remain calm.
- The victim should be accompanied by another person as he/she returns to a lower altitude. The companion should then take the victim to see a physician.

BACK OR NECK INJURY

Suspect a back or neck injury if you find someone unconscious; a head injury is also possible. Do not move the victim until trained emergency personnel with appropriate equipment are available. Call 911 or your local emergency medical services system immediately.

WARNING: Back or neck injuries are very serious. Any movement of the head, either forward, backward, or side to side can result in paralysis or death. Do not move a victim with a suspected back or neck injury unless the victim's life is in danger, for example, from a fire or flood. If you must move the victim, always keep his/her head, neck, and body in alignment.

MOVING AN UNCONSCIOUS PERSON WITH A SUSPECTED BACK INJURY:
If the victim is vomiting or unconscious, transport him/her on their side. Roll the victim gently, keeping his/her head, neck, and body in alignment. Do not let the head move alone. Move the entire body together.

TREATMENT:
Warning: Do not move the neck independently of the body.
• Watch the person's breathing and be prepared to start mouth-to-mouth resuscitation.
• Do not move the person's head except to prevent the tongue from obstructing the airway. Gently maneuver the jaw, while minimizing any neck or head movements.
• If you must move the person, transport him/her face-up, unless the person starts to vomit.
• If the victim vomits, roll the victim onto his/her side, keeping the victim's head, neck, and body in alignment.

BITES & STINGS

TREATMENT:
• Have the victim sit or lie still; if the bite is on an arm or leg, keep that limb below the level of the heart. Keep the affected limb as still as possible. Do not let the victim walk unless absolutely necessary and, if so, then slowly.
• Use an ice pack on all bites and stings except snakebites.
• Do not suck out the venom.
BEE STINGS:
• Remove stinger by gently scraping the skin with a knife blade, card edge, or fingernail. (Do not use tweezers or any instrument that squeezes the stinger.)
• If the victim has difficulty breathing; swollen lips, tongue, and ears; or possible hives and skin swelling, he/she may have an allergic reaction.
BLACK WIDOW AND BROWN RECLUSE SPIDER BITES:
• These bites require medical treatment, especially in young children. Transport the victim to a hospital immediately. If possible, take the spider to the hospital for identification.
HUMAN BITES AND ANIMAL BITES:
• These bites require medical attention; wash the area with generous amounts of soap and water and call a physician.
• The victim may need antibiotics and/or injections to prevent tetanus or rabies. Rabies in humans is usually fatal and should be treated before symptoms appear. If you think the animal may have rabies, capture it, or call the local police, health department, or game warden to have the animal captured, so the animal can be watched for symptoms of rabies.

"Unless you absolutely need them, doctors are good people to stay away from and hospitals are very good places to stay out of." Eugene Robin

BITES-SNAKES

If bitten by a rattlesnake, cottonmouth, or copperhead, a person may have any or all of the following symptoms: severe pain, rapid swelling, discoloration of the skin around the bite, weakness, nausea and vomiting, difficulty breathing, blurring vision, seizures, and shock.

• ABCs: Maintain an open airway. Restore breathing and circulation, if necessary.
• Keep the victim quiet to slow circulation, which will help stop the spread of the venom.
• If the victim was bitten on the arm or leg, place a light constricting band such as a belt 2-4 inches above the bite, between the bite and the torso. The band should not be so tight that it cuts off the circulation. You should feel a pulse below the band. You should be able to slip your fingers under the band, although with some resistance. The wound should ooze.
• Do not remove the band until medical help arrives.
• If the area around the band begins to swell, move the band 2-4 inches above the first site.
• Wash the bite area thoroughly with soap and water, and cover the wound with a sterile or clean bandage or a clean clothe or handkerchief.
• Immobilize a bitten arm or leg with a splint.
• Treat the victim for shock.
• Do not let the victim walk unless absolutely necessary and, if so, then slowly.
• The victim may have small sips of water if desired (but no alcohol) and if he/she has no difficulty swallowing. Do not give water if the victim is nauseated, vomiting, having seizures, or unconscious.

If the person was bitten by a **coral snake**, symptoms may not occur immediately. Any or all of these symptoms may be present: slight pain and swelling at the site of the bite, blurred vision, drooping eyelids, difficulty speaking, heavy drooling, drowsiness, heavy sweating, nausea and vomiting, difficulty breathing, paralysis, and shock.

• Do not tie off the bite area.
• Quickly wash the affected area with soap and water.
• Immobilize a bitten arm or leg with a splint.
• Keep the victim quiet.
• Seek medical assistance promptly, preferably at the nearest hospital emergency department. If possible, have someone call ahead to notify the hospital of the poisonous snakebite and type of snake so that the hospital can locate antivenom.
• Do not apply cold or ice compresses.
• Do not give the victim food or alcoholic beverages.

If the person was bitten by a **nonpoisonous snake:**
• Keep the affected area below the level of the victim's heart.
• Clean the area thoroughly with soap and water.
• Put a bandage or clean cloth over the wound.
• Seek medical attention; a tetanus shot or other medication may be necessary.

"Sound vibrations have the potential to change neurological, molecular, or cellular activity in the body." Dr. Arthur Harvey

BLEEDING

BLEEDING: WOUNDS

The best way to control bleeding is with direct pressure over the site of the wound. Do not attempt to apply a tourniquet yourself, leave to a professional.

- Use a pad of sterile gauze, if available.
- A sanitary napkin, clean handkerchief or even your bare hand, if necessary, will do.
- Apply firm, steady direct pressure for 5 to 15 minutes. Most bleeding will stop within a few minutes.
- If bleeding is from a foot, hand, leg or arm, use gravity to help slow the flow of blood. If there are no broken bones, elevate the limb so that it is above the victim's heart.
- Severe nose bleeding can often be controlled by leaning forward or lying down and applying direct pressure such as by pinching the nose with the fingers. Apply pressure 10 minutes without interruption.

BLEEDING: HEAD INJURIES

If there is bleeding from an ear, it can mean there is a skull fracture.

- Call for emergency help. Let a professional medical person attend the wound.
- Special care must be taken when trying to stop any scalp bleeding when there is a suspected skull fracture. Bleeding from the scalp can be very heavy even when the injury is not too serious.
- Always suspect a neck injury when there is a serious head injury. Keep the neck and head still.
- Keep the airway open (check Rescue Breathing).
- When stopping the bleeding, don't press too hard. Be very careful when applying pressure over the wound so that bone chips from a possible fracture will not be pressed into the brain.
- Do not give the victim any fluids, cigarettes or other drugs. They may mask important symptoms.

BLEEDING: INTERNAL
*****WARNING SIGNS:**

Coughing or vomiting blood or passing blood in the urine or stool.
Cold, clammy pale skin; rapid, weak pulse; dizziness.

- Get emergency medical help immediately.
- Have the victim lie down and relax. Stay calm and keep the victim warm.
- Do not let the victim take any medication or fluids by mouth until seen by a doctor who permits it.

"For a quarrel to occur, an unknown third part must be active in producing it between two potential opponents."
Ron L. Hubbard

RESCUE BREATHING
BREATHING: UNCONSCIOUS PERSON

There are many possible causes of unconsciousness, but the first thing you must check for is breathing.
• Try to awaken the person. Shake or tap the victim's shoulder gently. Shout: "Are you all right?"
• If there is no response, check for signs of breathing. Have someone call for emergency medical help immediately.
> *Be sure the victim is lying flat on his/her back. If you have to, roll the victim over. To avoid possible neck injury, turn his/her head with the body as one unit.
> *Loosen tight clothing around the neck and chest.
• Open the airway.
> *If there are no signs of head or neck injury, place one hand on the victim's forehead and apply firm, backward pressure with the palm to tilt the head back.
> *Place the fingers of the other hand under the bony part of the lower jaw near the chin and lift to bring the chin forward, thus supporting the jaw and helping to tilt the head back.
> *Place your ear close to the victim's mouth. Listen for breathing. Watch for chest and stomach movement for at least 5 seconds.
> *If there is any question in your mind, or if breathing is so faint that you are unsure, assume that they are not breathing.
> *Give rescue breathing immediately.

RESCUE BREATHING FOR ADULTS:
• Put your hand on the victim's forehead. While holding the forehead back, gently pinch the nose shut with your fingers.
• To open the airway, put your other hand under the victim's jaw and lift the chin until it points straight up.
• Take a deep breath. Open your mouth wide. Place it over the victim's mouth. (For neck breathers, pinch nose and mouth and breathe into neck opening). Blow air into the victim until you see the victim's chest rise.
• Remove your mouth from the victim's. Turn your head to the side and watch the chest fall while listening for air escaping from the victim's mouth. Give another breath.
• If you hear air escaping and see the chest fall, Rescue Breathing is working. Continue until help arrives.
• Check the victim's pulse (check for heart attack).
• Repeat a single breath every 5 seconds (12 breaths per minute). Wait for chest deflation after each breath.
• If you don't hear air escaping, airway is blocked (check for choking).

RESCUE BREATHING FOR INFANTS AND SMALL CHILDREN:
• Check for breathing by carefully tilting the child's head back to open the airway. It should not be tilted as far back as for an adult, even less for infants. Look, listen and feel for breathing. If tilted back too far, it will make the obstruction worse.
• If not breathing, cover the child's mouth and nose with your mouth. Initially give 2 full, slow breaths in succession. Allow 1 to 1.5 seconds per breath. For infants give 2 slow, gentle breaths at 1 to 1.5 seconds per breath.
• Blow air in with less pressure than for an adult. Give small puffs. A child needs less air. Feel the chest inflate as you blow.
• Listen for air escaping.
• Repeat once every 3 seconds (20 breaths per minute).

"What comes around goes around."

BREATHING: DROWNING

• Get the victim out of the water at once; be careful to support the neck. A panicked victim may accidently drown the rescuer as well, so use extreme caution to avoid direct contact with the victim.

IF THE VICTIM IS CONSCIOUS:
Push a floating object to the person or let the victim grasp a long branch, pole, or object. Rescuers should not place themselves in danger. Go to or swim to the victim as a last resort.

IF THE VICTIM IS UNCONSCIOUS:
Take a flotation device with you if possible. Approach the victim with caution. Once ashore or on the deck of a pool, the victim should be placed on his/her back.

• If the victim is not breathing, check for airway clearance and open the airway. If after a few seconds the victim is still not breathing, immediately begin Rescue Breathing (check Rescue Breathing).

BRUISES

A bruise is probably the most common type of injury. It occurs when a fall or blow to the body causes small blood vessels to break beneath the skin. The discoloration and swelling in the skin are caused by the blood seeping into the tissues, and the bruise changes colors as it heals.

Symptoms include pain and initial reddening of the skin. The skin color changes to blue or green. Finally, the area becomes brown and yellow before fading.

TREATMENT:
• A bruise on the skull may indicate damage inside the skull. Call 911 or your local emergency medical services system and keep the victim quiet until help arrives.
• As soon as possible, apply cold compresses or an ice bag to the affected area (cold constricts blood vessels, decreasing bleeding and swelling).
• If the bruise is on an arm or leg, elevate the limb above the level of the heart to decrease blood flow to the area.
• After 24 hours, apply moist heat (a warm, wet compress) to aid healing. Heat dilates (opens) blood vessels, increasing circulation to the affected area.
• If the bruise is severe or painful swelling develops, call you physician; there may be a broken bone or other injury.

BROKEN BONES

The purpose of first aid for broken bones is to prevent further injury until you get the person to a doctor or hospital emergency department.

There are 2 types of fractures:
1. Closed: the bone is broken but the skin has not been punctured.
2. Open: the skin is broken along with the bone.
Treat the victim for a suspected fracture if a body part does not look normal or work normally, or if the victim heard or felt a bone break.

TREATMENT:
• Unless the victim is in imminent danger (from fire or a possible explosion, for example), do not move him or her until the suspected broken bone has been splinted.
• Leave the limb in the position you found it. Apply the splints in that position.
• Applying splints:
> 1. Any firm material can be used for splints, including boards, poles, oars, skis, metal rods, or even thick magazines or thick folded newspapers.
> 2. A splint must be long enough to extend beyond one joint above the fracture and one joint below.
> 3. Use clothing or other soft material to pad splints to prevent skin injury.
> 4. Fasten splints with a bandage or cloth at a minimum of 3 sites:
>> -below the joint and below the break.
>> -above the joint and above the break.
>> -at the level of the break.
• Apply pressure dressing to control any bleeding, as follows:
> 1. Place a pad (clean handkerchief or cloth) over the wound.
> 2. Press firmly with one or both hands.
> 3. If you do not have a pad or bandage, close the wound with your hands or fingers.
> 4. Apply pressure directly over the wound.
• Hold the pad firmly in place with a strong bandage (for example, strong gauze, neckties, cloth strips).
• Keep the victim lying down.
• Take the victim to a physician or hospital emergency department by car or ambulance-depending on the extent of the injuries-as soon as the fracture is immobilized.

"One of the great arts of living is the art of forgetting."

BURNS

Burns can result from heat (thermal burns), electricity, or chemicals. The object of first aid for burns is to prevent shock and contamination and to control pain. Any severe burn, sometimes even sunburn, can be complicated by shock. A person should consult a physician for all burns, except those in which the skin is reddened in only a small area.

WARNING: Never apply butter or margarine, ointment, greases, baking soda, or other substances to burns. Prompt professional help is needed for burns that cover more than 15 percent of an adult's body or 10 percent of a child's body and for burns of the face, hands, and feet.

TREATMENT:

Small (first-degree) thermal burns:
• If the skin is not broken, immerse the burned part in clean, cold running water or apply a cold compress (made from a clean towel soaked in cold water) to relieve pain. If there are broken blisters, apply cold running water only.
• Place a pad (clean handkerchief or cloth) over the burn and bandage loosely.

Extensive thermal or electrical burns:
• Call (or have someone call) 911 or your local emergency medical services system immediately.
• Cool the affected area quickly with cold running water.
• Do not put ice on the burn.
• Place the cleanest available cloth over all burned areas to keep out air.
• Keep the victim lying down, with a burned arm or leg elevated.
• Place the victim's head and chest slightly lower than the rest of the body; raise the legs if possible.
• Do not give the person alcohol.

Chemical burns:
WARNING: Burns from certain chemicals require special first aid. Familiarize yourself with these treatments if you work in areas where they are used, such as a factory or a laboratory.
• Call 911 or your local emergency medical services system immediately.
• For chemical burns other that those needing special first aid (see the warning above), immediately flush the burn using a large quantity of running water for at least 5 minutes; this is critical to reduce the extent of the injury.
• Continue to flush with water while removing clothing from the burned area.
• After the flushing, follow any instructions concerning burns that are on the label of the chemical that caused the burn.
• Place a large bandage or the cleanest available cloth over the burn.

"There are three states of existence. The lowest state is what you own. The next higher state is what you do. The highest state is what you are." Richard Russell

CHILDBIRTH

Childbirth is natural and normal. There are only a few things to remember if you are helping a woman deliver her baby. Try to remain calm. If the contractions are 2 or 3 minutes apart, or if the baby's head is visible, birth is usually imminent.

TREATMENT:
- Call 911 or the emergency medical services system in your area as soon as possible. You may be able to get instructions on the telephone if you cannot get the woman to a physician or hospital.
- Put a piece of plastic and clean sheet on the bed; if no sheets are available, spread newspapers under the woman. Wash your hands.
- Be patient and let nature take its course. Wait for the baby to come out on its own.
- As the baby emerges, you will likely need to do nothing more than support the child at the same level as the mother. Do not interfere with the birth.
- After the baby's head emerges, the shoulders and rest of the torso should follow. If no further progress is made after the head is out, gently pull downward on the head to get the shoulder to emerge.
- Keep your hands out of the birth canal.
- Handle the baby very gently and carefully. He/she will be slippery.
- If the baby has not started to breathe by itself, first hold the baby with the feet above the head so nasal mucus can drain. If that does not work, rub the baby's back. If necessary, clear the airway and use mouth-to-nose-and-mouth resuscitation. Be very gentle.
- Do nothing to the baby's eyes, ears, nose, or mouth (except to clean any thick mucous secretions from around the nose or mouth that interfere with breathing).
- Wait at least 5 minutes to cut the umbilical cord (unless it is wrapped around the baby's neck; then cut it immediately). To cut the umbilical cord, do the following:
 1. Boil scissors or clean them with alcohol.
 2. Tie a clean string or cloth in a knot around the umbilical cord about 4 inches from the baby to stop circulation in the cord.
 3. Tie a second string in a knot around the cord 6 to 8 inches from the baby (leaving 2 to 4 inches between the strings).
 4. Cut the cord between the two strings with clean scissors.
- Do not wash white material off the baby. It protects the skin.
- Gently massage the mother's abdomen to help her uterus contract.
- The mother usually delivers the placenta (afterbirth) about 5 to 20 minutes after the infant is born. Keep the placenta in a container for medical examination.
- Keep the baby and mother warm with blankets or clean newspapers.

CHOKING

• For a choking victim who **can** speak, cough or breathe, **do not** interfere. If the choking continues without lessening, call for emergency medical help.

• For a choking victim who **cannot** speak, cough or breathe, have someone call for emergency medical help and take the following action:

FOR A CONSCIOUS VICTIM

* Stand behind the victim, who can be standing or sitting.
* Wrap your arms around his/her middle, just above the navel.
* For adults, clasp your hands together in a doubled fist and press in and up in quick thrusts. Be careful not to exert pressure against the victim's rib cage with your forearms.
* For infants, position along the entire length of the rescuer's arm. Apply firm, controlled blows with the other hand to the infant's back between the shoulder blades.
* Repeat the procedure until the victim is no longer choking or becomes unconscious.

FOR AN UNCONSCIOUS VICTIM

* Place the victim on the floor or ground and give Rescue Breathing. If the victim does not start breathing and it appears that your air is not going into the victim's lungs, try giving 2 more breaths.
* With the victim remaining on his/her back, try giving manual thrusts. To give the thrusts to adults, place one of your hands on top of the other with the heel of the bottom hand in the middle of the abdomen, slightly above the navel and below the rib cage. Press into the victim's abdomen with a quick upward thrust. Repeat 6 to 10 times if needed. Do not press to either side. For infants, give 4 back blows. Then give 4 chest thrusts by placing 2 fingertips over the center of the chest and depressing 1 inch.
* Clear the airway
 -Hold the victim's mouth open with one hand using your thumb to depress the tongue.
 -Make a hook with the pointer finger of your other hand, and in a gentle sweeping motion reach into the victim's throat and feel for a swallowed foreign object which may be blocking the air passage.
 -Give 6 to 10 abdominal thrusts, probe in mouth, give 2 full breaths, repeat until successful.
 -For infants and small children, look first. Sweep mouth only if you see the object.
 -If object comes out and the victim is not breathing, start Rescue Breathing immediately.

"There is strong evidence that cigarette smoking, fluoride in your drinking water, and synthetic hormones cause cancer," Dr. William Campbell Douglass

CIRCULATION

CARDIOPULMONARY RESUSCITATION (CPR)

Cardiopulmonary resuscitation, or CPR, is a combination of external artificial circulation and mouth-to-mouth resuscitation. If you are trained in CPR, perform both procedures together as directed if the person's heart has stopped and he/she is not breathing. If the oxygen supply to the brain is cut off for about 4 to 6 minutes, brain damage or death may result.

CPR should be done only by persons trained in this technique. Do not perform CPR if you are not trained. Simply call for emergency assistance.

If you have not been trained in CPR, now is the time to contact your local American Red Cross office for information on training classes. Many hospitals and community groups also offer training. Periodic retraining is necessary. The following information is refresher assistance only for those who have already been trained in CPR.

FINDING THE HAND POSITION FOR CPR: Move your fingers up the center of the victim's chest to the notch where the ribs meet the breastbone. With 2 fingers on this notch, place the heel of your other hand 2 finger-widths above your fingers. Remove your fingers from the notch and place this hand on top of your other hands. The fingers may be interlaced. Do not allow your fingers to rest on the ribs.

TO PERFORM CHEST COMPRESSIONS: After finding the correct hand position for CPR, press down on the chest 15 times. With each compression, press down quickly and forcefully to a depth or 1 1/2 to 2 inches. Let the chest rise after each compression, but do not remove your hands from the chest.

TREATMENT:

Adults and children

• Call (or have someone call) 911 or your local emergency medical services system. Do not waste time.

• For one rescuer:

1. Kneel near the person's shoulder. Check the airway and breathing. If the victim is not breathing, give mouth-to-mouth resuscitation (2 initial deep breaths).

2. If the neck pulse is absent or questionable, start circulation by external cardiac compression:

-Move your fingers up the center of the victim's chest to the notch where the ribs meet the breastbone.

-With 2 fingers on this notch, place the heel of your other hand 2 finger-widths above your fingers.

-Remove your fingers from the notch and place this hand on top of your other hand (use only 1 hand for a small child). Your fingers may be interlaced. Do not allow your fingers to rest on the ribs.

-Bring your shoulders directly over the victim's body; keep your arms straight (do not bend your elbows).

-Press down to depress the breastbone 1-1/2 to 2 inches (1 to 1-1/2 inches for a child under 8 years old) 15 times. Let the chest rise after each compression, but do not remove your hands form the chest.

-Stop chest compressions to give mouth-to-mouth resuscitation, blowing 2 full breaths into the victim's mouth.

-If the pulse returns before breathing begins, perform mouth-to-mouth resuscitation at 12 breaths per minute on an adult victim.

3. Continue this sequence of chest compressions and mouth-to-mouth resuscitation.

• For two rescuers:

Follow the same procedure as for one rescuer, with one person doing 5 compressions while the other does mouth-to-mouth resuscitation. The first rescuer resumes chest compressions only after the second has completed a slow breath.

CPR FOR INFANTS

TREATMENT:

Infants

• Call (or have someone call) 911 or your local emergency medical services system. Do not waste time.

• Place the infant face-up.

• To make sure the baby is not simply asleep, shake the infants shoulder, pinch skin, or tap cheek. Shout; a sleeping baby will wake up.

• Tilt head back slightly, just enough to open airway.

• Breathe gently 2 times into the infant's mouth and nose until you see the chest rise. If the chest does not rise, you may need to gently adjust the position of the baby's head forward or backward to open the airway.

• Check for a brachial pulse (inside upper arm, about a third of the way up from the elbow).

• If the pulse is absent, start cardiac compressions as follows:

 1. Place the tip of your index and middle fingers over the center of the breastbone (1 finger-width below the nipples).

 2. Press down about 1/2 to 1 inch (1/2 inch for a newborn).

 3. Do at least 100 compressions per minute, 120 per minute for a newborn.

• Give mouth-to-nose-and-mouth resuscitation (5 compressions, then 1 breath).

• Continue this sequence of chest compressions and mouth-to-nose-and-mouth resuscitation until emergency help arrives. Do not give up.

• If the infant's pulse returns, stop chest compressions but continue the slow breaths.

• Continue to monitor breathing and pulse. Be prepared to maintain either one or both, as necessary.

CUTS AND ABRASIONS

In caring for minor wounds, it is most important to prevent infection. Never put your mouth over a wound. Bacteria normally present in the mouth may infect the wound. Do not breathe on the wound. Do not allow fingers, soiled handkerchiefs, or other material to touch the wound.

If the wound appears minor and only needs simple first-aid treatment, call your physician to determine the need for a tetanus booster. If the person has had a tetanus booster within the previous 5 years, another tetanus injection is usually not needed.

TREATMENT:

• Immediately clean the wound and surrounding skin with soap and warm water, wiping away form the wound, and then rinse with large amounts of clean water.

• Hold a sterile pad firmly over the wound until any bleeding stops. It may be necessary to elevate the body part while holding the pad to stop the bleeding.

• Apply pressure directly over the wound with the palm of your hand. If the bleeding continues, keep adding pads-do not remove the first pad.

• Bandage the sterile pads in place with gauze, a belt, or a tie.

• If the bleeding persists, seek immediate medical care by going to a hospital emergency department or calling 911 or your local emergency medical services system.

Other wounds:

Call 911, your local emergency medical services system, or a physician if:

• Blood spurts from the wound.

• The wound is long or deep and may require stitches

• The wound has been in contact with dirt or manure.

• The wound is a deep puncture wound.

• Slow bleeding continues for more than 4 to 10 minutes.

• The wound is from a bite (animal or human).

• Any sign of infection is present-pain, reddened area around wound, swelling.

• The wound is on the face or anywhere that a noticeable scar would be undesirable.

• If you suspect that a nerve or tendon is cut, especially in hand wounds, and there is a loss of feeling or motion below the wound.

"Vitamin C, E, B6, magnesium, Co-Enzyme Q10, and L-Carnitine are all excellent therapies for heart patients."
Dr. Julian Whitaker

DRUG OVERDOSE

A drug overdose is a poisoning. And don't take drunkeness lightly. Alcohol is as much a poison as stimulants, tranquillizers, narcotics, hallucinogens or inhalants. Remember: Alcohol alone or in combination with certain other drugs can kill. If you are dealing with this situation:
 • Call for emergency medical help at once.
 • Check the victim's breathing and pulse. If breathing has stopped or is very weak, open the airway. If after a few seconds, the victim is still not breathing, immediately begin Rescue Breathing. Caution: People under the influence of alcohol or drugs can become violent. Be careful!
 • While waiting for help:
 *Watch breathing.
 *Keep the victim warm with a blanket or coat.
 *Do not throw water in the victim's face.
 *Do not give the victim liquor or a stimulant.

ELECTRIC SHOCK

• Do not touch a person who has been in contact with electrical current until you are certain that the electricity is turned off. Shut off the power at the plug, circuit breakers or fuse box.

• If the victim is in contact with a wire or a downed power line, use a dry stick to move it away. If the ground is wet, do not approach.

• Check for breathing. If the victim's breathing is weak or has stopped, open the airway. If after a few seconds the victim is still not breathing, immediately begin Rescue Breathing (check Rescue Breathing).

• Call for emergency help or get someone to call for help immediately. While you wait for help to arrive:
 *Keep the victim warm by covering with a coat, blanket, jacket, etc ...and have them lying down.
 *Give the victim nothing to drink or eat until he/she is seen by a doctor.

EYE INJURIES

CHEMICALS IN THE EYE:
 Take immediate action! This is a very serious injury. Any delay in treating the victim will make his/ her injuries much worse. Chemicals in the eye can lead to blindness if you do not act quickly.

TREATMENT:
- Immediately hold the person's head under a faucet and rinse the eye with large quantities of cool running water while holding the victim's eye open.
- Let water flow from the inside corner of the eye (by the nose) outward so that the chemical does not rinse into the other eye. If both eyes are affected, let water flow over both.
- Be sure to lift and separate the eyelids so that all of the eye is rinsed.
- Continue rinsing for at least 15 minutes.
- Do not use boric acid, eye drops, drugs, or ointments. Such substances may increase the injury.
- Do not allow the victim to rub the eyes.
- After rinsing the eye or eyes, cover with a pad (sterile gauze or a clean cloth or handkerchief) and bandage in place with the eye or eyes closed.
- Take the victim to a hospital emergency department or to an ophthalmologist (physicain specializing in the care of eyes) immediately.
- If the victim is wearing contact lenses, the lenses should be removed by a physician as soon as possible.

FOREIGN BODIES IN THE EYE:
 Symptoms may include pain, burning sensation, tearing, redness of the eye, and sensitivity to light. Particles such as eyelashes, cinders or specks of dirt that are resting or floating on the eyeball or inside the eyelid may be carefully removed.
WARNING: Never attempt to remove any object that is sticking into the eyeball. Seek medical help immediately.

If the foreign body is sticking into the eyeball:
- Do not attempt to remove the object.
- Do not allow the victim to rub the eyes.
- Wash your hands with soap and water before carefully examining the victim's eyes.
- Gently cover both eyes (because when one eye moves, so does the other) with sterile or clean compresses and tie lightly in place around the victim's head. If compresses are not available, use a scarf, a large cloth napkin, or other clean fabric and tie around the victim's head.
- Take the victim to a hospital emergency department or to a ophthalmologist (physicain specializing in the care of eyes) immediately.

If the foreign body is resting or floating on the eyeball or inside the eyelid:
- Do not allow the victim to rub the eyes.
- Wash your hands with soap and water before carefully examining the victim's eyes.
- Gently pull the upper eyelid down over the lower eyelid and hold for a moment. This causes tears to flow, which may wash out the particle.
- If this doesn't work, fill a clean medicine dropper with warm water and squeeze water over the eyeball to flush out the particle. If a clean medicine dropper is not available, hold the victim's eye under a gentle stream of running water, or use a glass or water to flush out the particle.
- If this still doesn't work, gently pull the lower eyelid down. If the particle is on the inside of the lower eyelid, carefully lift it out with the corner of a clean, moistened handkerchief, cloth, or paper towel.
- If the particle still remains, gently cover the eye with a sterile or clean compress and seek medical help immediately.

FISHHOOK INJURY

A fishhook caught in the body is a common injury. If the fishhook goes deep enough so that the barb is embedded in the skin, it is best to have a physician remove it. If a physicain is not available, however, remove the fishhook carefully according to the following directions.

WARNING: Never attempt to remove a fishhook caught in the eye or the face. Seek medical help immediately.

TREATMENT:
- If only the point of the hook, and not the barb, entered the skin, remove the hook by backing it out.
- If the barb of the hook is embedded in the skin, push the hook through the skin until the barb comes out.
- Cut the hook with pliers or clippers at either the barb or the shank of the hook. Carefully remove the remaining part.
- Clean the wound with soap and water and cover with a bandage.
- Seek medical help as soon as possible. Fishhook wound may become infected, particularly with tetanus.

FROSTBITE

Frostbite is the freezing of parts of the body caused by exposure to very low temperatures. The toes, fingers, nose, and ears are most often affected. The victim is usually not aware of frostbite.
Pink skin is a warning sign of frostbite. The skin then changes to white or grayish-yellow as frostbite develops. (These changes may not be obvious in darker-skinned people.) There is initial pain, which quickly subsides. The skin feels numb and cold.

WARNING: Warming the frostbitten area and then allowing it to refreeze is worse than doing nothing.

TREATMENT:
- Take the victim indoors as soon as possible.
- Cover the frostbitten area with a warm hand or warm cloth.
- If the fingers or hand are frostbitten, have the victim hold the hand in his/her armpit, next to the torso.
- Put the frostbitten part in warm water (101-103 degrees F, or 38-39 C). If warm water is not available or it is impractical to use it, gently wrap the frostbitten area in blankets.
- Do not apply hot water, a hot water bottle, or a heat lamp on the frostbitten area.
- Do not rub or cover the frostbitten area with snow or ice. Do not break any blisters.
- When the frostbitten part is warmed, encourage the victim to exercise his/her fingers and toes. Give the person a warm, nonalcoholic drink.
- Go to a hospital emergency department quickly.

HEAD INJURIES

WARNING: Head injuries require urgent medical attention. Call (or have someone call) 911 or your local emergency medical services system immediately. If you find someone unconscious, always suspect head, neck or back injuries.

Symptoms of head injury may include a cut, bruise, lump, or depression in the scalp; unconsciousness, confusion, or drowsiness; bleeding from the nose, ear, or mouth; clear or bloody fluid flowing from the nose or ear; pale or reddish face; headache; vomiting; seizures; pupils of unequal size; difficulty speaking; restlessness; and irregular pulse.

TREATMENT:
* If the person is unconscious, has stopped breathing, is choking, or could have a back or neck injury, keep him/her lying flat on the back with the head straight. Do not move the victim unless his/her life is in danger-for example, from a fire or flood. If you must move the victim, always keep his/her head, neck and body in alignment.
* ABCs: Maintain an open airway. Restore breathing and circulation, if necessary.
* If there is no sign of a back or neck injury, turn the person's head to the side to allow any blood, vomit, or other fluids to drain.
* If the person is breathing well and has not vomited, do not move him/her until professional help is available.
* Control bleeding from a head wound by applying a pressure dressing.
* Do not give the person any food or drink.
* Keep him/her comfortable and warm, and try to be calm and reassuring.
* If the person is unconscious or unable to communicate, look for emergency medical identification such as a card, necklace, or bracelet that could suggest a health-related cause of unconsciousness or illness (for example, diabetes, epilepsy, heart disease, allergy, or hemophilia). If the person regains consciousness, keep him/her lying quietly until help arrives.

HEART ATTACK

A heart attack is a life-threatening emergency. It occurs when a portion of the heart does not receive enough blood and oxygen due to a narrowing or obstruction of the coronary arteries that supply the heart muscle. If the heart lacks blood and oxygen for more than 20 or 30 minutes, a part of the heart muscle will die.

Symptoms of a heart attack may include central chest pain that is severe, crushing (not sharp), constant, and lasts for several minutes (may be mistaken for indigestion): chest discomfort moving through the chest to either arm, either shoulder, the neck, jaw, middle of the back, or pit of stomach; profuse sweating; nausea and vomiting; extreme weakness; pale skin; blue lips and fingernails; and extreme shortness of breath. The victim may be anxious and afraid.

TREATMENT:
If the victim is unconscious and not breathing, or is having difficulty breathing:
• First call (or have someone call) 911 or your local emergency medical services system.
• ABCs: Maintain an open airway. Restore breathing and circulation, if necessary.
If the victim is conscious:
• First call 911 or your local emergency medical services system. Inform the dispatcher that the victim may be having a heart attack. If phone service is not available, take the victim to the nearest hospital emergency department promptly.
• Gently place the victim in a comfortable sitting or semi-sitting position. A pillow or two under the head may provide greater comfort. The victim should not lie flat.
• Loosen tight clothing, particularly around the victim's neck.
• Keep the victim comfortably warm by covering his/her body with a blanket or coat.
• Do not give the person any food or drink.

Warning: Not all chest pains are symptoms of a heart attack. But it is always a good idea to report any chest pains to a doctor.

HEAT EXHAUSTION

Heat exhaustion is a condition in which someone becomes overheated because of prolonged exposure to high temperatures and high humidity. If you are not sure whether the person has heat exhaustion or heat stroke, which is a life-threatening emergency, treat as heat stroke.

Symptoms of heat exhaustion may include pale and clammy skin; excessive perspiration; rapid pulse; weakness; headache; nausea; dizziness or fainting; and cramps in the abdomen or limbs. The person's temperature is usually less than 104 degrees F.

TREATMENT:
• If symptoms are severe or last more than an hour, call 911 or your local emergency medical services system promptly. The person may have heat stroke.
• Move the victim into the shade or a cool location, preferably an air-conditioned room.
• Have the victim lie flat with his/her legs elevated.
• Put cool wet cloths on the person's forehead and torso.
• If the victim is conscious, give sips of diluted salt water (1 teaspoon of table salt to 1 quart of water), but only if he/she is not having any difficulty breathing.
• Do not give alcoholic beverages.

HEAT STROKE

Heat stroke, a life-threatening emergency, is a disturbance in the body's natural heat-regulating system caused by very high body temperature. It is much more serious and urgent than heat exhaustion.

Signs of heat stroke include flushed hot and dry skin (usually with no sweating); rapid, strong pulse; and confusion or unconsciousness. Body temperature is usually greater that 104 degrees F.

TREATMENT:
- Call 911 or your local emergency medical services system immediately. Delay could be fatal.
- Cool the person, if possible, by putting him/her in a bathtub full of cold water (but do not use ice). If that is not possible, spray or sponge the victim with cold water and fan the skin while it is wet.
- Do not give alcoholic beverages.

LIGHTNING STRIKE

Being struck by lightning is a serious injury in which the victim's heart can stop beating. The electricity generated by lightning disrupts the electrical activity in the brain that controls breathing and heartbeat. Heat generated by lightning can also cause severe burns and internal injuries, and broken bones can occur from sudden, strenuous muscle contractions. The victim may also be thrown into the air from the force of the lightning strike.

You may safely touch a person who has been struck by lightning because the source of the electrical power has dissipated.

Symptoms may include any or all of the following: disorientation, or dizziness; inability to speak; unconsciousness; breathing problems; burn marks; bleeding; and shock. If the victim was thrown by the force of the lightning, he/she may have additional injuries.

TREATMENT:
- Call 911 or your local emergency medical services system. Lightning injuries are often much more serious than they seem at first.
- ABCs: Maintain an open airway. Restore breathing and circulation, if necessary.
- Treat for bleeding.
- Treat for shock.
- Treat any broken bones.
- Calm and reassure the victim.

NOSEBLEED

TREATMENT:
- Ask the person to sit and lean forward.
- Press both nostrils firmly toward the center of the person's nose with your thumb and index finger. Hold for 10 to 15 minutes without letting up on the pressure.
- If bleeding does not stop, put a small, clean pad of gauze into one or both nostrils and repeat the pressure from outside with your thumb and index finger.
- After the bleeding stops, apply cold compresses to the nose and face.
- If bleeding continues, see a physician promptly or go to a hospital emergency department.

"All human activity, in short, is little more than a reaction to regular cycles of long-term change in our planet's weather and climate." Dr. Raymond .H. Wheeler

POISON IVY, OAK, & SUMAC

An oily substance on the leaves and stems of these plants causes skin irritation. Symptoms may include rash, itching, redness, tiny blisters, headache, or fever 1 to 22 days after suspected exposure. Symptoms generally worsen over 7 to 10 days.

Poison ivy and poison oak usually have 3 leaves to a stem ("Leaves of three, let it be"). Poison sumac has clusters of 7 to 13 leaves to a stem. These plants may be bushes or trees and are usually the first to turn color in the fall. Avoid plants with dark spots on the leaves or stems.

TREATMENT:

• Cut clothing from the exposed area so that irritants are not transferred to unexposed areas of the body. Use gloves if possible.

• Avoid touching the contaminated area and clothing.

• Wash the exposed area thoroughly with soap and water.

• Calamine lotion or commercial products may be used to reduce itching and swelling. Follow label instructions.

• Wash yourself thoroughly (especially under the fingernails) after treating the person.

• If blisters develop, call your physician.

POISONING

Small children are most often the victims of accidental poisoning. Poisons are all around them. Keep cosmetics, detergents, bleach, cleaning solutions, glue, lye, paint, turpentine, kerosene, gasoline and other petroleum products, alcoholic beverages, aspirin and other medications out of their reach. If a child has swallowed or is suspected to have swallowed any substance that might be poisonous, assume they have indeed swallowed it and call for help.

Check to see if the victim has any burns around the mouth. This could indicate poison had been ingested.

Locate and keep the suspected substance and container.

IF THE VICTIM IS CONSCIOUS:

• Call the Poison Control Center.

• Do not give counteragents unless directed by the Poison Control Center or a physician.

• Do not follow directions for neutralizing poisons found on the container.

• Dilute poison by giving victim moderate amounts of water if directed by the Poison Control Center people.

IF THE VICTIM IS UNCONSCIOUS:

• Call 911.

• Check to see if the victim is breathing. If not, tilt victim's head back and perform Mouth to Nose Rescue Breathing. Do not give mouth to mouth Rescue Breathing.

• Do not attempt to stimulate victim.

IF THE VICTIM IS VOMITING:

• Roll the victim over onto his/her side. This helps insure the victim will not choke on what is brought up.

"By doing what we really truly love to do, by being playful, by being in the moment and doing what we are passionate about, we generate the perfect place from which to create." Ken Page

RAPE/SEXUAL ASSAULT

Rape or other sexual assault occurs when an individual is forced to participate in sexual activities against his/her wishes. In adults, rape usually occurs when one or several adults partially or completely penetrate a woman's vagina or other body opening through force. Men can also be victims of rape, if forced to participate in anal or oral intercourse without consent. Rape is a crime in every state. Some state laws have been expanded to include rape in marriage and between individuals of the same sex.

Rape also can be perpetrated against children by other children or by adults. This is child abuse; talk to your physician or the police if you suspect child abuse.

If you have been raped, or if another person has been raped, call the police immediately to report the crime. Next, call a relative, a friend, or a rape hotline (or other community agency with rape counseling available, such as a domestic violence safe house). Then call a physician or a hospital emergency department to let them know that a rape has occurred and that you or another individual will be seeking medical treatment.

SYMPTOMS:
Any or all of the following may be present:
1. Severe pain.
2. Bleeding.
3. Noticeable signs of physical abuse such as cuts, burns, or bruises.
4. The victim may be overcome with fear, anxiety, or depression, and may suffer from feelings or degradation and embarrassment.

TREATMENT:
• Call 911 or your local emergency medical services system.
• ABCs: If the victim is unconscious, maintain an open airway. Restore breathing and circulation, if necessary.
• Stop any severe bleeding.
• Treat any broken bones.
• Treat for symptoms of shock.
• Comfort the victim as much as possible.

The rape victim should be given a private room or taken to a secluded area at the physician's office or hospital emergency room. A rape counselor, police officers, and medical personnel may all be present to help. The victim may be asked several times to describe what happened and to give a description of the assailant. This can cause emotional stress.

A physician will recommend that the victim have a complete physical examination. The exam is performed to protect the victim from disease and to establish proof that the rape occurred. The exam will include taking samples from the mouth, vagina, rectum, and other areas, and testing for infections such as chlamydia, gonorrhea, and syphilis. Additional test may be taken for pregnancy and for HIV, the virus that causes AIDS.

After medical attention, have someone stay with the victim. The victim needs support and reassurance and should not stay alone. Seek counseling promptly for assistance in handling the overwhelming emotional aspects of the rape that can last for years.

SEIZURE

WARNING SIGNS:
- Limbs may jerk violently.
- Eyes may roll upward.
- Breathing may become heavy with dribbling or frothing at the mouth.
- Breathing may even stop in some cases.
- The victim may bite his/her tongue so severely that it may bleed and cause and airway obstruction.

DURING THE SEIZURE:
- Call for emergency medical help at once.
- Let the seizure run its course.
- Do not attempt to force anything into the victim's mouth. You may injure yourself and/or the victim.
- There is little you can do to stop the seizure.
- Help the victim lie down and keep from falling and injuring him/herself.
- Loosen restrictive clothing.
- Do not use force or attempt to restrain a seizure victim.
- Move objects out of the way which may injure the victim (like chairs, desks, tables, etc.)
- If an object endangers the victim and cannot be moved, put clothing or soft material between the seizure victim and the object.

AFTER THE SEIZURE:
- Check to see if the victim is breathing. If not, give Rescue Breathing at once (check Rescue Breathing).
- Check to see if the victim is wearing a Medic Alert, or similar bracelet or necklace. It describes emergency medical requirements.
- Check to see if the victim has any burns around the mouth. This would indicate poison. The victim of a seizure or convulsion may be conscious but confused and not talkative when the intensive movement stops. Stay with the victim. Watch the victim to make sure breathing continues. Then, when the victim seems able to move, get medical attention.

SPLINTERS

A splinter, or sliver, is a small piece of wood, glass, or other material that becomes wedged under the surface of the skin.

TREATMENT:
- Wash your hands and the person's skin around the splinter with soap and water.
- Place a sewing needle and tweezers in boiling water for about 5 minutes or hold over an open flame to sterilize.
- If the splinter is sticking out of the skin, gently pull out the splinter with the tweezers at the same angle at which it entered.
- If the splinter is not deeply lodged below the skin and is clearly visible, gently loosen the skin around the splinter with the needle and carefully remove the splinter with the tweezers at the same angle at which it entered.
- After the splinter is removed, wash the area with soap and running water and apply a bandage.
- If the splinter breaks off in the skin or is deeply lodged, call you physician about removing it and find out whether you need a tetanus shot.
- Watch for any signs of infection such as pus, redness, or red streaks leading up the body from the wound toward the heart. Call your physician if any infection occurs.

SEVERED LIMB

The severed part may be a finger, toe, arm, or leg. This is a serious medical emergency, usually involving heavy bleeding.

TREATMENT:
- Call 911 or your local emergency medical services system, or take the victim and the severed part to a hospital emergency department immediately.
- ABCs: If the victim is unconscious, maintain an open airway. Restore breathing and circulation, if necessary. The person may be conscious but seem dazed by the injury. Treat the victim for shock.
- While waiting for paramedics to arrive, or emergency medical services are not readily available, do the following:
 - Cover the stump area with moist sterile gauze. If possible, apply a splint and elevate the stump area to help stop bleeding.
 - Do not scrub wounds with antiseptic solutions.
 - Remove any jewelry from the affected area.
 - Rinse the severed part with water and wrap in moist, sterile gauze, a washcloth, or towel.
 - Place the wrapped, severed part in a plastic bag.
 - Place the part in a container (preferably plastic or foam) cooled by a separate plastic bag containing ice or ice water.
 - Do not place the severed part directly on ice or in water. Do not use dry ice or formaldehyde.

SHOCK

Shock is a dangerous collapse of the circulatory system. Symptoms of shock include cold, clammy skin with beads of perspiration on the forehead and palms; pale skin color; a cold feeling or shaking chills; nausea; vomiting; or shallow, rapid breathing. If standing or sitting, the victim may feel dizzy or faint.

Shock usually accompanies severe injury or conditions that cause serious fluid or blood loss. Anaphylactic shock, caused by a severe allergic reaction, is often life-threatening.

TREATMENT:
- Call 911 or your local emergency medical services system.
- If possible, keep the victim lying down, with the head lower than the trunk. Elevate the victim's legs if there are no broken bones.
- Treat the cause of the shock if possible (for example, control the bleeding).
- Keep the victim's airway open.
- Because the victim may vomit, turn his/her head to the side so the vomit will not be swallowed.
- Give water if the victim is conscious and able to swallow, but only if you feel medical help will be delayed for more than 1 hour. Do not give fluids to anyone who is unconscious or semiconscious, or if abdominal injury or a ruptured bowel is suspected.
- Never give alcoholic beverages.
- Keep the victim comfortable and warm. Reassure the victim.

SPRAINS & STRAINS

If you are uncertain about whether an injury is a sprain, strain, or a broken bone, treat it as a broken bone. A sprain is an injury to ligaments; tissues supporting the joints in the body. The ligaments may be stretched or completely torn. A sprain usually results from overextending or twisting a limb beyond its normal range of movement, thus stretching and tearing some of the fibers of the ligament.

Symptoms of a sprain may include the following: pain, swelling, tenderness when the affected area is touched, and black and blue discoloration of skin around the area of the injury.

A strain results from pulling or overexerting a muscle or tendon. Symptoms include pain, swelling, and muscle spasms. Back strains are common injuries. To treat a sprain or strain use the RICE routine. For a sprained wrist, elbow, or shoulder, put the affected arm in a sling.

SPRAINED WRIST
1. Place a padded splint underneath the lower arm and hand.
2. Tie the splint in place.
3. Place the lower arm, and elbow at right angle to the victim's chest. Put the lower arm into a sling and tie it around the victim's neck.

The RICE routine-first aid for minor injuries

RICE is an acronym for **Rest, Ice, Compression**, and **Elevation**. These are the four steps often recommended for immediate care of minor injuries such as sprains, strains, and muscle pulls. If you are in doubt about the nature of your injury or how severe it is, talk to your physicain before using **RICE.**

REST: Stop playing or exercising and rest the injured part of your body to help reduce swelling and stop further bleeding in the tissues.
ICE: Apply an ice pack to the injured area at regular intervals (20 to 30 minutes at a time, every 3 hours) over the first 2 to 4 days after an injury. By narrowing your blood vessels, the cold temperature relieves pain and also helps limit swelling and bruising.
COMPRESSION: Wear an elastic compression bandage around the injured body part for at least 2 days. The bandage should cover the injured area but also extend a few inches above and below it. Do not wrap the bandage so tightly that it cuts off circulation in the injured part. Loosen the bandage if swelling increases. Compression, like ice, helps limit swelling and bruising, and provides pain relief by supporting injured muscles and tendons. (WARNING: If you have diabetes or vascular disease, talk to your physician before using an elastic bandage; if wrapped too tightly, an elastic bandage can interfere with circulation.)
ELEVATION: As often as possible, keep the injured part elevated above the level of your heart. Elevation reduces pressure in the tissues, which helps drain any fluids that have collected in the tissues because of your injury. In addition, elevation reduces swelling and bruising.

See your physician if pain or swelling persists. For sprains or strains of the ankle, wrist, or hand, it is useful to know how to wrap a figure-eight bandage.
FIGURE -EIGHT BANDAGE:
1. Anchor the bandage with 1 or 2 circular turns.
2. Bring the bandage diagonally across the top of the foot and around the heel and ankle.
3. Continue the bandage down across the top of the foot and under the arch.
4. Continue figure-eight turns, with each turn overlapping the preceding turn by about 3/4 of its width.
5. Bandage until the foot (not the toes), ankles, and lower legs are covered. Secure the bandage with tape or clips.

SUNBURN

Sunburn is usually a first-degree burn of the skin caused by overexposure to the sun's rays. Prolonged exposure can lead to a more severe burn. Any or all of the following symptoms may be present; redness, pain, mild swelling, and, in severe cases, blisters and considerable swelling.

TREATMENT:

• Put cold water on the sunburned area.

• If sunburn is severe, submerge the sunburned area in cold water until pain is relieved. It is also helpful to place cold, wet cloths on the burned area.

• Do not rub the skin.

• Elevate severely sunburned arms or legs.

• If possible, put a dry sterile bandage on the severely sunburned area.

• Take acetaminophen or aspirin for the pain.

WARNING: Do not give aspirin to children or adolescents who are ill with a fever. Aspirin has been linked with Reye's syndrome, a potentially fatal condition. If you are pregnant or breast-feeding, talk to your physician before taking any medication.

• Seek medical attention for severe sunburn. Do not break blisters or put ointment, sprays, antiseptic medications, or home remedies on severe sunburns.

TICK REMOVAL

A tick is a parasite that embeds its head in your skin and feeds on your blood. Tick bites can cause Lyme disease or Rocky Mountain spotted fever.

After hiking or camping in forests or fields, check your body for ticks, especially in your hair, around your ankles, and in the genital area. Always wear a long-sleeved shirt, long pants tucked into your socks, and shoes. Use an insect repellent formulated to ward off ticks. Also, ask your veterinarian to recommend a tick repellent for your pets.

TREATMENT:

• Using tweezers, firmly grasp the tick's head as close to the skin as possible. Pull gently but steadily.

• After removing the tick, dispose of it without touching it, and disinfect the bite with alcohol.

• If you can't remove the tick, see your physician who can make a small incision to remove the head.

• Never use a lighted cigarette or match to remove a tick.

TRANSPORTING AN INJURED PERSON

Do not move an injured person before a physician or emergency medical services team arrives unless there is imminent danger of further injury such as from a fire or flood. You must move the person, keep the following guidelines in mind.

WARNING: If there is any chance of a back or neck injury, be careful. Any movement of the head, either forward, backward, or side to side, can result in paralysis or death. If you must move the victim, keep the person lying down. Always keep his/her head, neck, and body in alignment. Control bleeding, maintain breathing, and splint all suspected fractures before moving. If this is not possible, carry or pull the victim to safety.

1. Carrying the victim to safety:

 -If the victim must be moved, a stretcher is the best means of transporting.

 -If you do not have a stretcher, use a board as a substitute and strap the victim to it.

 -If needed, improvise with clothing, a rug, or blanket placed over poles or sturdy branches.

2. Pulling the victim to safety.

 -Firmly grasp victim's shirt or coat collar so their head is resting on your forearm.

 -Keep the head close to the ground or floor and keep the body in a straight line.

 -Make sure the collar or clothing around the neck is not pulled to obstruct the airway.

"A man can fail many times, but he isn't a failure until he begins to blame somebody else."

WOUNDS IN THE CHEST OR ABDOMEN

Severe or large wounds may be a life-threatening emergency. For minor cuts and abrasion see Cuts and Abrasions.

TREATMENT:

For gaping abdominal wounds call 911 or your local emergency medical services system. Treat the situation as a life-threatening emergency and follow the next steps while you are waiting for help:

1. Keep the person lying down.
2. Attempt to control bleeding with a pressure dressing:
 -Gently cover protruding organs with a damp dressing (sterile gauze or a cloth pad), but do not push the organ back in place.
 -Hold the dressing firmly (but not too tightly) in place by hand or with a bandage.
3. The person may be in shock; if so, treat for shock.

For deep chest wounds:

1. Put a large gauze/cloth pad over wound. The pad must be larger than the wound to be effective.
2. Cover the pad with airtight material such as plastic, aluminum foil, or rain gear.
3. Hold the pad firmly in place, but only on 3 sides. You must allow air to escape when the victim exhales; otherwise, air trapped in the chest may make breathing even more difficult. After this step, if a victim's breathing is more labored or his/her condition worsens, remove the pad and reapply it, being careful to allow air to come out when the person exhales.

For embedded foreign objects:

1. Unless it obstructs the airway, do not remove the object. Call 911 or your local emergency medical services system, or get the victim to a hospital emergency department where immediate treatment can be started.

FIRST AID KITS

The question asked is what do you need in a first-aid kit? A first-aid kit should contain the following basic items. They should be very accessible with one at home and one in your automobile. You should check the contents regularly and make sure all items can be used in case of an emergency. Include any prescription medications that you or a family member might need. See checklists.

- First-aid manual
- Gauze
- Adhesive tape
- Plastic adhesive bandages
- Elastic bandage
- Sling
- Antiseptic cream
- Calamine lotion
- Activated charcoal
- Diphenhydramine capsules
- Roll of cotton
- Scissors
- Tweezers
- Thermometer
- Disposable cold packs
- Antiseptic wipes
- Soap
- Syrup of ipecac
- Aspirin and acetaminophen tablets
- Blankets

SURVIVING
HUMAN ACTIONS
GUIDES/RULES/ACTIONS

"No shade-tree? Blame not the sun but yourself." Chinese proverb

TEN RULES FOR SURVIVAL

When most people think of survival, they think of taking practical steps. However, survival is also a mind set, and that is what I want to emphasize. Above all, don't think of survival in a negative way, as an escape from a deteriorating situation. Rather think of it as a preparation for taking advantage of the future. The following rules are not a formula for getting rich, but survivors always have a chance to get rich.

(1) YOU (AND YOUR FAMILY) FIRST. We are taught most of our lives to give consideration to others to such an extent that it tends to become a habit. We accept second rate merchandise without complaining, back down in the fact of criticism by bosses, feel guilty and knuckle under when challenged by the IRS or some other department of the government, and automatically do things on request for other people that use up valuable time or are not in our best interests. During hard times, or when one's life is at stake, people are not so polite. However, unless you have formed the habit of putting yourself and your family first-even at the expense of someone against who you have no hostility-you will not be able to take drastic survival action if and when it is necessary, whether it be insisting on your civil rights or obtaining medical treatment for a child. Start taking care of Number One right now and you won't have to worry about taking care of him/her later. Get your way every day when you can, and you'll be more likely to get it when you desperately need it. It is worth keeping in mind that the world's best survivor up until now is the shark which has been swimming in the oceans and eating everything in sight for more than 45 million years.

(2) MAXIMIZE YOUR HEALTH. How often have you heard it said that health is more important than money or worldly success? But how many people are living up to this fundamental truth? Most people worry about their bank balances more than their waistlines or their chances of getting cancer, or a stroke. If you have your health and the inevitable optimistic spirit and physical energy that go with it, you can survive the worst kind of financial setback and make a comeback. There is enough literature on health around to fill a university library, so there's no point in going into details here. However, a few hints:

A) As someone who has had many medical problems I can tell you that doctors don't know everything and a really good doctor in any specialty is hard to find. So when any problem appears to be serious, seek the opinions of at least three doctors.

B) Promptly take care of secondary medical problems, such as teeth repair, the need for new glasses, a hearing aid, foot problems, etc. There's nothing worse than not being able to see well, hear or walk in a time of crisis.

C) Keep an emergency medical list in the house and the number of the doctor or hospital you will call in the event of an emergency.

D) Thoroughly explore alternative medicine, which often can prevent serious illness. One good book: " The Life Extension Companion" by Rube Pearsen and Sandy Shaw (Warner Books).

(3) REDUCE YOUR DEPENDENCE ON MONEY. Money is the great enslaver. You have to work or serve somebody else to get it, you need it to exchange for food, clothing and the other necessities, but it is intrinsically worth nothing and its value is beyond your control. It is merely a piece of paper printed by the government or a check you write against computerized numbers in a bank. Obviously, you will have to keep on using a bank, but you don't have to give the bank absolute power over you. The first step in reducing money dependence is to get out of debt, or reduce debts as much and as rapidly as possible. What you don't owe, you don't have to earn. Pay off your mortgage and the obligation on your car. Invest in tools, weapons and other up-to-date equipment you can use or sell. Keep enough cash in your house to live for at least three months and keep you bank money in big banks (never in only one bank) and never more than $100,000 in a single bank account. Get in the money saving habit and park the money you save in Treasury Bills, preparing for the inevitable day when you can come out of financial hibernation and invest aggressively without fear. And don't worry about low interest rates, capital preservation is the name of the current game.

(4) FILL UP THE STOREHOUSE THAT CAN NEVER BE EMPTIED-ADD TO YOUR KNOWL-EDGE AND EDUCATION. The one thing that cannot be taken away from you is the knowledge in your head and your trained mental ability. Therefore, invest in yourself. Study and deepen your knowledge of your profession. Learn a new profession. Study accounting or a foreign language, take a computer course, or learn a trade that you might be able to use in the event that civilization as we know it breaks down.

TEN RULES FOR SURVIVAL

HOW TO SURVIVE AND PROSPER IN THE YEARS AHEAD:

(5) IMPROVE YOUR PHYSICAL SKILLS. Learn to swim if you don't know how, take a course in pistol or rifle shooting, ride a bicycle or jog regularly. Take up skating, skiing, mountain walking, or climbing. In the end, your survival could depend on whether you can walk to town.

(6) HOLD GOLD AND SILVER. Gold and silver are the traditional money of the world. In the event of a total collapse of the world's money system they will go back into circulation as money, with bullion gold coins such as the Krugerand, Canadian Maple Leaf and the US$20 Liberty being the most useful for day-to-day transactions. You should keep some of these coins in your house or near at hand in a vault. However, not too many. The problem with gold (and silver as well) is that it's price is volatile. In the event of world deflation, the price of gold could drop drastically before rising again. Big gold bars are also of little transactional use except as holdings in a safe deposit box in Switzerland. I have recommended keeping from 10 to 20 percent of your assets in gold if you don't need income. The new world order media will tell you over and over that gold's day as money is over. But the central banks still hold 930 million fine troy ounces of the yellow metal, worth $372 billion, down less than 10 percent since 1975. So if it's not really money, we can ask, why are the central banks still holding it? Could it be that they really don't have confidence in the world's paper money system?

(7) KEEP SOME MONEY OUT OF THE COUNTRY. The big multinational corporations are spreading their tentacles around the world, parking assets and manufacturing facilities in country after country, and leaving the US in the lurch, so why shouldn't you? The new world order folks want the world to be one big happy financial family, so why don't you get into the swing? No, we don't mean the sucker plays called "emerging markets," but Swiss Franc security and income from Swiss Annuities. Since I began writing about them, the Swiss Franc has jumped another four percent, making a 19 percent rise against the dollar so far this year-and that doesn't count the up to 10 percent interest you can get on the Annuities, which have paid off without fail for the past 140 years. I expect the Swiss Franc to go one-to-one against the US Dollar within three years, which will tack on another 20 percent or so in profits. I already have more requests for information than I can easily handle, so I don't want to sound too enthusiastic. After all, if you have money in Switzerland, you might have to pay a visit t here from time to time , and that will cost plenty of money for air fare and hotel bills, to see this orderly and beautiful country.

(8) GET A SECOND HOME OR RETREAT outside of the United States or away from big cities in a safe and comfortable part of the country. This recommendation is especially important if you live in or near a big city, which would be most vulnerable to any sort of economic or social collapse. If you can't swing a second residence have an organized plan about where you can go if you have problems where you are.

(9) GET AND LEARN HOW TO USE AT LEAST ONE GOOD FIREARM, OR OTHER WEAPON. I'm not exactly a gun nut at this stage in my life, but when the chips are really down, the old equalizer is your best insurance policy. Guns also are as good as gold in trading for groceries. A self defense course or two for the family also fits into this category as do things like short wave radios, flashlights, extra cans of gasoline, alcohol, cook stoves, and the like.

(10) GET TO KNOW YOUR NEIGHBORS, OR PEOPLE YOU WOULD LIKE TO BE YOUR NEIGH-BORS. Nothing really important can be accomplished without other people believing in the same things, aiming for the same things, and working together. You can't always find this in your literal physical neighborhood, or at your work place. However, a search through social groups, community organizations, clubs or political parties will uncover friends who will stand with you in times of travail, or in an emergency.

THE ELEVENTH RULE
If I could give you an eleventh rule it would be to devote some portion of your day to purely spiritual values, or for simple meditation. Giving some time to a higher power will strengthen you immeasurably in dealing with the challenge or survival.

BECOME SELF-RELIANT

- Become self employed.
- Get out of debt.
- Have a safe homestead.
- Raise your own food.
- Store food.
- Have communications.
- Be aware.

14 THINGS YOU SHOULD DO BEFORE THE UPHEAVAL

Hundreds of thousands of families have made the decision that they are no longer going to rely on some "government" to take care of their family in a time of crisis. It really doesn't make any difference if the crisis is caused by plant layoffs, bank failures, urban riots, personal attack, drug/gang crime, food shortages, the New World Order, hurricanes/floods/earthquakes, terrorist attack, or even the start of World War III. What is important is how you respond to the threat. Actively preparing to care for yourself and your family gives you a valid feeling of well being. In addition, should a threat occur in your life, you will be vastly better off than those who pretend it can't happen to them!

1- Build a small solar energy system.
2- Develop a family and friends communication network.
3- Defend yourself.
4- Develop a water supply that uses no energy, or store a supply of water.
5- Start a food storage program.
6- Install emergency heat in your home.
7- Financial independence by being out of debt.
8- Move away from dangerous cities.
9- Raise your own food.
10- Learn to preserve food.
11- Build a Nuclear, Biological, and Chemical shelter.
12- Develop an early warning system for approaching trouble. Get alternate sources of news. Get a dog.
13- Build a reference library with information to assist you in the coming changes.
14- Strengthen your body by exercise, balanced diet, food supplements, and any needed medical care.

**Preparation is the key and these fourteen things may help
and give you peace of mind.**

AIDS/PLAGUE

PRECAUTIONS AGAINST AIDS: The best prevention is to assume that there are many ways to become infected with the AIDS virus. Not all ways are known and you must be on guard at all times.
• Get educated. Read both sides of the story. Remember the Center For Diseases Control isn't always factual in the information that it releases. AIDS is contagious and lethal. There is no cure. Remember there is no cure for the common cold and prevention is the most effective measure. It could be the major plague of our time. Don't underestimate it or assume anything. The more one knows about AIDS, the better chances are to avoid infection. Evaluate all AIDS information carefully, discarding the nonsensical or false.
• Know who the "high risk groups" are. If you are in any of those groups, be very careful. If not, be careful when in contact with a person in these groups.
• Practice "safe sex." Do not have sex with an infected person or a person you don't know unless you use a condom and/or diaphragm and you realize your chances of becoming infected are greatly increased. Don't practice anal sex. Know your partners and talk to them about AIDS.
• Do not inject drugs (heroin, speed, cocaine, etc.) with needles and syringes used by others. Be careful about flu shots or other innoculations for they could be a possible source.
• Use disinfectants. While the AIDS virus is able to stay alive outside the body in ideal conditions, it is easily killed with any good disinfectant, including soap and water, hydrogen peroxide, rubbing alcohol, and household bleach (one part bleach to nine parts water).
• Accept blood transfusions only when necessary and only if properly screened for AIDS and prepared by appropriately housed blood banks.
• Don't assume AIDS is primarily a sexually transmitted disease. Always keep in mind that other modes of becoming infected are possible and even probable. Don't become static of some other future-proven route of infection, such as mosquito bites, "casual contact," or kissing.
• Remember that AIDS is still primarily confined to gay and bisexual men in the United States at this time, but heterosexuals are not immune to the disease. The virus does not prefer one human to another. It will infect both men and women given the opportunity. Don't give it that opportunity!
• AIDS-infected people are just as infectious as AIDS-sick people. Treat both the same-very carefully.
• When in public, cleanliness is the best precaution. Patronize only clean restaurants, theaters, and other such public or private establishments. Use only clean public toilets and drinking fountains, and try to avoid such facilities as often as possible. Try to stay out of congested areas when possible, as coughing, sneezing, and spitting may increase your chances of infection. Common sense here can prevail.
• Don't go to the hospital unless absolutely necessary and only consent to surgical procedures or blood transfusions when necessary.
• Visit your doctor if you suspect you may have been infected with the AIDS virus. After testing you, he will tell you if you have AIDS or not. If you don't have it, consider yourself lucky and take the above precautions to heart. If you do, begin immediate treatment and get counseling for yourself and advice on how to help prevent infection to others.

All of the above precautionary measures can help one's chances of escaping AIDS infection; but, remember, infection is still possible. The more that is learned about the disease, the more precautions we will be able to ascertain.

During the flu epidemic of 1918-1919 more than 550,000 Americans died of the disease which is more than 10 times the American losses in battle during all of World War One.

ANIMAL ATTACKS

ANIMAL ATTACKS
• Avoid eye-to-eye contact with any 'vicious' animal, especially a dog.
• Be careful of rabies which is evident by foaming at mouth, glazed eyes, and staggering.
• If attacked, use sticks or stones to protect yourself. Also a bicycle or object of the sort can be used as a protective barrier.
• For dogs-Stand still-speak firmly (as the owner might) using clear commands such as "No," "Stay there," or "Sit." Try using a "good boy" gentle voice to talk to the dog. If a small dog goes for your ankles-a soft kick may work. If running or jogging, stop. Walk away before continuing to run. If chased by a dog (or other animal) drop an article of clothing or a bag! It may stop to investigate it. Hit on the nose hard and fast. Brace forearm in front of you, offering it to dog. When seized, jam it to back of jaws and instantly bring over your other arm (palm flexed and facing floor) so bony edge of forearm forces into back of dog's neck as you force the head backwards and over the arm with quick jerk using a rolling action.
• For snakes: Make noise. Wear protective clothing and boots. Use walking stick in advance of your footsteps.
• For tigers/cats: Try freezing still, staring back hard, yelling and or screaming.
• For insects: Wear protective clothing. Use insect repellant and B-6 vitaimins. If not available, use mud. Steer clear of their environment such as swamps, ponds, and bogs. Use the smoke from a fire or cigarettes to repel the bugs. Light can attract many types.
• For bees, wasps, hornets: Wear plenty of clothes for protection. If attacked, dive for water or head to thick undergrowth.
• For sharks: Don't turn and flee but face and swim to one side as he comes in. Suddenly swim at shark. At close quarters, try kicking, punching, and handing off. Scream underwater. Slap surface water with hands. If armed-stab gills or eye.

ARREST/SEARCH

- Stay calm, cool and collected. Also be quiet and respectful.
- Watch what you say, it really will be used as evidence.
- Don't argue, don't make jokes and don't wave your hands about. All of these may go wildly 'wrong' and the situation may escalate.
- Ask to see their identification and badges. Get the name and number of the official.
- Police may use all force reasonably necessary (if charge is illegal, person may sue later).
- You must be informed of the charge promptly so you can prepare your defense.
- You do not have to talk, simply give your name and address.
- You are entitled to contact family or a lawyer by phone.
- You are entitled (in most cases) to the aid of a lawyer. If you can't afford one, the state generally must supply and pay the cost of one.
- You are allowed to apply for bail (in most instances), so you can be free from jail pending trial. This doesn't apply in cases of capital offenses, such as first degree murder in many states.
- You are entitled to a speedy, public and fair trial by an impartial jury of your peers.
- In court you are presumed innocent (and need not prove it) until proved otherwise by the state, via evidence clear and beyond a reasonable doubt.
- You cannot be forced to take the witness stand to testify for or against yourself.
- You have the right to confront witnesses against you and have them cross-examined by your lawyer.
- You have the right to subpoena witnesses in your behalf.
- You have the right to object to unreasonable search and seizure of you or your home for evidence to be brought to court.
- You may be tried only once for each offense.
- You may usually appeal to a higher court.
- You will not be subjected to cruel and unusual punishment.
- If detained against your will, you have the right to petition the court for a writ of habeas corpus to determine if detention is lawful and your case must be heard promptly.
- You may not be subjected to any bills of attainder by act of legislature depriving you of property, if found guilty of felony or treason.
- You may not be subjected to any ex post facto (after the act) laws.

BIOLOGICAL/CHEMICAL
ACCIDENT/ATTACK

- Prevention: Avoid contamination area. Take passive measures by being aware. Locate and identify potential hazards and know the environment that you are in. Limit the spread of the contamination if possible. If not, move out of the contaminated area. Be informed and report when necessary.
- Protection: If you are not able to move from the contaminated environment, wear appropriate gear. This may include gas mask, gloves, protective pants, shirts, jackets, and boots.
- Decontamination: Use necessary measures to rid yourself and immediate environment of the contaminates.

"No medicines can cure the vulgar man." Chinese proverb

CAR ACCIDENT

Prevention: Obvious as it may be, always try to avoid any head-on collision with another vehicle or a fixed object such as a wall or tree. These are the most dangerous type of accidents of all. Aim to scrape along a wall. Go for dense bushes, not a solid tree. If a car is heading straight for you, brake and look for an escape route. Remember the other driver might try to pull over in the same place as you, so only turn when you see which way he's swerving. Turn away from him, even if you have to side-scrape an "innocent" car.

After an accident:
- STOP! Even if your own vehicle is OK (for example, if someone else swerved to avoid you and crashed).
- If you've caused an obstruction, ensure there are no further accidents by getting someone to stop or direct oncoming traffic.
- Remain calm even if injured or in shock. If there is serious injury, the first priority must be to apply first aid and call an ambulance. If fuel is leaking, and there is any danger of fire or explosion, don't smoke. Move everyone back to a safe distance.
- Call the police (and an ambulance) if there is serious injury, traffic obstruction or damage to vehicles or property. Inform them later if you damaged an unoccupied car, it's an offence not to.
- Don't argue about what happened, and don't admit liability.
- If anyone saw the accident, take their name and address so they can make a statement to your insurance company.
- Make a sketch of the scene before anything is moved; road names, position of trees and lampposts, road markings, position of vehicles in relation to each other, length and position of skid marks.
- Make a note of damage sustained by all vehicles involved. If you've got a camera with you, this is even better because you need as accurate a record of the damage as possible.
- Collect names, addresses and registration numbers and give you own. If anyone refuses, note their car license number so it can be traced.
- If someone is injured, you must produce your insurance certificate there and then, or report to the police within 24-hours.
- Contact your insurance company within 24-hours and ask for accident report and claim forms. Supply them with full, accurate details and a written estimate of repair costs from a garage, any letters or bills from the other driver(s), plus any police Notice of Intended Prosecution.
- Remember that people may be expecting you to arrive. Telephone ahead to say that you are going to be late.

CAR THEFT

PREVENTION Most cars are taken by amateurs who can be stopped fairly easily. You can increase your protection against this type of crime by taking the following sensible precautions:

LOCK UP:
•An unlocked car is an open invitation to a car thief. Lock up when you leave your car and take the keys with you.
•Lock the trunk or tailgate.
•Close all windows. Professional thieves have tools that unlock cars through the smallest openings.
•Be sure vent or wind-wing windows are shut tight.
•When you park the car, remove cellular phones, cassette players and other valuable possessions. Do not leave gift wrapped packages or cameras lying on the seat. Lock all valuables in your trunk or take them with you.
•Lock your car even if you are making a quick stop at the gas station, convenience store or mini-mall.

PARK CAREFULLY:
•Don't leave an auto in unattended public parking lots for an extended period. A car is five times more likely to be stolen form an unattended lot than from the street or attended lot.
•If possible, park your car in a lot where you don't have to leave your keys.
•Never attach a tag with your name and address to your key ring. If the keys are lost or stolen, the tag will lead the thief directly to your car and your home. If you have to leave your keys with a parking attendant, leave only the ignition key.
•At night, park in well lit areas with lots of people around.
•Turn wheels sharply toward the curb when parking, this makes it extra difficult for thieves to tow your car.

OPERATION I.D.:
•With an electric engraver, etch your driver's license number on cassette players and other valuables.
•Record your vehicle identification number and store it in a safe place.
•Keep the vehicle registration in your wallet or purse, not in your car.

USE ANTITHEFT DEVICES:
•When buying a car, check the manufacturer's list of antitheft options, such as interior hood and trunk releases, locking steering columns and others.
•Consider the purchase and installation of security devices, such as:
 *interior hood lock release
 *second ignition switch or kill switch
 *locking gas cap
 *fuel switch to prevent fuel from reaching carburetor
 *locking devices for batteries, wheels, decks, etc.
 *alarm device to activate a siren, horn or lights, or all three, to frighten the thief away.
 *device that attaches to the steering wheel or brake pedal

CARJACKING: This violent, random form of auto theft is on the rise. A driver of any vehicle can be a target of someone with a weapon. It can happen anywhere, day or night. Here are some precautions:
•Keep your doors locked.
•Park in well-lit, busy areas.
•Be alert of your surroundings, of people approaching your vehicle.
•Stick with the traffic, avoid lightly traveled streets, especially after dark.
•Keep car and house keys on separate key chains.
•Keep the garage door opener in your purse or briefcase.
•When stopped in traffic, always leave enough room to make an emergency getaway.
•If someone is threatening you with a weapon, give up the vehicle--it's not worth your life.

"The first and greatest commandment is: don't let them scare you." Elmer Davis

CIVIL/URBAN UNREST

• **Be aware by recognizing danger.** Have communication such as a radio, CB, or scanner. Use your senses. Panic spreads fast so when you feel threatened like your hair standing on end and the adrenalin working. Take action. Fight down the panic and stay calm.

• **Get away-stay out of harm's way.** Avoid trouble areas and/or dangerous parts of cities. Move away from dangerous cities.

• **Avoid confrontation and try go around potential problems.** Have an escape route that you have selected ahead of time. Remember, "Those who live by the sword, die by the sword." You might end up the target of a person's built up anger even though you are not a part of the problem.

• **Act like the natives.** Try to blend in so you don't attract attention. Be careful of what you wear. Be aware of your surroundings.

• **Hide equipment/supplies away from your home.** Have a retreat or place where you can escape to as a safe haven. As governments get more totalitarian they make the citizens outlaws by banning things like gun or gold. Bury things or have them hidden away.

• **Learn to defend yourself.** Choose an art that is compatible to your beliefs such as karate, aikido, mace, pepper spray, or shooting. If you face trouble head on, you should resist with everything possible in a life or death situation.

• **Don't get involved in mobs or mob behavior.** They become mindless and objectivity is lost.

• **Crushed in a crowd?** Self preservation is the key. Try to ride it out like a bouy in the sea. If caught in a crowd surge, stay away from anything solid like a wall, barrier, or pillar. Keep hands out of pockets and loosen tie.

Soccer riot in Lima, Peru.

"Stress is only a burden when you respond to it with a feeling that you have lost control." R.S. Elliot

CRIME PREVENTION AND PERSONAL SAFETY

BABY-SITTING SAFETY
• Always post emergency numbers and your address by the telephone for your babysitter.
• Leave a number where you can be reached and other information the sitter might need.

SEXUAL ASSAULT
• About one-third of sexual assaults occur in the victim's home.
• About 40% of sexual assaults are committed by persons known to the victims such as dates, acquaintances, neighbors, co-workers, or even spouses.
• Rapes also occur in the street, in school yards, and in parking lots. Be alert to your surroundings and the people around you.
• Call your local rape crisis center to sign up for prevention and self-defense classes.
• Many strategies are involved with rape avoidance. Studies show a combination of screaming, physical resistance, and fleeing is most effective.

CAR SAFETY
• Always lock your car even when you will be gone for only a few minutes.
• Lock your doors when driving.
• Park in well-lighted areas, and observe your surroundings when you leave your car at night.
• Always have your car and house keys in hand so you will not have to fumble for them.
• Keep your car in good working condition.
• If your car breaks down, use distress signals such as putting the hood up, putting a white flag on the aerial, or setting your emergency flashers. Remain in the car with the doors locked. Wait for the police or ask anyone who does stop to send a tow truck or the police. Be wary of accepting help from strangers.
• If you are followed by another car, honk your horn all the way to the nearest gas station, police or fire station, or lighted house.
• If someone threatens you while you are in your car, lock all doors, and blow the horn in short bursts to attract attention.
• Do not pick up hitchhikers.

ON THE STREET
• Walk confidently. Be alert. Notice who passes you and who is behind you.
• Walk in well-lighted areas. Do not walk near bushes, alleys, etc.
• Wear clothes and shoes that give you freedom of movement.
• Do not overburden yourself with bags or packages that might make running difficult.
• Carry as little cash as possible. Carry a whistle, alarm, or loud horn.
• Hold your purse tightly, close to your body. Keep your wallet in a front or buttoned hip pocket or inside coat pocket.
• Do not hitchhike.
• If a car stops you for directions or information, always reply from a safe distance. Never get too close to the car.
• If a car persists in bothering you, cross the street and walk or run in the opposite direction.
• If you feel someone is following you, turn around and check. Proceed to the nearest lighted house or place of business.
• If you feel you are in danger, do not be afraid to scream and run.

SAFETY FOR SENIOR CITIZENS
• Have social security or retirement checks sent directly to your checking or savings account.
• Beware of get-rich-quick scams or persons who ask you to give them large sums of money. If it sounds too good to be true, it probably is.
• Be wary of good deals on expensive home repair or home improvements.

TELEPHONE SAFETY
• Do not give information about yourself to strangers over the telephone or admit that you are alone.
• Consider listing your name and number in the telephone book without your address. Also, list only the initial of your first name.
• Keep all emergency numbers near the telephone. Hang up immediately on obscene telephone callers.

IN AN ELEVATOR
• Check the elevator before entering. Wait for the next elevator if you are suspicious of any occupant..
• When riding in the elevator, stand near the control panel. If accosted, press all the buttons, including the alarm.

"Ignorance of the law is no excuse."

DOMESTIC VIOLENCE

Are you abused? Does the person you love.....
☐ Track all of your time?
☐ Humiliate you in front of others?
☐ Criticize you for little things?
☐ Threaten to hurt you or the children?
☐ Force you to engage in sex against your will?
☐ Hit, punch, slap, kick, or bite you or the children?
☐ Destroy personal property or sentimental items?
☐ Anger easily when drinking alcohol or taking drugs?
☐ Control all the finances and force you to account in detail for what you spend?

☐ Constantly accuse you of being unfaithful?
☐ Discourage your relationships with family and friends?
☐ Prevent you from working or attending group meetings?
☐ Use, or threaten to use, a weapon against you?

If you are hurt, what can you do? There are no easy answers, but there are things you can do to protect yourself:
☐ Call the police or sheriff. Assault, even by family members, is a crime. The police often have information about shelters and other agencies that help victims of domestic violence.
☐ Leave, or have someone come stay with you. Go to a battered-woman's shelter. You can call a crisis hotline in your community, or a health center, to locate a shelter. If you believe that you and your children are in danger, leave immediately!
☐ Get medical attention from your doctor or a hospital emergency room. Ask the staff to photograph your injuries and keep detailed records in case you decide to take legal action. If you have a friend take pictures of your injuries, make sure the camera used leaves a date on each shot for proof later of time and date.

☐ Don't ignore the problem!
☐ Contact family court for information about a civil protective order that doesn't involve criminal charges or penalties.
☐ Talk to someone. Part of the abuser's power comes from secrecy. Victims are often ashamed to let anyone know about intimate family problems. Go to a friend or neighbor, or call a domestic-violence hotline to talk to a counselor.
☐ Plan ahead and know what you will do if you are attacked again. If you decide to leave, choose a place to go, and set aside some money. Put important papers together--marriage license, birth certificates, checkbooks, savings account books, social security cards, insurance information-- in a place where you can get to them quickly.

☐ Have you hurt someone in your family?
☐ Accept the fact that your violent behavior will destroy your family. Be aware that you break the law when you physically hurt someone.
☐ Take responsibility for your actions and get help.
 When you feel tension building, get away. Work off the angry energy through a walk, a project, or a sport.
 Call domestic violence hotline or a health center and ask about counseling and support groups for people who batter.

The high costs of domestic violence:
• Men and women who follow their parents' example and use violence to solve conflicts are teaching the same destructive behavior to their children.
• Jobs can be lost or careers halted as a result of injuries, arrests, or harassments.
• Lives can be lost, violent behavior often leads to death!

Take a stand!
☐ Reach out to someone you believe is a victim of family violence, or to someone you think is being abusive. Don't give up easily, changes take time. Ending the family's isolation is a critical step.
☐ Use organizations and businesses to raise community awareness by hosting speakers on domestic violence, launching public education campaigns, and raising funds for shelters and hotlines.
☐ Ask the local newspaper, radio station, or TV station to examine the problem and publicize resources in the community through special features and forums.
☐ Form coalitions or watchdog groups to monitor the responses of local law enforcement agencies and courts. Offer praise where appropriate and demand reform when necessary.
☐ Most communities offer resources for victims of family violence. Check your telephone directory or ask a law enforcement agency.

"In marriage, three rules apply: 1) No expecation; 2) No blame; 3) No judgement." R.E. McMaster, Jr.

ECONOMIC COLLAPSE

- **REDUCE YOUR DEBT:** Reducing ones debt to as close to zero as possible is essential. That may involve selling off some of your real estate investment, moving to a smaller home, refinancing your home mortgage to a 15-year loan, and eliminating your credit cards. Stop paying interest.

- Do not be dependent on the government for your well-being.

- Take control of your own finances. Read many alternate sources of information. Do your homework. Be careful to understand what is going on. Avoid states of denial. Become as independent as possible.

- Make yourself save a minimum of 10%. Most people live above their means. Learn to live below your means. If you save a minimum of 10% per month, you can grow your wealth very safely. Some can save 20%-25%.

- Diversify your investments, include investing in Swiss money instruments.

- Avoid weak financial institutions. Get out of harm's way. Thousands of banks, S& Ls and insurance companies are tottering on the brink of disaster. And in spite of the perception to the contrary, there is no substantive insurance safety net under these institutions.

- Avoid popular investment markets. There are few goof opportunities for conservative investors. Stocks are overvalued. Corporate bonds are vulnerable and will drop as U.S. interest rates rise. Be very selective in investment real estate.

- Find investment safe havens. The three best and most conservative investments to put your money into over the next few years are gold and silver, foreign government bond funds, and U.S Treasury bill money market funds. Don't announce to the world what you are doing; keep a low profile.

- Legally bulletproof your business and personal matters. America is the most litigious country in the world, with 700,000 lawyers and 187 million new civil lawsuits per year. Every doctor, professional business person or business owner has a nightmare about being sued into ruin.

- Change your mindset about the news, about investments and about your financial security. To survive the coming hard times, you must change the way you do things, the way you think, and the way you invest. You must read between the lines in today's news reports ... find alternative investments and financial institutions ...and plan for the future.

- Purchase a one-year food supply and have a large water source. Own tangible assets or commodities that can be bartered or traded.

- Buy real estate in a small town or rural community that can serve as a retreat or place of refuge.

DRUGS/SUBSTANCES

Warning signs: Has a friend become moody, short tempered, and hostile? Are they spaced out? Are they suddenly failing courses and hanging out with kids you don't trust. Stop and think about it. Your friend may have an alcohol or other drug problem.

Here are some additional signs of drug or alcohol abuse:
- ☐ Increased interest in alcohol or other drugs; talking about them, talking about buying them.
- ☐ Owning drug paraphernalia, such as pipes, hypodermic needles, or rolling papers.
- ☐ Having large amounts of cash or always being low on cash.
- ☐ Drastic increase or decrease in weight.
- ☐ Slurred or incoherent speech.
- ☐ Withdrawal from others, frequent lying, depression, paranoia.
- ☐ Dropping out of school activities.

If your friend acts this way, it is not a guarantee that he/she has an alcohol or other drug problem. You need to compare the behavior now to behavior in the past. But it's better to say something and be wrong than to say nothing and find out later that you were right to be worried.

How to talk to a friend who's in trouble:
- ☐ Plan ahead what you want to say and how you want to say it.
- ☐ Pick a quiet and private time to talk.
- ☐ Don't try to talk about the problem when your friend is drunk or high.
- ☐ Use a calm voice and don't get into an argument with your friend.
- ☐ Let your friend know that you care.
- ☐ Ask if there is anything you can do to help. Find out about local hotlines and drug-abuse counseling and offer to go along with him/her.
- ☐ Don't expect your friend to like what you're saying. But stick with it; the more people who express concern, the better the chances of your friend getting help.
- ☐ Remember, it's not your job to get people to stop using drugs. Only they can decide to stop.

Take control of your life and decide not to use drugs!
- ☐ Look for help. Talk about the situation with someone who knows about drug abuse and helping abusers.
- ☐ Skip parties where you know there will be alcohol or other drugs.
- ☐ Hang out with friends who don't need alcohol or other drugs to have fun.
- ☐ Get involved with drug-free activities. Ask your friends to join.

Take a stand.
- ☐ Remind friends that buying or possessing illegal drugs is against the law. Penalties for drug-related offenses are harsh and can include loss of benefits like students loans.
- ☐ Remind friends that using intravenous drugs places them at risk of getting AIDS.
- ☐ Organize drug-free activities (dances, movies, community service projects, walk-a-thons or marathons, etc.) to raise money for charities.
- ☐ Use plays, songs, and raps to show younger children the consequences of drug abuse.
- ☐ Organize an anti-drug rally.
- ☐ Tell the police, a teacher, or parents about drug dealers in your school or community. Many areas have telephone numbers to let people report these crimes anonymously.

FIRE DRILL

Plan and practice a fire drill. It should include:
- Make sure alarm and detector devices are known to all family members.
- Establish a special alarm signal that is unmistakable.
- Make sure the location of fire extinguishers are known.
- Make sure escape routes are known.
- Designate special responsibilities: someone to call for help from a neighbor's phone, someone to help the elderly and older siblings to help the younger.
- Show and make it known how to switch off the gas and electricity.
- Give name and address of neighbors who should be alerted. In a multi-occupied building this fire drill should be drawn up with and practised by all of the residents.
- Make location of an assembly point outside known.
- Make known numbers of emergency services.

FIRE ESCAPE PLAN

- Install an early warning system. Use enough smoke detectors for the size of your house. Check them with real smoke on a regular basis.
- Make sure all family members recognize the sound the smoke detector makes. It is a warning of a fire and that they should exit as quickly as possible.
- Make a habit of sleeping with the bedroom doors closed to hold back smoke, heat, and gases which may give you extra minutes to exit safely.
- If a smoke detector is activated, check the bedroom door and feel it. If it is hot then leave it closed and get out through the bedroom window.
- Have all family members practice opening their bedroom window without any help and make sure they can cope with a screen or storm window.
- If there is only a little bit of smoke, you can escape through the hallway. Stay crouched or on hands and knees if necessary to stay low under the smoke and heat.
- If the bedroom door does not feel hot, it can be opened a few inches, but be ready to close it quickly if there is a rush of heat and/or smoke.
- As a general rule, children should not try to go through a hallway to rescue a younger brother or sister. They should get out first, and rescue attempts, if any, should be made from the outside of the house.
- Everyone should meet at a predesignated spot outside and away from the house.
- Do not go back into the house to try to salvage things. The poisonous gases are not visible but may be present in lethal amounts.
- Practice your family fire escape plan on a monthly basis. It is extremely important that everyone react correctly. Any mistakes can be fatal.
- Eliminate fire hazards to minimize the chances of a fire occurring at your home. Have it checked out by your local fire department.

FIREFIGHTING ACTIONS

Here are a few hints in helping to fight fires. Remain calm and don't panic. You must act quickly and decisively. Attack at the base of the flames.

QUENCH: Water is the standard element in fighting fires. Know where the nearest source of water is located. Use hoses, buckets, or hats to deliver the water to the fire. Use any furniture, wet mat, or wood panel as a fire shield from behind which you can direct water at a close range into the center of the fire. Spray at the center of the fire then to the edges to cool down the outer edges then spray back to the center or base of the fire along with any hotspots. A bucket brigade from a pool or stream can be effective if you can't approach it closely. Be careful about placing water near live electricity-if possible switch off the power. Keep the spray of water away from burning oil, fat, or liquid. They can be cooled by a fine spray of water which blankets rather than explodes the conflagration. Keep water away from burning car engine since gas floats on water and will help to spread the fire.

SMOTHER: Take a large jacket or coat and throw it on the fire and stamp or press it down to smother the flames. You can also use a mat, blanket, or heavy curtain. Act quickly and decisively while the fire is small. The slower the response, more material can catch fire. Wet the cloth when possible. A damp cloth or rag can snuff burning oil in a container or cooking pot. You can use sand, dirt, and soil as alternative smothering agents. If you have a fire extinguisher, that could work the best.

BEAT: If the fire gets too big to smother you may be able to beat it out. You can make a beater from anything that is handy such as a coat, branch, limb, or door mat. Really try and flatten the fire. Your feet can be used to trample and kick the source of the fire.

RESTRICT: Try and isolate the fire to prevent the spread. Move furniture and fabrics out of reach of the flames. Never underestimate the speed of a wildland fire especially if pushed by a strong wind. You may not be able to outrun it. Do not try and attempt to fight a fast moving fire unless you understand what you are doing. Try and attack the fire with the wind at you back.

OVERESTIMATE: Always overrate the fire you are fighting. Check carefully once you think it is extinguished. Pull away any charred debris, and look for coals and embers. Scrape it down with an axe, shovel or garden tool. Soak thoroughly with water and feel carefully with the back or your hands for hot spots. Be careful of movement in structures after a fire since they can be weakened and staircase and floors could give or collapse.

TRAPPED BY FIRE

- Remain calm and don't panic.
- Close all doors between yourself and the fire.
- Seal the bottom of your room door with blankets, rugs, or clothes.
- Open the window and stand by it or exit if possible.
- Call for help.
- A closed door can offer up to a half hour of resistance to flames. If the room fills up with smoke stay low to the ground.

FIRE /ESCAPE PLAN

ESCAPE PLAN

 In the event of a disaster such as a fire you may have to evacuate your home on a moments notice. Be prepared to get out fast. Develop an escape plan by drawing a floor plan of your home. Show the location of doors, windows, stairways, and large objects. Also include fire extinguishers, smoke detectors, first aid kits, utility shut off points, and emergency supplies. Draw two escape routes for each room and mark the location where family members should meet in case of fire. Make sure to practice emergency escape drill with all family members at least a couple times each year.

First Floor:

Second Floor:

GANGS

Warning signs of gang involvement:
- a sudden change in friends
- unexplained wealth
- hanging out
- staying out late
- drug use
- using gang signs or wearing gang clothes
- poor grades
- skipping school

Know how to identify gang members. Many gangs adopt their own style and language to set themselves apart from others. This may include:
- Clothing - Gangs may favor certain colors or types of clothing (bandanas, sports team jackets, hats, etc).
- Slang - Gang members often use terms and phrases that are unfamiliar to the general public.
- Jewelry - Gold chains and large rings are common
- Tatoos - A gang member may get a gang tattoo to show loyalty and pride.
- Hand signs - They may use hand signals to help identify fellow gang members.
- Weapons - They may carry clubs, pipes, knives, handguns and automatic weapons.

GANG ACTIVITY- The following are signs of gang activity:
- Graffiti - challenges rivals (who may respond violently against the whole neighborhood), promote the strength of their gang, and mark their territory.
- Drug Dealing - Some gang members sell drugs in schools and on the streets. This leads to more crime, violence and drug abuse in the community.
- Vandalism - Some gangs destroy public and private property. Their destruction ruins neighborhoods and cost taxpayers a lot of money.
- Theft - Many gang members are unemployed. They may steal from individuals, homes and businesses in order to support themselves.
- Assaults - Gang violence usually involves other gangs, but not always. For example, a new recruit might be required to attack someone walking through the neighborhood in order to prove him or herself.
- Threats - Gangs may use fear to get money or favors from youths, residents and local businesses.
- Drive-By-Shootings - Many gang members find it easy to get powerful handguns and automatic weapons. As a result, drive-by shootings have become an increasingly common gang activity.

Families are the key to prevention of gang problems. If you are a parent, here are some steps to take:
- Build positive self-esteem in your child. A child who feels good about self is unlikely to be attracted to a gang. Show your child love and affection. And praise his or her efforts and achievements.
- Be a good role model for your child. Teach nonviolent ways of solving problems through what you say and do.
- Discuss the dangers of gangs and ways your child can stay out of them.
- Stay involved in your child's life. Know who your child's friends are. Know where and how your child spends free time.
- If you think your child may be involved with a gang: Talk with him/her, but don't accuse. Contact your local law enforcement agency. Seek advice and help from your child's teachers. Coaches, and counselors; religious leaders; community and youth workers, etc.
- Other family members and friends can also help. They can: show a child that he or she is important, help watch for any changes in the child's behavior, and act as positive influences.

Community involvement is important too. Here are a few ideas:
- Be aware of gangs
- Report all crime
- Remove graffiti
- Speak up
- Support community and youth organizations
- Get businesses and schools involved
- Organize a neighborhood watch
- Work with law enforcement officials

HIJACK/KIDNAP

HOSTAGE SITUATION: The terrorists and hostages are likely to be in a highly emotional state in a hijack, you must remain as calm as possible. Everyone is at great risk in such a stressful situation where emotions are at their most volatile.
- **Don't** be aggressive. • Keep your mind occupied. .• Avoid eye-to-eye contact with the terrorists.
- **Don't** make yourself stand out. By drawing attention ot yourself, you increase the risk of being 'singled out'.
- Hide or dispose of documents or other items which might increase hostility towards you.
- Cooperate with terrorists in preparing meals, tending the injured and generally looking after others-including the terrorists themselves.
- Try to reassure any hostages showing signs of strain, make allowances for behavior caused by stress.
- If a rapport can be built up with the terrorists, ask if conditions can be improved for everyone-blankets to counter cold, for example.
- Drink plenty of water. You need over a liter (two pints) a day. Food intake can be reduced dramatically but water is essential.
- Avoid alcohol, it dehydrates your body and you need to keep your wits about you.
- Be prepared for difficulties with sanitation, particularly in an aircraft/train/bus, where toilets are not designed for extended use.
- If you understand the 'politics' of the situation, **do not** imagine that you could dissuade the terrorists from their cause. It would be safer to agree with them.
- Talk to your captors about personal matters, show them photographs of your children. The more they begin to see you as an individual with a life and relatives or a family of your own, the less you may represent a 'victim'. The more they identify with you personally, the more difficult it becomes for them to harm you.

RESCUE:
If a rescue attempt is made, get to the floor and use your arms to protect your head. Do not move until you are told by your rescuers that it is safe to do so. **Do not** try to be a hero. Rescuers will not have time to make positive identification before shooting to kill. Their priority is minimum casualties. **Do not** risk accidental injury. Follow instructions exactly and make an orderly exit as quickly as possible, the aircraft or building may have been wired with explosives. Vehicle/aircraft fuel may be a fire risk.

KIDNAP:
Kidnap can only be guarded against by careful and comprehensive security measures. Avoid struggling-you may be injured -but if you can attract attention, witnesses can raise the alarm and give valuable information to the police. Once abducted, stay as calm as possible. **Do not** get aggressive.

Try to work out where you are being taken, look out for identifiable landmarks, If blindfolded or in a windowless vehicle, listen for sounds that might tell you where you are. You can also try to work out your route from the movement of the vehicle. It might help you keep your mind occupied. At best, if your sense of direction is accurate, it might help you if you get a chance to escape. One thing valuable to remember at all times is that as a hostage you are more valuable ALIVE.

Getting to know your kidnappers may help you to assess how to behave, but **be cooperative**. The more they can relate to you, the better. You may receive better treatment.

ESCAPE:
Escape may be worth considering, but should be attempted only if you are extremely confident of success, though inventing plans may be a way of keeping up morale. If you are denied reading material and other ways of passing the time, you must keep yourself mentally alert and your mind off your situation as much as possible. Recite poems or songs, recall movies scene-by-scene, set yourself sums and puzzles, invent stories and commit them to memory-whatever works. Plotting an escape may make you feel better, but think again. Are the kidnappers armed? How many of them are there? Where are you? Where will you go? It may be safer to stay put.

RANSOM:
ALWAYS inform the police if you are asked to pay a ransom (or subjected to any form of blackmail). Payment will not necessarily obtain safe release of a kidnap victim. Kidnappers could go on asking for more money or inflict injury anyway. Get as much information from the kidnappers as possible. If contact is made by telephone, keep track of important information. Keep any written communications clean for forensic analysis by the police.

Instructions for the handover of cash may be set up by a series of telephone calls or letters, both are ways for the police to trace the kidnappers. Kidnappers may invent highly complex procedures for the transfer of ransom payments to reduce the risk of capture. Recent schemes have involved a complicated network of bank accounts and bank self-service cash machines. However, banks will usually be ready to cooperate with the police.

Although the police must be involved, it is often stated very early on by kidnappers that you must NOT involve them. At all costs, the press must be prevented from hearing of the kidnap, media coverage will give the game away.

"To be wronged is nothing unless you continue to remember it."

HIGHWAY ROBBERY

Develop your street smarts. These are some tips to help avoid being robbed:

WALKING THE HIGHWAY

- Don't walk at night, if possible. Darkness gives robbers the advantage. If you must walk at night, stay on well-lit, well-traveled streets. Plan your route.
- Walk with someone. Robbers often seek victims who are alone.
- Travel light. Leave extra cash, obvious or expensive jewelry and other valuables at home. Carry only what you need -- avoid using large shoulder bags. Don't make yourself a target!
- Step with confidence. Keep your head up and walk with a sure step. People who look lost, scared or unsure of themselves are more attractive to robbers.
- Avoid shortcuts. Cutting through parks, alleys, schoolyards, etc., can lead to trouble.
- Head toward people if you are being followed. For instance, walk to a gas station, a restaurant, a convenience store, a police station, fire station, and any open business.
- Look out in shopping malls. When carrying packages to your car, be alert for anyone who may be following you -- they could be planning to rob you.
- Walk in the middle of the sidewalk. This is especially important at night. It can foil robbers hiding in storefronts, doorways, alleys and between or under parked cars.
- Don't talk to strangers. Even a friendly conversation with a person you don't know can lead to trouble.
- Avoid loiterers and people in groups. Trouble often lurks nearby. Steer clear -- cross the street, take another route, avoid the situation.

DRIVING THE HIGHWAY

- Help avoid emergency stops. Make sure your car is in good condition. For unfamiliar destinations, know your route in advance. If necessary, stop at a public place to ask directions or read a map.
- Don't pull over for flashing headlights. Emergency vehicles have red or blue flashing lights.
- Don't pull over if a motorists says something is wrong with your car. To check your car, drive to the nearest service station.
- Travel on well-lit roads, and park in well-lit areas near your destination. Keep valuables out of sight and use your trunk if you have one.
- Don't pull over if bumped from behind. Drive to the nearest public area, and call the police.
- Keep your car locked when you are driving and when you leave it parked. When stopped in traffic, leave enough space ahead to drive away, if approached. When returning to a parked car have your keys ready -- and check inside and under it before getting in.

HUNGER IN THE WILD
UNIVERSAL EDIBILITY TEST

1. Test only one part of a potential food plant at a time.
2. Break the plant into its basic components-leaves, stems, roots, buds, and flowers.
3. Smell the food for strong or acid odors. Keep in mind that smell alone does not indicate a plant is inedible.
4. Do not eat for 8 hours before starting the test.
5. During the 8 hours you are abstaining from eating, test for contact poisoning by placing a piece of the plant part you are testing on the inside of your elbow or wrist. Usually 15 minutes is enough time to allow for a reaction.
6. During the test period, take nothing by mouth except purified water and the plant part being tested.
7. Select a small portion of a single component and prepare it the way you plan to eat it.
8. Before putting the prepared plant part in your mouth, touch a small portion (a pinch) to the outer surface of the lip to test for burning or itching.
9. If after 3 minutes there is no reaction on your lip, place the plant part on your tongue, holding it there for 15 minutes.
10. If there is no reaction, thoroughly chew a pinch and hold it in your mouth for 15 minutes. Do not swallow.
11. If no burning, itching, numbing, stinging, or other irritation occurs during the 15 minutes, swallow the food.
12. Wait 8 hours. If any ill effects occur during this period, induce vomiting and drink a lot of water.
13. If no ill effects occur, eat 1/2 cup of the same plant part prepared the same way. Wait another 8 hours. If no ill effects occur, the plant part as prepared is safe for eating.

CAUTION: Test all part of the plant for edibility, as some plants have both edible and inedible parts. Do not assume that a part that proved edible when cooked is also edible when raw. Test the part raw to ensure edibility before eating raw.

EDIBLE PLANTS:

• Nuts - All can be eaten. Bitter taste removed by leaching in water.
• Grasses - Pile grass onto cloth and beat out seeds with a stick. Get rid of chaff and pound seeds in container. Boil or roast. Stems are edible too.
• Berries should be tested very carefully first. Even if birds eat them they may be poisonous.
• Tree bark, especially the inner layer is edible-boil, roast, or chew. Avoid if bitter.
• Ferns (especially the young coils) are a safe standby. Scrub away hairs in water and boil.
• Elephant grass grows taller than a man and has seeds like firework sparklers. Boil roots, flowers, & shoots.
• Bamboo has many edible parts: seeds, shoot, and roots. This grass grows from tall swamp grasses to trees over 10 feet high.
• Seaweed clinging to rocks or floating is edible when it is fresh, firm, and healthy. It will make you thirsty. Leave slimy, decaying seaweed alone.

IMPRISONMENT/ P.O.W SITUATION

• Plan ahead. Get a good map of the area and plan an escape route. Travel the route to see if it is practical. Learn about the local people's habits and customs. Know some survival skills like finding shelter, water, and food. Learn what native foods you can eat that are available along the escape route.

• Anticipate and prepare for the worst. Remember Murphy's law: "That which can go wrong will go wrong, and it will do so at the most in convenient possible time."

• Make your move early. You may be confused, but so might everybody else. Once any sort of routine settles in, the difficulties involved in any escape plan will increase rapidly.

• Choose the potential enemy in advance and make an effort to learn about about them. Find out their particular strengths and weaknesses. Potential enemies should be fairly obvious except in the case of random terrorists. Never underestimate your adversary. Learn as much as you can about their beliefs, customs, habits, and culture, what makes them tick.

• If you happen to be imprisoned, stay responsible and stay as busy as you can.

• The military code of conduct includes the following items: Do not surrender while the means to resist are still available. Do not accept parole or special favors from the enemy. Resist any efforts on the part of the enemy to obtain any information except name, rank, service number, and date of birth. Remember that you are responsible for your actions.

• Prisoners who are broken without much effort on the part of the enemy do very poorly during their imprisonment and many of them died in captivity. Your will to survive can depart along with the loss of self pride which can cause you to quit caring about living.

• Don't count on any help from governments. Try and be as self sufficient as possible. If the trouble gets really deep, try to take care of your own needs. Make plans on your own, staying alert to the total situation.

• Morale is very important in these situations. Communication can make or break a prisoner. If you know someone in a POW situation, try and communicate and continue to do so until you are sure of their fate. Be careful on what is communicated and understand that all communications are carefully screened. Continue writing even if you think it is not getting through.

• Avoid talking to the media. The media manipulates and shapes the news and reality that is created by the media may be entirely different from the actual situation. There may be a lot of media pressure but it is best to avoid it. You may have good intentions, but with the ability of people to edit and censor information, especially when there may be several parties involved, the actual outcome may come out harmful to the situation even though your intentions were good. It is important to get involved with responsible groups whose aims may be similar and fight for your cause.

• Those who hold hostages thrive on publicity. Try not to give it freely. There is a good chance that if there is no public relations value that the captors will eventually lose interest and may be easier to communicate with. There is no guarantee that things will change but as long as the news is on the forefront of the media the situation probably won't change much.

• Being a captive, like many disasters, is survivable by the victims and is not easy on anyone involved.

• The captive must clearly understand that survival depends on planned preparation and the actions taken during the first few hours of the emergency. If your initial response is correct, it is much more likely that you will be able to sustain life. The family and friends that make up the support group can have an enormous impact on the outcome of this situation. If the captive can be made to believe that there is no support from the home front then the perception can be one of no hope.

• Correct behavior as a prisoner/hostage has positive effect on others in the same situation an increases their chances of survival.

KEEPING KIDS SAFE

A great thing about kids is their natural trust in people, especially in adults. It's sometimes hard for parents to teach children to balance this trust with caution. But kids today need to know common-sense rules that can help keep them safe and build the self-confidence they need to handle emergencies.

MAKE SURE YOUR KIDS KNOW:
☐ How to call 911 or "0" in emergencies, and how to use a public phone. Help them practice making emergency phone calls. Be sure emergency numbers-police, fire, poison control, and emergency medical-are by all phones.
☐ Their full name, address, and phone number (including the area code), plus your work phone number. If you have a cellular phone and/or beeper, teach your children these numbers as well.
☐ How to walk confidently and stay alert to what's going on around them.
☐ To walk and play with friends, not alone.
☐ To refuse rides or gifts from anyone, unless it's someone both you and your child know and trust.
☐ To tell a trusted adult immediately if anyone, no matter who, touches them in a way that makes them feel uncomfortable.

SAFEGUARD YOUR CHILDREN:
☐ Learn about warning signs that your child might be involved with drugs or gangs; learn how you can help steer your child away from them.
☐ Spend time listening to your children or just being with them. Help them find positive, fun activities that they can take part in.
☐ Always know-and know about-your child's activities. Know where your child is, and when he or she will return.
☐ Be sure you and your child are clear on your rules and expectations for activities. Make absolutely clear what is OK and what is not.

HOME ALONE-WHAT KIDS SHOULD KNOW:
☐ What steps you want them to follow when they get home; such as phoning you at work or a neighbor or grandparent who is at home.
☐ Not to let strangers-adults or children-into the home for any reason.
☐ Not to tell telephone callers that they're alone.
☐ That door and window locks must always be used. Be sure your children know how to work them.
☐ Not to go into the home if a door is ajar or a window is broken, but to go to a neighbor's or public phone and call the police.
☐ Your rules about acceptable activities when you are not at home. Be very clear.

LOST

- Do not panic.
- Stop!
- Sit down, rest, relax, and think back.
- Mark where you are so it is easily identifiable.
- Try to find you way again on the path or trail. Climb up to get a better view.

MAIL BOMBS

The likelihood of you ever receiving a bomb in the mail is remote. Unfortunately, however, a small number of explosive devices have been mailed over the years resulting in death, injury, and destruction of property.

What can you do to help prevent a mail bomb disaster? First, consider whether you or your organization could be a possible target. Some motives for mail bombs include revenge, extortion, love triangles, terrorism, and business disputes.

Keep in mind that a bomb can be enclosed in either a parcel or an envelope, and its outward appearance is limited only by the imagination of the sender. However, mail bombs have some unique characteristics which may assist you in identifying a suspect mailing. To apply these factors, it is important to know the type of mail your organization and your home receive.

- Mail bombs may bear restricted endorsements such as "Personal" or "Private." This factor is important when the addressee does not usually receive personal mail at the office.
- Addressee's name/title may be inaccurate.
- Return address may be fictitious.
- Mail bombs may reflect distorted handwriting or the name and address may be prepared with homemade labels or cut-and-paste lettering.
- Mail bombs may have protruding wires, aluminum foil, or oil stains and may emit a peculiar odor.
- Cancellation or postmark may show a different location than the return address.
- Mail bombs may have excessive postage.
- Letter bombs may feel rigid, or appear uneven or lopsided.
- Parcel bombs may be unprofessionally wrapped with several combinations of tape used to secure the package and may be endorsed "Fragile-Handle With Care" or "Rush-Do Not Delay."
- Package bombs may have an irregular shape, soft spots, or bulges.
- Package bombs may make a buzzing or ticking noise or a sloshing sound.
- Pressure or resistance may be noted when removing contents from an envelope or parcel.

IF YOU ARE SUSPICIOUS OF A MAILING AND ARE UNABLE TO VERIFY THE CONTENTS WITH THE ADDRESSEE OR SENDER:
- Do not open the article.
- Isolate the mailing and evacuate the immediate area.
- Do not put in water or a confined space such as a desk drawer or filing cabinet.
- If possible, open windows in the immediate area to assist in venting potential explosive gases.
- If you have any reason to believe a letter or parcel is suspicious, do not take a chance or worry about possible embarrassment if the item turns out to be innocent-instead, contact your local police department and Postal Inspector for professional assistance.

NATIONALISM/
DUAL NATIONALTY/PASSPORTS

TRAVEL SAFELY WITHOUT ANY RESTRICTIONS. It's a long shot, but if you're ever skyjacked and the skyjackers don't like Americans (a strong possibility), it wouldn't hurt to have your second passport along. Also, our country restricts travel to certain places, excluding places you may want to visit. Less problems with a second passport.

BUY EXCLUSIVE PROPERTY OVERSEAS. Many countries forbid foreigners to buy property, especially in restricted areas. And even where you can buy real estate, financing is usually a problem, unless of course, you're a national.

GO INTO BUSINESS OVERSEAS. Given the changes in the world order over the last five years, a number of incredible business opportunities have opened up. But again the restrictions on foreigners are formidable. Establish a second citizenship in the country of your choice.

GET A JOB IN A FOREIGN COUNTRY. The United States is one of the most difficult places in the world for a foreigner to get a work permit. Consequently many foreign countries make it at least as difficult for Americans to find work within their borders. As a result most American based multinational corporations place a premium on hiring executives who have a dual nationality. The same rules apply if you're looking for a job on your own. A dual nationality can make it easier.

INVEST IN OFFSHORE MUTUAL FUNDS. Very few foreign countries are registered to sell their securities in the United States and foreign brokers will not sell unregistered securities for fear of running afoul of the S.E.C. If you want these securities it is some times essential to have a foreign identity.

OBTAIN SHARES OF THE WORLD'S FASTEST GROWING STOCKS. In some countries like Switzerland, Taiwan, and South Korea they restrict the right of foreigners to buy securities or certain classes of securities in their markets. A dual nationality might help you obtain the right deal.

SAVE MONEY ON TAXES. There is a big tax loophole that thousands of Americans of dual nationality are taking advantage of right now. It's not a credit. It's not a deferral. It's an outright exclusion of money from gross income that can save you from paying 40% or more of your income on taxes each year.

PURCHASE FOREIGN SECURITIES WITHOUT RESTRICTION OR HINDRANCE. This includes Eurobonds, Unit trusts and investment funds. As with offshore mutual funds, many of the securities listed above range from difficult to impossible to obtain without a foreign identity.

QUALIFY FOR FREE MEDICAL CARE OR TUITION. Some countries make free medical care and/or tuition to their citizens. Find out if it is possible and the way that you can go about it.

BENEFIT FROM FOREIGN SOCIAL SECURITY SYSTEMS. You may be entitled to citizenship in certain countries which would in turn, entitle you to certain benefits including Social Security.

"Nationalism is an infantile disease. It is the measles of mankind." Albert Einstein

NEIGHBORHOOD WATCH PROGRAM

Here's a community-based program that's been proven to deter crime. The National Neighborhood Watch program, sponsored by the National Sheriffs' Association since 1972, unites law enforcement agencies, local organizations and individual citizens in a community wide effort to reduce residential crime. Thousands of these programs have been developed around the country, breaking down the isolation of neighbors as they work together and with law enforcement officers. It is a remarkably successful anticrime effort, as participants work together as a true community: neighbor looking out for neighbor.

☐ Any community resident can take part, young and old, single and married, renter and home owner.

☐ A few concerned residents, a community organization, or a law enforcement agency can spearhead the effort to organize a Neighborhood Watch.

☐ Members learn how to make their homes more secure, watch out for each other and the neighborhood, and report activities that raise their suspicions to the police or sheriff's office.

☐ You can form a Neighborhood Watch group around any geographical unit: a block, apartment building, park, Watch groups are not vigilantes. They are extra eyes and ears for reporting crimes and helping neighbors.

HOW TO GET STARTED

☐ Neighborhood Watch helps build pride and serves as a springboard for efforts that address other community concerns, such as recreation for youth, child care and affordable housing. Many of your neighbors may wish that a program like Neighborhood Watch already existed in their area, but don't know how to start one. They may not realize just how simple it is. If you don't start a Neighborhood Watch program in your area, perhaps no one will. But once you take these first simple steps, you may be amazed at how easy it is to organize the program and what a difference it will make.

☐ Form a small planning committee. Decide on a date and place for an initial neighborhood meeting.

☐ Contact your local law enforcement agency. Request that a crime prevention officer come to your meeting to discuss your community's problems and needs. Ask the officer to bring a list of local and national contacts that will assist you in organizing and maintaining your program.

GETTING ORGANIZED

☐ Contact as many of your neighbors as possible and ask them if they would be willing to meet to organize a Neighborhood Watch group in your area. Once your program is beginning to get under way, there are several concrete steps you should take to make the organization solid and successful:

☐ Contact your local law enforcement agency for help in training members in home security and reporting skills, and for information on local crime patterns.

☐ Select a Neighborhood Watch coordinator and block captains who are responsible for organizing meetings and relaying information to members.

☐ Recruit new members, keep up to date on new residents, and make special efforts to involve the elderly, working parents, and young people.

☐ Work with local governments or law enforcement to put up highly visible Neighborhood Watch signs and decals. These alert criminals that community members will watch and report their activities-often, this is enough to discourage them!

NEIGHBORS LOOK FOR...

☐ Screaming or shouting for help.
☐ Someone looking into windows of houses or parked cars.
☐ Unusual noises.
☐ Property being taken out of houses or buildings where no one is at home, or the business is closed.
☐ Cars, vans, or trucks moving slowly with no lights or apparent destination.
☐ Anyone being forced into a vehicle.
☐ A stranger running through private yards or alleyways.
☐ A stranger sitting in a car or stopping to talk to a child.
☐ Abandoned cars.

DEVELOPING CITIZEN AWARENESS

☐ Recognizing suspicious activity and learning how to report it.
☐ Organinzing victim assistance programs.
☐ Establishing "safe houses" for children in trouble.
☐ Developing neighborhood "youth escort services" that can accompany older people and children on errands.
☐ Organizing a "Crime Stoppers" program that allows individuals to offer information on crimes, anonymously.
☐ Setting up daily Crime Watch broadcasts, mobilizing scanner owners, and publishing neighborhood newspaperes with security tips and updates.

Once you get started in organizing a Neighborhood Watch, there is virtually no limit to the innovative ways to combat crime and increase involvement of members of you community. Your neighborhood will not only become safer and more secure, but will have the added benefit of neighbors brought closer together, with opportunites to rekindle the sense of community that many areas of the country have lost over the years.

NUCLEAR ATTACK

BEFORE:

Understand the dangers you would face in an attack. Some facts:

• Crops grown the year after the attack are expected to be fit for human consumption. Also the year after an attack, radiation to farm workers would be slight and crop yields would be reduced.

• Ozone damage would be temporary but balance would be restored. Some vegetables are very prone to increased levels of UV light. Wheat, corn, and rye would not be disturbed as much by increased levels of UV.

• Fallout is dirt and debris blown up from the crater of a nuclear explosion which enters the fireball and is fused, vaporized and made radioactive. Fallout could cause the blockage of sunlight, hence a cooling similar to a volcanic eruption (perhaps a year without summer). Fallout radiation cannot make anything radioactive. Fallout itself consist of sand-like particles too large to be inhaled. Dangerous amounts of fallout can generally be seen but special instruments are needed to measure the danger of radiation exposure.

•Radiation sickness is caused from large doses of radiation in a short period of time resulting in sickness and death. It is neither contagious nor infectious. But people made sick by radiation are temporarily more susceptible to infection. Exposure that causes sickness is much lower than those that cause death. Being sick does not indicate that one is necessarily going to die.

• Radiation exposure can be kept below sickness levels by using a good fallout shelter; by delaying outside activities until decay has reduced the exposure rate; and by limiting the time of exposure on urgent tasks.

• No one should thirst or starve for fear of contaminated water or food. Illness can be caused as readily by malnutrition and poor sanitation as by radiation injury.

• Ecological consequences: temporarily increased rainfall, fire hazard in dead pine forests, longer-term threat of increased erosion and silting, outbreaks of disease-carrying insects and rodents in damaged urban areas.

• EMP effect (Electromagnetic pulse) is a highly charged/time varying electromagnetic pulse that destroys and or renders inoperative electrical and electronic equipment, radio transmissions, power transmissions and most all non-hardened electronic systems will "burn out." It is estimated that a 25 megaton warhead detonated at a high altitude burst over the Midwest will wipe out 90% of US power transmissions.

• Protection is possible via a fallout shelter. The further you are from the fallout particles the less radiation you will receive.

MAKE YOUR OWN PREPARATIONS BEFORE AN ATTACK

• Make psychological preparations. Have access to a fallout shelter.

• Store food ,water, and other supplies. Include a supply of potassium iodide which can help prevent damage caused by fallout.

• Build a fallout shelter or go to a retreat property or basement shelter.

LEARN WHAT ACTIONS YOUR SHOULD TAKE AT THE TIME OF ATTACK

• Be aware of alert signals either an air raid siren or the emergency broadcast system.

• If you should hear the attack warning signal, go immediately to a public fallout shelter or to your home fallout shelter. This may pose a problem since many locals in the United States don't have facilities. Improvise by using a basement or creating one.

• If you hear the attention or alert signal tune into a local radio or TV station to get the nearest information. Keep the telephone lines free.

• Stay tuned to your radio for the location of the fallout.

• If you see a flash, take cover instantly. You may have from 5 to 60 seconds before the heat and the blast waves arrive. Avoid injuring your eyes by not looking at the flash.

• Where to take cover. Any kind of building, basement, subway station, tunnel, ditch, culvert, underpass, storm sewer, cave, rock outcropping, pile of heavy materials, under a car or bus. If no cover is available, simply lie down on the ground and curl up while trying to be as flat as possible. After taking cover you should lie on your side in a curled-up position, and cover your head with your arms and hands.

• Move to a fallout shelter later where you can get protection from the radioactive fallout.

IN THE EVENT OF AN ATTACK

• **Get at least 10 miles away from any and all possible nuclear targets.**

• Seek private shelter at home.

• Seek public shelter in your community.

• Leave your community to seek shelter in a less dangerous area.

• If you see a flash -take cover instantly! Close your eyes. Act as quickly as possible and take cover in any protective area such as building, basement, or ditch. Then take a curled up position and cover your head with your arms and hands. Then move to a fallout shelter later.

AFTER AN ATTACK

• People will adapt. Wear protective clothing and UV glasses.

• Disease is liable to be epidemic for survivors of a nuclear war are malaria, plague, shigella, typhoid fever, typhus, tuberculosis, diptheria, hepatitis, whooping cough, yellow fever, influenzas, and meningitis.

"The fire you kindle for your enemy often burns yourself more than him." Chinese Proverb

PROTECTING KIDS FROM CRIME & VIOLENCE

Would your child know what to do if...
☐ He got lost at a shopping mall?
☐ A nice-looking, friendly stranger offered her a ride home after school?
☐ A friend dared him to drink some beer or smoke a joint?
☐ The baby-sitter or neighbor wanted to play a secret game?

A great thing about kids is their natural trust in people, especially in adults. It's sometimes hard for parents to teach children to balance this trust with caution. But kids today need to know common-sense rules that can help keep them safe and build the self-confidence they need to handle emergencies.

START WITH THE BASICS
☐ Make sure your children know their full name, address (city and state), and their phone number with the area code.
☐ Be sure kids know to call 911 or "0" in emergencies and how to use a public phone. Practice making emergency calls with a make-believe phone.
☐ Tell your children never to accept rides or gifts from someone they and you don't know well.
☐ Teach children to go to a store clerk, security guard, or police officer for help if lost in a mall or store, or on the street.
☐ Set a good example with your own actions: lock doors and windows, and check to see who's there before opening the door.
☐ Take time to listen carefully to your children's fears and feelings about people and places, especially ones that scare them or make them feel uneasy. Tell them to trust their instincts when something frightens or troubles them.

AT SCHOOL AND PLAY
☐ Encourage your children to walk and play with friends, not alone. Tell them to avoid places that could be dangerous: vacant buildings, alleys, playgrounds or parks with broken equipment and litter.
☐ Teach children to settle arguments with words, not fists, and to walk away when others are arguing. Remind them that taunting and teasing can hurt friends and make enemies.
☐ Make sure your children are taking the safest routes to and from school, stores, and friends' houses. Walk the routes together and point out places they could go for help.
☐ Encourage kids to be alert in the neighborhood, and to tell a trusted adult-you, a teacher, a neighbor, a police officer about anything that doesn't seem quite right.
☐ Check out the school's policies on absent children, are parents called when a child is absent?
☐ Check out day care and after-school programs; look at certifications, staff qualifications, rules on parental permission for field trips, reputation in the community, policies on parent participation. Drop by for a visit at random times.

AT HOME ALONE
☐ Leave a phone number where you can be reached. Post it by the phone, along with numbers for a neighbor and for emergency situations-police and fire departments, paramedics, and the poison control center.
☐ Have your child check in with you or a neighbor when he/she gets home. Agree on rules for having friends over and for going to a friend's house when no adult is home.
☐ Make sure your child knows how to use the window and door locks.
☐ Tell your child not to let anyone into the home without your permission, and never to let a caller at the door or on the phone know that there's no adult home. Kids can always say their parents are busy and take a message.
☐ Work out an escape plan in case of fire or other emergencies. Rehearse the plan with your children.

PROTECTING YOUR CHILD AGAINST SEXUAL ABUSE
☐ Let your child know that he/she can tell you anything, and that you will always be supportive.
☐ Teach your child that no one, not even a teacher or a close relative, has the right to touch him/her in a way that feels uncomfortable. Let them know that it's okay to say no, get away, and tell a trusted adult.
☐ Don't force kids to kiss or hug or sit on a grown-up's lap if they don't want to. This gives them control and teaches them that they always have the right to refuse.
☐ Tell your child to stay away from strangers who hang around playgrounds, public restrooms, and schools.
☐ Be alert for changes in your child's behavior that could signal sexual abuse: sudden secretiveness, withdrawal form activities, refusal to go to school, unexplained hostility toward a favorite babysitter or relative & increased anxiety.

"Peace is not the absence of conflict, but the ability to cope with it."

ROBBERY

PREVENTION - Ways to discourage robbery.
• Lock unused doors.
• Vary the schedule and the route for your bank deposits each day, only keeping necessary cash in the drawer. Then, if you are robbed, you'll reduce your losses.
• Avoid working alone. If you must, turn on a hidden radio or TV so robbers will think there is someone with you.
• Make sure your cash register is clearly visible to passersby. Arrange the counter so that the customer and/or robber is visible from the street.
• Avoid placing signs or displays near windows which block visibility from the street.
• Record the serial number of the bottom bill in each bin of the cash drawer, and instruct employees not to use these bill in making change.
• Keep bait money in a spare compartment of cash registers. The bait packet should be separated by face value as other bills. Keep a list of the serial and series year numbers to give to law enforcement officials if you are robbed.
• If your business runs an exceptionally high risk of robbery, you may want to invest in a bulletproof cashier screen. A screen defuses the robber's threat, but other prevention measures may be equally effective at a lower cost.
• Advertise your security alarm system with signs in visible locations.
• Display signs at entrances and exits indicating that safes require secondary keys not in possession of employees.
• Place colored tape markers at exits, at heights of 5 feet 6 inches and 6 feet. Then, if you are robbed, you can get an accurate estimate of the suspect's height as he leaves.
• Develop a mutual aid system among stores on your block. Agree to keep an eye on each other's buildings and watch for any suspicious activities. Install buddy buzzer alarms so you can signal your neighbor to call the police if you are being robbed.

DURING:
• Someone points a gun at you and demands your money. What do you do? Give it to him. **Never, never refuse a robber!** Unless you know you will come out the winner.
• If you have a silent alarm and can reach it unnoticed, use it. Otherwise, wait until the robber leaves. (Use your alarm with care. Excessive false alarms can cause problems for law enforcements and for you).
• If possible, signal other employees. Have a prearranged signal for such emergencies. Again, if the robber will see you, wait. Try to avoid sudden moves. Many robbers are just as nervous as you are.
• The most important thing to do if you're robbed: observe. The description of the suspect you give to police may be the only information they have to go on.

AFTER
• Call the police immediately-- don't waste a minute.
• Write down everything you can remember about the robber and the crime itself: the robber's appearance such as height, weight, color of hair and eyes, scars, tattoos, and accent. Anything unusual such as clothing, weapon and mannerisms. Try to remember the robber's exact words and try to observe any vehicle the robber uses to get away.
• Keep everyone away from surfaces the robber may have touched.
• Cooperate fully with the law enforcement and prosecutors. Your help is crucial, so stick with the case.

"Property given away is the only kind that will forever be yours."

SAFE SCHOOLS

When crime, drugs and violence spill over from the streets into the schools, providing a safe learning environment becomes increasingly difficult. More students carry weapons. Gunfights replace fist fights. Many students must travel through drug dealers or gang turf. Violence becomes an acceptable way to settle conflicts. When this happens, children cannot learn and teachers cannot teach. Creating a safe place where children can learn and grow depends on a partnership among students, parents, teachers, as well as other community institutions.

To help prevent school violence:
- ☐ Find out how crime threatens schools in your community.
- ☐ Take action to protect children.
- ☐ Promote nonviolent ways to manage conflict.

How do these ideas translate into action? Here are some practical suggestions for young people, parents, school staff and others in the community.

STUDENTS:
- ☐ Settle arguments with words, not fists or weapons.
- ☐ Report crimes or suspicious activities to the police, school authorities, or parents.
- ☐ Take safe routes to and from school and know good places to seek help.
- ☐ Get involved in your school's anti-violence activities. Have poster contests against violence, hold anti-drug rallies, volunteer to counsel peers. If there are no programs, help start one.

PARENTS:
- ☐ Sharpen your parenting skills. Work with your children to emphasize and build their positive strengths.
- ☐ Teach your children how to reduce their risk of being victims of crime.
- ☐ Know where your kids are, what they are doing, and whom they are with at all times!
- ☐ Help your children learn nonviolent ways to handle frustration, anger and conflict.
- ☐ Become involved in your child's school activities such as PTA, field trips, and help out in class or lunchroom.
- ☐ Work with other parents in your neighborhood to start a McGruff House or other block parent program.

A McGruff House is a reliable source of help for children in emergency or frightening situations. Volunteers must meet specific standards, including a law enforcement record check. Programs are established locally, as a partnership among law enforcement, schools, and community organizations. For information, call 801-468-8768.

SCHOOL STAFF:
- ☐ Evaluate your school's safety objectively. Set targets for improvement.
- ☐ Develop consistent disciplinary policies, good security procedures, and a response plan for emergencies.
- ☐ Train school personnel in conflict resolution, problem solving, crisis intervention, cultural sensitivity, classroom management and counseling skills.
- ☐ Work with students, parents, law enforcement, state governments, and community-based groups to develop wider-scope crime prevention efforts, such as Drug-Free and Gun-Free School Zones.

COMMUNITY PARTNERS:
- ☐ Law enforcement can report on the type of crimes in the surrounding community and suggest ways to make schools safer.
- ☐ Law enforcement officers in many areas participate in school activities and talk with students about crime prevention, drug abuse and other problems.
- ☐ Community-based groups, church organizations, and other service groups can provide counseling, extended learning programs, before and after school activities, and other community prevention programs.
- ☐ Local businesses can provide apprenticeship programs, participate in adopt-a-school programs, or serve as mentors to area students.

"Great people are not effected by each puff of wind that blows ill. Like great ships, they sail serenely on, in a calm sea or a great tempest."

SELF DEFENSE

AVOID VIOLENCE!

Unless someone actually jumps out and attacks you, there may be a chance to prevent a situation from slipping in to violence. Look at you potential attacker. Compare their size and weight and apparent strength with your own. Is it likely that the attacker is armed? Look for:

- Long hair and clothing you could grab.
- Heavy boots/shoes which might cause serious injury.
- Friends--yours or the attackers--who may come to your defense or become otherwise involved.
- A red face, flushed with blood, implies that the attacker is not ready for fighting, otherwise the blood would be diverted to the muscles.
- A white, thin-lipped face and 'tight' voice imply that violence is imminent.
- Follow your instincts. If you have a feeling that there is a problem, there usually is one.
- A fist shaken at you or emphatic hand gestures, including a lot of pointing, may pre-empt violence.
- Are you restricted in movement by your clothing, especially by your footwear?
- Is there anywhere nearby which would give you an advantage? Higher ground?

KEEP TALKING

Try to diffuse the situation by using words and talking out of it. Pretend to not speak the language. You might calmly say:

- There is no need to hit me. If you want my money, here it is.
- I know you are angry but I don't want to fight you.

When a mugger demands money, he/she may be very nervous. Usually a short demand or a threat is made. Rapists, similarly, may just make short, sharp statements.

One way of dealing with the situation is to start talking about yourself, where you are going, about your ill health- which may begin to make you more of a person. The attacker may start to relate to you more as a person and less as a victim and lose concentration, giving you the opportunity to escape. Stay calm. There may be nothing you can do to avoid a physical confrontation.

PREPARING TO FIGHT BACK

The time to decide how and if you will fight back is NOW. No one can make the decision for you. Evidence suggests that people who have at least attempted to fight back bear less psychological scars than those who have not tried to defend themselves. Obviously every situation is different, only you can judge what you must do. If you do fight back, get angry and give it everything you have. You don't have to fight fairly, your attacker won't! During the confrontation, take any opportunity you can to escape, alert the police or reach safety. This isn't weak, it is sensible.

CARRY A SMALL PERSONAL ALARM

- Get one that is small and loud to scare off potential attackers.

CARRY A WEAPON

- Learn to use a knife, gun, club, or aerosol sprays. Check the laws, some may be illegal.

USE IMPROVISED WEAPONS

- Coins from your pocket can be thrown in an attacker's face.
- Wrap them up in a handkerchief and use as a club.
- Use your bag, purse, briefcase, aim for the head.
- Umbrellas and walking sticks can be used as clubs or jabbed into feet or stomach, or brought up between the legs to an attacker's groin.
- Hard-soled shoes are essential to be able to kick effectively. Aim for the groin. Scrape your shoe down a shin.
- High heels should be aimed at an attacker's foot or hand. Putting all her weight on a thin heel means an average woman can exert a pressure of nearly three-quarters of a ton!
- You cannot run in high heels. Take them off and throw them, or use them to strike the attacker.
- A powerful flashlight may dazzle an attacker and also could make a handy club.
- Grab a handful of dirt, gravel or sand and throw it into the attacker's face.
- Roll up a newspaper and jab it end first into the face or stomach.
- Jab a credit card, comb, hairbrush, anything into the upper lip below the nose.
- Scrape a comb across the attacker's face or back of the hand.
- Dig a pen or pencil into the attacker's hand or face, the attacker's impulse may be to defend the eyes.
- Jab or scratch with keys.
- Powder from a compact may temporarily blind an attacker.
- Perfume, hairspray or deodorant can be sprayed into an attacker's eyes.
- Take fingers pointed out and jab into eyes.
- Use the palm of the hand and thrust into lower jaw and push up and back. Then take knee and strike it into the groin.

Man's four basic conflicts here on earth are conflict with 1) God, 2) his fellow man, 3) himself, 4) God's Creation-nature.

SELF DEFENSE

BREAKING GRIPS: Use everything: bend knee hard into testicles; smash with foot under attacker's knee, drag foot down shin and stamp on instep of attacker's foot. Kick under kneecap. Close-range kick with knee is best as it is harder for the protagonist to grab and pull you off-balance. If you do kick from a distance (say against knife/bottle/razor attack), don't use orthodox football type kick which can be seen coming for miles. Do it this way:

- Lift knee up into your stomach and lean back.
- Shoot leg out horizontally turning foot sideways.
- Pull foot back instantly after connecting.

Ram with point of elbow; butt with head if in range; pry off fingers by wrenching them backwards, especially the little fingers; escape through the attacker's thumbs; use persistent pressure with edge of little finger (palm flat, fingers together, thumb flexed outwards) under assailant's nose to break fierce grip (not necessarily on you). Dig thumbnail into cuticles of attacker's fingers. Stick fingers into attacker's eyes (first and little fingers, or first and third fingers, of one hand make useful jabbing fork spaced just right for most eyeballs). Distract attention instantly when attacked. Handkerchief/ashtray contents/spit can be aimed at attacker's face followed up by your own attack. Or escape. But be quick about it.

Arm from behind throttling you. If right arm is being used then attackers right foot will probably be forward and just behind yours (and vice versa if left arm is used). Stamp hard on instep with heel.

Fingers strangling you from behind. Grab any of the fingers and bend them backwards, then whip hands sideways away from your head.

Strangled from the front:

- Grab any finger(s) and bend/twist/wrench quickly backwards, shoving his hands far apart.
- Bring both of your arms (closed together) up between opponent's hands viciously and moving outward to cleave the grip.

Bear-hugged from front. Slap an arm up over outside one of attacker's arms. Quickly cup his chin and snap his head back. Check knee up hard and stamp on instep when all else fails.

Body-hugged from behind. Pry his fingers back instantly, before grip becomes concrete. Butting backwards with head can work if upper arms pinned, then grab for attacker's fingers (if set in consolidated grip try screwing knuckles into back of hand).

Pushed in chest. Press both hands on top of hand pushing you, lean forward, step backwards and force down with bottom edges of your hands to lever him down. This is very effective.

Wrists (and lower arms) gripped. Escape through the thumbs which are weakest part. If your hands are held up to protect face and wrists are grabbed, swing both arms down and outward immediately and break his grip at the thumbs. If your hands are low and wrists or forearms gripped, then instantly wrench arms up and outward, again pressuring opponent's thumbs. But if two hands are gripping one of your wrists whip up your other hand between attacker's arms, close over fist of the imprisoned hand and wrench either up or down (and toward attacker) depending whether your wrist being gripped is high or low. Or, if circumstances allow, just hit attacker with other fist in face/solarplexus/stomach.

Being butted/kicked/punched. Try to sway/duck/dodge with the body movement first ...as trunk movement is much quicker than arm reaction. Things happen so fast you are virtually defenseless, but:

• When lapels are grabbed be ready for a butt in the face by oncoming head. Your only defense is to get in first by butting forward hard so top of your head hits opponent on bridge of nose.

• When lying on the ground and being kicked try to keep rolling, shielding parts being kicked with arms. But always protect the head as priority. Clasp base of the skull with both hands, bring wrists across ears and side of head and press elbows together. Bring knees up, crossing ankles to save genitals.

***** In all attacks it pays to shout and yell more than you need. Fake pain. Also shout when you are attacking. Expelling air makes you stronger and the excitement helps to intimidate an opponent.**

SURVIVAL IN THE HOME

Home security tips:

- Secure all outside doors with deadbolt locks. Outer doors should be solid core wood (1-3/4 inches thick) or metal.
- Place a metal or wooden rod in the track of sliding glass doors.
- Use secure locks on windows. Hardware is available that will allow windows to be partially opened during warmer weather, yet maintain security.
- Have good lighting at all entrances.
- Install a viewer in your door.
- Make sure you know who is at the door before you open it. Do not rely on chain locks. Insist on identification from repair and sales persons. If in doubt, call their company to verify their identity.
- Do not admit persons asking to use your telephone. Offer to make the call for them.
- Know your neighbors, and work out a mutual watch and warning system to prevent burglaries and other break-ins.
- Identify your belongings by engraving your driver's license or Department of Motor Vehicles identification number on your possessions.
- Close and lock doors and windows when you leave home.
- If you come home and find a door or window open or signs of forced entry, do not enter. Call the police for assistance.
- Use automatic timers to turn lights on and off to give the appearance you are at home.
- Stop mail and other deliveries when you leave for vacation.
- Do not hide spare keys. Give your keys to trusted neighbors.
- If you live in an apartment or condominium, be attentive and careful if you are alone in the laundry room or garage.
- Have the locks re-keyed when you move into a new home.

STRANDED

- Make sure everyone is safe
- Apply first aid to those in need.
- Take appropriate protection measures such as making a shelter, checking for water, and lighting a fire to stay warm.
- Have signaling equipment ready, make an SOS with rocks, be ready to communicate by any means necessary.
- Relax.
- Make a plan of action.

"The four basic virtues of the Bible are humility, empathy, responsibility, and duty." R. E. McMaster Jr.

SWINDLERS

- Avoid unclaimed or repossessed merchandise unless you know the dealer because you may be shown pieces that are damaged, seconds, or mismatched and then switched to something more expensive.
- Beware of puzzle contests. Simple solutions are often lures to get you to sell magazines, cosmetics, or other goods. Your prize may be a "come on" to get you to buy an over priced item.
- Don't be fooled by get rich quick ads. These misleading "opportunity" ads promise quick profits and easy formulas for success. They may involve offers of jobs, profit ideas, business plans, etc. and probably involve some sort of purchase.
- If you should win a prize it should never cost you money to collect. A store credit for $100 is often good for nothing because prices are usually raised to offset it.
- Watch selling-out sales carefully. Some stores have fake selling-out sales just to get you into the store. Be sure the merchant is really selling-out before you buy.
- Be wary of the private party sales. Such ads are often run by residence dealers. They operate stuffed flats selling furs, jewelry and furniture. Prices are actually high and goods often misrepresented.
- Resist tempting deals for your car. The salesman's boss may deny an offer after you're hooked. The price of a used car is often inflated so that the dealer can appear to give you a real good deal on your car.
- Don't fall for the sympathy approach (I'm working my way through college). It's often a line to get you to sign up. Organized crews are trained to tell sob stories. Once you sign, they move on to the next town.
- Widows beware of obituary ghouls. Swindlers sometimes read obituary notices and send widows bills for non-existent debts such as a gift for you the departed ordered just before he died. Don't pay until you're sure.
- Avoid home repair swindles. Don't let yourself be swindled by a contractor who overcharges you or doesn't finish the job and then skips town. Check the person out with the Better Business Bureau. It's best to deal with a person you know.
- Don't get fleeced on land deals. Beware of ads trying to sell you out-of-the-way investment property or rural real estate. Chances are you'll end up with land you don't want and can't sell. Especially beware of anyone who offers you a land deal if you pay in advance.
- Don't be a victim of invest by phone frauds. Anyone with a telephone is a target for unscrupulous dealers trying to get you to invest in worthless commodities, securities and tax shelters. Use common sense and never give money to anybody without checking carefully on them first.
- Would you believe you can cut your gasoline bills in half? Fuel saving devices for your car are often fakes. The US. Attorney Generals office received 15,000 complaints about one fuel saving gadget. There are others on the market.
- There's no easy way to earn money at home. Most work at home schemes require you to buy something in order to earn. You find later there is no market for what you produce, or your efforts are not up to standards.
- Beware of leads to unexpected inheritances. Swindlers have collected millions of dollars in fake expenses by leading people to believe they can inherit money from estates or distant relatives.
- You risk your life or your money on quick cures. If you are worried about your health see your physician. Don't take chances on quack medicines or mail order cures.
- Watch out for high interest rates. Credit costs can more than double the total cost of things you buy. Compare the cash price and the total cost when all interest and finance charges are included. Know the true annual interest rate. Shop around for financing as you would for shoes.
- Avoid bait and switch ads. Such unbelievable ads are often come-ons, and the item is not really for sale. Salesmen may try to get you to switch to overpriced items. Also watch fake measurements and grades of merchandise.
- Read and understand everything before you sign. Have a question? Ask a lawyer.

TERRORIST THREAT

If you are a prime target:
• Keep your home, office and workplace secure.
• Do not advertise your presence or your movements, even a wedding announcement could tell an assassin where you are going to be at a certain time.
• Book hotel accommodations under an assumed name.
• Do not stick to a pattern. Vary transport, times and routes to work. Avoid roadworks and congested streets. Change vehicles during longer journeys.
• Make a habit of looking out of the window before leaving a building. Watch out for people loitering on foot or sitting in parked vehicles.
• Glance over your shoulder frequently but unobtrusively, you do not want to attract attention. Use reflections in shop windows to see if you are being followed.
• Be 'friendly' with neighbors. You may need them to let you know if anyone is asking questions or taking an unusual interest in you, but do not divulge you business or movements to them.
• Telephone ahead when making journeys and telephone base when you arrive.
• Arrange a coded phrase to be used if you're in danger or under duress and need help. Choose an arrangement of words that can be added into normal conversation and innocent sounding such as "I didn't bring a raincoat" or "the roads were clear" or "sorry" or "this is a really bad line."

Bombs:
If you see a suspicious package or container:
• Do not touch it, moving it may trigger an explosion.
• Do not shout "Bomb." This could cause dangerous panic.
• Move away and tell others do to the same, but tell them quietly and calmly.
• If you are on a moving underground/subway train, **do not** activate the alarm between stations. In some countries the train will stop immediately, which could jolt the package. Usually the emergency signal only alerts the driver, who will stop the train at the next station.
• On trains with doors between cars, tell other people to move away and alert the guard or conductor.
• If you see someone leave a bag or package behind, call after them. If they deny any association or just run off, treat the object as suspect.
• Make a mental note of the appearance of the person. Your description of them may prove vital later.
• If you have a camera with you, take a photograph, even a back view may be helpful in identification.
• Inform a police officer or other responsible official or telephone a police emergency number.

TRAPPED/TIGHT SPOT

IN A TIGHT SPOT-You are never lonelier than when buried alive. Trapped in or by roof-fall or subsidence, or in any circumstance where there may be a narrow avenue of escape--either to open air or to a position where you can signal for rescue (through chink blowing air)--crawl, wriggle, squeeze or push through. But if safe where you are and you are virtually sure of rescue: stay there. Don't risk precipitating further rubble collapse. Only if no chance of rescue should tentative efforts be made to inch through. Crawling and squeezing through can be safe, such as slots, slits and bedding planes in cave unaffected by roof collapse and possibly offering an escape route when main corridor is blocked. Such escape routes include porthole/manhole/skylight/squeezes.

Main principles are:

• Strip off clothing so that if you are forced to back out it doesn't bunch up and cause jamming. Belts with large buckles are dangerous on same count.

• Most likely person to succeed in wriggling through goes first and follow, if possible, any draft of air or gleam of light.

• If roof unstable, wait until he gets through. Then follow, handling everything as if it were high explosive. When surroundings are solid, however, wriggle through with hands touching the feet of person in front.

• A body stiff with tension is more likely to get stuck than one relaxed. Experiment with body positions. Don't rush to get through. Big people can squeeze through amazingly small spaces so long as they relax.

• Help a stuck person by "talking" him through. Push and pull if physically possible and if captive relaxes.

• Don't try to yank someone through hole by pulling on a rope, belt or sheet tied around his waist. Could jam him fast. Instead use a hand line. First man through tows string of blankets tied together with reef knots. He anchors this at far end. Anyone stuck can then pull themselves along hand over hand. Even so, this could lead to muscles tensing, and a jammed person would have to stop and relax to progress.

• Probably best plan for helping wriggler in difficulty is a loop at the end of the string of belts. Stuck person works foot into loop and (a) bends at knee of that leg; (b) helpers take in slack of line and anchor it; (c) captive straightens leg squirming forward from its power, then flexes knee again; (d) helpers pull in slack again ...and so on.

• Don't try sliding down sloping area with arms out ahead, it is almost impossible to get back. Instead try one arm ahead at a time. Or tuck both beneath chest.

• Where roof lifts a little, stoop with hands on knees. Or go on all fours, and crouch on haunches when resting. Or waddle along on haunches. This keeps knees off the ground. (It is possible to blackout through pain on kneecaps. They are not designed to carry the body. Body heat escapes through them onto cold floor, and crawling on knees over any distance is far too inefficient.) Ways of avoiding wriggling on knees: Lie on outside of leg and hold body up on forearm. Trail other foot behind as you shove forward. Change over to other side for a rest. Or sit on a leg and squirm forward lifting lower thigh and buttock during each thrust.

• Go into flat-out crawling and wriggling ...tuck elbows into sides, hands under shoulders. Or grip fists under chin with elbows nudging solar plexus, and thrust forward with the toes (lift body and knees clear at each reptilian movement.) It is not a good plan to reach forward all the time with both hands, your body drags along the floor.

"All people smile in the same language."

UNEMPLOYMENT

ACTIONS TO TAKE WHEN YOU LOSE A JOB:
- Tell your family immediately.
- Evaluate the reasons for job loss.
- Deal with the emotions involved.
- Prepare for your departure.
- Negotiate a severance pay package if possible.
- File for unemployment compensation or other benefits due to you.
- Take a vacation or at least a step back to prepare for the task at hand.
- Plan your strategy.
- Go forward with confidence.
- Seek guidance and think about how you can get by until you land your next job.

HOW TO COPE WITH A BUREAUCRATIC MAZE:
Dealing with agencies:
- Call ahead for directions. Make sure you're headed to the right place. Find out who will be able to help you when you get there. Learn what documentation you will need to have with you.
- Carry proof of identification, your Social Security card, proof of residence, and any documentation required by the office you intend to visit.
- Take something to do while you wait.
- Write down the name of the person you talk to. Note what they tell you in case you need to refer to it later.
- Ask questions to get the information you need.
- Be pleasant. Most people really do want to help. Make it easy for them and they are likely to go an extra mile for you. Make it difficult, and they are likely to terminate the discussion.
- Keep copies of all letters and documentation you receive from agencies or through the mail. Never ignore them. Make sure you understand what they mean and what action you should take. If you're not sure, contact the agency or business and ask to have the document explained in terms you understand. If necessary, get advice from an appropriate source about what options you might have.

Slums of makeshift shacks during the 1930's.

"If the unemployed could eat plans and promises they would be able to spend the winter on the Riveria." W.E.B. Du Bois

GUIDES
FOR
HUMAN
ACTIONS

SOCIAL/SPIRITUAL

THINKING & GROWING RICH

•**DESIRE:** The first step towards riches and starting point of all achievement. Whatever the mind of man can concieve and believe it can achieve. Six ways to turn desires into gold: 1) focus on the exact amount of wealth desired; 2) determine exactly what to give in return for wealth desired; 3) establish definite date you intend to possess desired wealth; 4) create a definite plan for desire, and begin at once, whether ready or not, to put plan into action; 5) have a clear, concise statement of desired amount of money, set time limit for its accumulation, state what you intend to give in return and describe clearly the accumulation plan; and 6) read your written statement aloud, twice daily, once just before retiring at night and once after arising in the morning. As you read--see, feel and believe yourself already in possession of the wealth.

•**FAITH:** The second step towards riches. Visualization of, and belief in attainment of desire. First: I know that I have the ability to achieve the object of my definite purpose in life; therefore, I demand of myself persistent, continuous action toward its attainment, and I here and now promise to render such action. Second: I realize the dominating thought of my mind will eventually reproduce themselves in outward, physical action, and gradually transform themselves into physical reality; therefore, I will concentrate my thoughts for thirty minutes daily, to become, thereby creating in my mind a clear mental picture. Third: I know through the principle of autosuggestion, any desire that I persistently hold in my mind will eventually seed expression through some practical means of attaining the object back of it; therefore, I will devote ten minutes daily to demanding of myself the development of self-confidence. Fourth: I have clearly written down a description of my definite chief aim in life, and I will never stop trying, until I shall have developed sufficient self-confidence for its attainment. Fifth: I fully realize that no wealth or position can long endure, unless built upon truth and justice; therefore, I will engage in no transaction which does not benefit all whom it affects. I will succeed by attracting to myself the forces I wish to use, and the cooperation of other people. I will induce others to serve me , because of my willingness to serve others. I will eliminate hatred, envy, jealousy, selfishness, and cynicism, by developing love for all humanity, because I know that a negative attitude toward others can never bring success. I will believe in myself, and in others that are helping me. I will sign my name to this formula, commit it to memory, and repeat it aloud once a day, with full faith that it will gradually influence my thoughts and actions so that I will become a self-reliant, and successful person.

•**AUTOSUGGESTION:** Step 3 is the medium for influencing the subconscious mind: 1) Go to some quiet spot where you won't be disturbed or interrupted; close your eyes and repeat aloud the written statement of the amount of wealth you desire, the time limit for its accumulation, and a description of the service or merchandise you intend to give in return for the wealth. As you carry out these instruction, see yourself already in possession of the wealth. "I believe I will have this money in my possession. My faith is so strong that I can now see this wealth before my eyes. I can touch it with my hands. It is now awaiting transfer to me at the time, and in the proportion that I deliver the service I intend to render in return for it. I am awaiting a plan by which to accumulate wealth, and I will follow that plan, when it is received." 2) Repeat this program night and morning until you see the wealth you desire. 3) Place a written copy of your statement where you can see it night and morning, and read it just before retiring, and upon arising until it has been memorized.

•**SPECIALIZED KNOWLEDGE:** Step 4 toward riches is personal experiences or observations. Decide what type of knowledge is needed and the purpose for it. Then it must be directed to fulfill your plans.

•**IMAGINATION:** The fifth step toward riches involves the workshop of the mind wherein are fashioned all plans created by man. The impulse, the desire, is given shape, form, and action through the aid of the imagination and observation with which it is fed. It is the faculty used most by the inventor, with the exception of the "genius" who draws upon the creative imagination, when he cannot solve his problem through the synthetic faculty of the mind. Synthetic Imagination: Through this faculty one may arrange old concepts, ideas, or plans into new combinations. This faculty creates nothing. It merely works with the material of experience and education. Creative Imagination: Through the faculty of creative imagination the finite mind of man has direct communication with Infinite Intelligence. It is the faculty through which "hunches" and "inspirations" are received. It is by this faculty that all basic or new ideas are handed over to man. It is through this faculty that one individual may "tune in", or communicate with the subconscious minds of other men.

THINKING & GROWING RICH

ORGANIZED PLANNING: The sixth step toward riches is crystallization of desire into action. Use these practical steps for building plans: (a) Ally yourself with a group of as many people as you may need for the creation and carrying out of your plan or plans for the accumulation of wealth (making use of the "Master Mind" principle described later.) (b) Before forming your "Master Mind" alliance, decide what advantages and benefits you may offer the individual members of your group, in return for their cooperation. No one will work indefinitely without some form of compensation. No intelligent person will either request or expect another to work without adequate compensation, although this may not always be in the form of wealth. (c) Arrange to meet with the members of your "Master Mind" group at least twice a week or more often, if possible , until you have jointly perfected the necessary plan or plans for the accumulation of wealth. (d) Maintain perfect harmony between yourself and every member of your "Master Mind" group. If you fail to carry out this instruction to the letter, you may expect to meet with failure. The "Master Mind" principle cannot be obtained where perfect harmony does not prevail. Keep in mind these facts: 1) you are engaged in an undertaking of major importance to you. To be sure of success, you must have faultless plans. 2) You must have the advantage of the experience, education, native ability and imagination of other minds. This is in harmony with the methods followed by every person who has accumulated a great fortune.

DECISION: The seventh step toward riches is the mastery of procrastination. Know what you want and you'll generally get it.

PERSISTENCE: The eighth step is a sustained effort necessary to induce faith. Persistence is an essential factor in the procedure of transmuting desire into its wealth equivalent. The basis of persistence is the power of will, you can train yourself to be persistent. Persistence is a state of mind, therefore it can be cultivated. Like all states of mind, persistence is based upon definite causes, among them these: (a) definiteness of purpose, (b) desire, (c) self-reliance, (d) definiteness of plans, (e) accurate knowledge, (f) cooperation, (g) will-power, and (h) habit. There are four simple steps which lead to the habit of persistence: (1) A definite purpose backed by burning desire for its fulfillment. (2) A definite plan, expressed in continuous acton. (3) A mind closed tightly against all negative and discouraging influences, including negative suggestions of relatives, friends and acquaintances. (4) A friendly alliance with one or more persons who will encourage one to follow through with both plan and purpose.

POWER OF THE MASTER MIND: Step nine involves the driving force of power essential for success in the accumulation of wealth. The "Master Mind" may be defined as "Coordination of knowledge and effort in a spirit of harmony, between two or more people, for the attainment of a definite purpose."

THE MYSTERY OF SEX TRANSMUTATION: The tenth step toward riches is the exchanging of one form of energy to another. It means the switching of the mind from thoughts of physical expression to thoughts of some other nature. Sex energy is the most powerful of all the stimuli which moves people into action. It is the most powerful of emotions and must be controlled through transmutation and directed in a focused way.

THE SUBCONSCIOUS MIND: The eleventh step involves the connecting link of the subconscious mind as the intermediary which translates one's prayers into terms which Infinite Intelligence can recognize, presents the message, and brings back the answer in the form of a definite plan or idea for procuring the object of the prayer. Understand this principle and you will not know why mere words read from a prayer book cannot, and will never serve as an agency of communication between the mind of man and Infinite Intelligence.

THE BRAIN: The twelfth step towards riches affirms the brain as the broadcasting and receiving station for thought.

THE SIXTH SENSE: The thirteenth step towards riches is the door to the temple of wisdom. It is the receiving set through which ideas, plans, and thoughts flash into the mind. These flashes are sometimes called hunches or inspirations.

"We must believe in free will, we have no choice." Isacc Bashevis Singer

CHANGING DESTINY

The following are eleven keys to help you change the course of your destiny:
• Get one thing done at a time.
• Take the conscious risk. Remember that nothing you're in fear of losing can ever by the source of your fearlessness. **Risk** saying no, leaving empty spaces empty, not defending yourself, appearing stupid, bearing your own burdens, being rejected, catching yourself in the act, taking the lead, letting go, and being no one. Remember that true strength is the flower of wisdom, but its seed is action.
• Rid your self of resentment. Ask for a fresh, changed and cheerful life, by refusing to create the things that have been bringing you down.
• Get rid of anxiety and step out of the rush. These thoughts and feelings will take you nowhere. Live like you have all the time in the world.
• Refuse to compromise yourself in the present moment for the promise of a happier one to come. When you are divided and conquered you can't be content, so make a choice in favor of self wholeness.
• Take the step that you are positive that you can't take. When you do this you shall discover that the "you" who would not was only a thought that believed it could not. Each step taken into what you think you can't do is one step further away from the nature which wants you to think that circles actually go somewhere.
• Take responsibility for your actions. Blaming conflict-filled emotions on any condition or person, outside of yourself is like getting upset or angry at your shoes for being laced too tight. Make a choice to change at the present moment. And you won't have to worry about how to be different the next time.
• Erase any fearful emotions and feelings. There is not such a thing as a shaky situation, so any time you start to tremble, don't look around you for the fault. Look inward. It is the inner-ground you're standing on that isn't solid.
• Release and relax yourself. Unrestricted and natural energy is to your health, happiness, and spiritual development what a snow-fed river is to a high mountain lake whose waters must be renewed each day. Each day you should be casual but industrious. Every moment you should be relaxed but alert.
• You must stop self sabotage. There is no way of pleasing the fear that you may displease others. In every moment of your life, you are either in control of yourself or you are being controlled by others.
• Become quiet and go within. The frantic search for any answer only delivers answers on the same frantic level.
A quiet mind:

-is spontaneously creative in any situation.
-can neither betray itself, nor anyone else.
-rests naturally when it isn't naturally active.
-seeks nothing outside of itself for strength.
-detects and easily rejects psychic intruders.
-is never the victim of its own momentum.
-is in relationship with a Higher Intelligence.
-never struggles with painful thoughts.
-gives its undivided attention to its tasks.
-receives perfect direction from within.
-deeply enjoys the delight of its own quietness.
-lives above expectations and disappointments.
-knows and helps to create its own destiny.

-knows without thinking.
-never compromises itself.
-fears nothing.
-can not be flattered or tempted.
-doesn't waste valuable energy.
-can't outsmart itself.
-refreshes itself.
-is instantly intuitive.
-never feels lonely.
-lives in a state of grace.
-can't be captured by regrets.
-commands every event it meets.

Just as you can see farther on a clear day, new understanding flowers in a quiet mind.

7 HABITS OF HIGHLY EFFECTIVE PEOPLE

The use and implementation of the 7 habits can lead to powerful lessons in personal change. They work through varying levels of dependence, independence, and interdependence and weave a web that can make the individual effective and powerful in directing their will. Change yourself first and then its effect will help change the world.

BE PROACTIVE: The freedom to choose your response after a stimulus using self-awareness, imagination, independent will and conscience. This includes taking the initiative, act or be acted upon, circle of concern/circle of influence, make and keep commitments. "You are the creator and in charge."

BEGIN WITH THE END IN MIND: This is based on the principle that all things are created twice. First in the mental and second is the physical. It can be by design or default. Create a personal mission statement. Begin at the circle of influence and go out from there and include power, guidance, wisdom, and security. The different centers are money, work, possessions, pleasure, friends, enemies, church, self, spouse and principle. This is the mental picture.

PUT FIRST THINGS FIRST: This is the physical creation. It is the fulfillment, the actualization, the natural emergence of habits 1 and 2. It is the day-in, day-out, moment-by-moment doing it. The action or act of doing. Organize and execute around priorities. How do you manage time? Learn to say "no" and delegate when necessary.

THINK WIN/WIN: This is a frame of mind and heart that constantly seeks mutual benefit in all human interactions. Agreements or solutions are mutually beneficial, mutually satisfying. It's not your way or my way; it's a better way, a higher way.

SEEK FIRST TO UNDERSTAND ...THEN TO BE UNDERSTOOD: Listen with the intent to understand, be an empathic listener. Diagnose before you prescribe. When we really, deeply understand each other, we open the door to creative solutions and alternatives. Our differences are no longer stumbling blocks to communication and progress. It becomes effective interdependence.

SYNERGIZE: The whole is greater than the sum or its parts. It is creative cooperation. When you communicate synergistically, you are simply opening your mind and heart and expressions to new possibilities, new alternatives, new options. The key is to value the differences in communication.

SHARPEN THE SAW: This is taking the time to sharpen the saw. It surrounds the other habits on the Seven Habits paradigm because it is the habit that makes all the other possible. It means exercising all four dimensions of our nature (physical, mental, social/emotional, & spiritual), regularly and consistently in wise and balanced ways. This is the single most powerful investment we can ever make in life - investment in ourselves, in the only instrument we have with which to deal with life and to contribute. We are the instruments of our own performance, and to be effective, we need to recognize the importance of taking time regularly to sharpen the saw in all four way. Renewal in the principle and the process that empowers us to move on and upward spiral of growth and change, of continuous improvement. Learn, commit, and do ...Learn, commit, and do ...

LEADERSHIP

•Unwavering courage based upon knowledge of self.
•Self control.
•A keen sense of justice.
•Definiteness of decision.
•Definiteness of plans.
•The habit of doing more than paid for.
•A pleasing personality.
•Sympathy and understanding.
•Mastery of detail.
•Willingness to assume full responsibility.
•Cooperation.

LAWS OF ECONOMIC FREEDOM

•The freedom to **try**, **buy**, **sell**, and **fail**.

LAWS OF HAPPINESS

To be happy:
•Live one day at a time.
•Have a sense of humor.
•Forgive and forget.
•Count your blessings.
•Take advantage of what you already have.
•Set some priorities.
•Make a change and stick to it.

LAWS OF SUCCESS

•Having and maintaining focus.
•Developing competence.
•Focusing on the task at hand.
•Having efficient and effective time management.
•Possessing persistence in the face of obstacles.
•Having the ability to recognize and seize opportunities.
•Being in the right place at the right time and knowing its importance.
•Being involved in something the individual wants to do.

TO SELL AN IDEA

•Prove the need.
•Document the evidence.
•Defuse disagreement.
•Develop possible alternatives.
•Select the most practical ideas.
•Add emotional appeal while describing the benefits.
•Consider the politics.
•Enlist allies.
•Prepare an action plan for implementing the idea.

REARING WELL-BALANCED CHILDREN

•Set a positive example.
•Communicate clear expectations.
•Emphasize the positive.
•Discuss consequences.
•Encourage children to make amends and restitution for the wrong they do.

"Success is getting what you want; Happiness is wanting what you get."

PRINCIPLES OF GOVERNMENT

1) The only reliable basis for sound government and just human relations is Natural Law.
2) A free people cannot survive under a republican constitution unless they remain virtuous and morally strong.
3) The most promising method of securing a virtuous and morally stable people is to elect virtuous leaders.
4) Without religion the government of a free people cannot be maintained.
5) All things were created by God, therefore upon Him all mankind are equally dependent, and to Him they are equally responsible.
6) All men are created equal.
7) The proper role of government is to protect equal rights, not provide equal things.
8) Men are endowed by their Creator with certain unalienable rights.
9) To protect man's rights, God has revealed certain principles of divine law.
10) The God-given right to govern is vested in the sovereign authority of the whole people.
11) The majority of the people may alter or abolish a government which has become tyrannical.
12) The United States of America shall be a republic.
13) A constitution should be structured to permanently protect the people from the human frailties of their rulers.
14) Life and liberty are secure only so long as the right to property is secure.
15) The hightest level of prosperity occurs when there is a free-market economy and a minimum of government regulations.
16) The government should be separated into three branches: legislative, executive, and judicial.
17) A system of checks and balances should be adopted to prevent the abuse of power.
18) The unalienable rights of the people are most likely to be preserved if the principles of government are set forth in a written constitution.
19) Only limited and carefully defined powers should be delegated to government, all others being retained in the people.
20) Efficiency and dispatch require government to operate according to the will of the majority, but constitutional provisions must be made to protect the rights of the minority.
21) Strong local self-government is the keystone to preserving human freedom.
22) A free people should be governed by law and not by the whims of men.
23) A free society cannot survive as a republic without a broad program of general education.
24) A free people will not survive unless they stay strong.
25) "Peace, commerce, and honest friendship with all nations-entangling aliances with none."
26) The core unit which determines the strength of any society is the family; therefore, the government should foster and protect its integrity.
27) The burden of debt is as destructive to freedom as subjugation by conquest.
28) The United States has a manifest destiny to be an example and a blessing to the entire human race.

PRINCIPLES OF A FREE ECONOMY

- Specialized production: let each person or corporation of persons do what they do best.
- Exchange of goods takes place in a free-market environment without governmental interference in production, prices, or wages.
- The free market provides the needs of the people on the basis of supply and demand, with no government imposed monopolies.
- Prices are regulated by competition on the basis of supply and demand.
- Profits are looked upon as the means by which production of goods and services is made worthwhile.
- Competition is looked upon as the means by which quality is improved, quantity is increased, and prices are reduced.

PRINCIPLES OF ECONOMICS

- People economize.
- People respond to incentives.
- Economic systems influence individual choices and incentives.
- The consequences of choice lie in the future.
- All choices involve cost.
- Voluntary trade creates weatlth.

"Freedom can only be won ...the warfare is continuous and each generation comes to the front to fight for it as though the battle had just been joined." Bishop R.A. Brown.

THE TEN COMMANDMENTS

• "Thou shalt have no other gods before Me. Thou shalt not make unto thee a graven image, nor any manner of likeness, of any thing that is in heaven above, or that is in the earth beneath, or that is in the water under the earth; thou shalt not bow down unto them, nor serve them; for I the Lord thy God am a jealous God, visiting the iniquity of the fathers upon the children unto the third and fourth generation of them that hate Me; and showing mercy unto the thousandth generation of them that love Me and keep My commandments.

• "Thou shalt not take the name of the Lord thy God in vain; for the Lord will not hold him guiltless that taketh His name in vain.

• "Remember the Sabbath day, to keep it holy. Six days shalt thou labor, and do all thy work; but the seventh day is a Sabbath unto the Lord thy God, in it thou shalt not do any manner of work, thou, nor thy son, nor thy daughter, nor thy manservant, nor thy maidservant, nor thy cattle, nor thy stranger that is within thy gates; for is six days the Lord made heaven and earth, the sea, and all that in them is, and rested on the seventh day; wherefore the Lord blessed the Sabbath day, and hallowed it.

• "Honor thy father and thy mother, that thy days may be long upon the land which the Lord thy God giveth thee.

• "Thou shalt not murder.

• "Thou shalt not commit adultery.

• "Thou shall not steal.

• "Thou shalt not bear false witness against thy neighbor.

• "Thou shalt not covet thy neighbor's house; thou shalt not covet thy neighbor's wife, nor his manservant, nor his maidservant, nor his ox, nor his ass, nor anything that is thy neighbor's."

"Love is the most essential ingredient in the entire Creation. It is life that secures the delicate balance of opposing forces-good and bad; positive and negative-and ensures the stability of the Universe. The Ten Commandments contain the complete formula of love. The first Ten Commandments are the original vectors which began all the energies necessary to generate and perceive the magnificence of love." Dr. Peter M. Rothschild

"Do unto other as others do unto you."

DECLARATION OF INDEPENDENCE

When in the Course of human Events, it becomes necessary for one People to dissolve the Political Bands which have connected them with another, and to assume, among the Powers of the Earth, the separate and equal Station to which the Laws of Nature and of Nature's God entitle them, a decent Respect to the Opinions of Mankind requires that they should declare the causes which impel them to the Separation.

We hold these Truths to be self-evident, that all Men are created equal; that they are endowed by their Creator with certain unalienable Rights; that among these are Life, Liberty, and the Pursuit of Happiness. That to secure these Rights, Governments are instituted among Men, deriving their just Powers from the Consent of the Governed, that whenever any Form of Government becomes destructive of these Ends, it is the Right of the People to alter or to abolish it, and to institute new Government, laying its Foundation on such Principles, and organizing its Powers in such Form, as to them shall seem most likely to effect their Safety and Happiness. Prudence, indeed, will dictate that Governments long established should not be changed for light and transient Causes; and accordingly all Experience hath shown that Mankind are more disposed to suffer, while Evils are sufferable, than to right themselves by abolishing the Forms to which they are accustomed. But when a long Train of Abuses and Usurpations, pursuing invariably the same Object; evinces a Design to reduce them under absolute Despotism, it is their Right, it is their Duty, to throw off such Government, and to provide new Guards for their future Security. Such has been the patient Sufferance of these Colonies; and such is now the Necessity which constrains them to alter their former Systems of Government. The history of the present King of Great Britain is a History of repeated Injuries and Usurpations, all having in direct Object the Establishment of an absolute Tyranny over these States. To prove this, let Facts be submitted to a candid World.

He has refused his Assent to Laws the most wholesome and necessary for the public Good.

He has forbidden his Governors to pass Laws of immediate and pressing Importance, unless suspended in their Operation till his Assent should be obtained; and when so suspended, he has utterly neglected to attend to them.

He has refused to pass other Laws for the Accommodation of large Districts of People, unless those People would relinquish the Right of Representation in the Legislature, a Right inestimable to them, and formidable to Tyrants only.

He has called together Legislative Bodies at Places unusual, uncomfortable, and distant from the Depository of their public Records, for the sole Purpose of fatiguing them into Compliance with his Measures.

He has dissolved Representative Houses repeatedly, for opposing, with manly Firmness his Invasions on the Rights of the People.

He has refused, for a long Time, after such Dissolutions, to cause others to be elected, whereby the Legislative Powers, incapable of Annihilation, have returned to the People at large for their exercise; the State remaining, in the meantime, exposed to all the Dangers of Invasion from without and Convulsions within,

He has endeavored to prevent the Population of these States; for that Purpose obstructing the Laws for Naturalization of Foreigners, refusing to pass others to encourage their Migration hither, and raising the Conditions of new Appropriations of Lands.

He has obstructed the Administration of Justice, by refusing his Assent to Laws for establishing Judiciary Powers.

He has made Judges dependent on his Will alone for the Tenure of their Offices, and the Amount and Payment of their Salaries.

He has erected a Multitude of new Offices, and sent hither Swarms of Officers to harass our People and eat out their Substance.

He has kept among us in Times of Peace, Standing Armies, without the consent of our Legislatures.

He has affected to render the Military independent of, and superior to the Civil Power.

He has combined with others to subject us to a Jurisdiction foreign to our Constitution, and unacknowledged by our Laws, giving his Assent to their Acts of pretended Legislation:

For quartering large Bodies of Armed Troops among us;

For protecting them, by a mock Trial, from Punishment for any Murders which they should commit on the Inhabitants of these States;

For cutting off our Trade with all Parts of the World:

For imposing Taxes on us without our Consent:

DECLARATION OF INDEPENDENCE

For depriving us, in many Cases, of the Benefits of Trial by Jury;

For transporting us beyond Seas, to be tried for pretended Offenses;

For abolishing the free System of English Laws in a neighboring Province, establishing therein an arbitrary Government, and enlarging its Boundaries, so as to render it at once an Example and fit Instrument for introducing the same absolute Rule into these Colonies;

For taking away our Charters, abolishing our most valuable Laws, and altering, fundamentally, the Forms of our Governments;

For suspending our own Legislatures, and declaring themselves invested with Power to legislate for us in all Cases whatsoever.

He has abdicted Government here, by declaring us out of his Protection and waging War against us.

He has plundered our Seas, ravaged our Coasts, burned our Towns, and destroyed the Lives of our People.

He is at this Time transporting large Armies of foreign Mercenaries to complete the Works of Death, Desolation, and Tyranny already begun with circumstances of Cruelty and Perfidy scarcely paralleled in the most barbarous Ages, and totally unworthy the Head of a civilized Nation.

He has constrained our fellow Citizens taken Captive on the high Seas, to bear Arms against their Country, to become the Executioners of their Friends and Brethren, or to fall themselves by their Hands.

He has excited domestic Insurrection among us, and has endeavored to bring on the Inhabitants of our Frontiers the merciless Indian Savages, whose known Rule of Warfare is an undistinguished Destruction of all Ages, Sexes, and Conditions.

In every stage of these Oppressions we have Petitioned for Redress in the most humble Terms: Our repeated Petitions have been answered only by repeated Injury. A Prince whose Character is thus marked by every act which may define a Tyrant is unfit to be the Ruler of a free People.

Nor have we been wanting in out Attentions to our British Brethren. We have warned them from Time to Time of Attempts by their Legislature to extend an unwarrantable Jurisdiction over us. We have reminded them of the Circumstances of our Emigration and Settlement here. We have appealed to their native Justice and Magnamimity and we have conjured them, by the Ties of our common Kindred, to disavow these Usurpations, which would inevitably interrupt our Connections and Correspondence. They too have been deaf to the Voice of Justice and Consanguinity. We must, therefore, acquiesce in the Necessity which denounces our Separation, and hold them, as we hold the rest of Mankind, Enemies in War, in Peace, Friends.

We, therefore, the Representatives of the UNITED STATES OF AMERICA, in General Congress, Assembled, appealing to the Supreme Judge of the World for the Rectitude of our Intentions, do in the Name and by Authority of the good People of these Colonies, solemnly Publish and Declare, that these United Colonies are, and of Right ought to be, Free and Independent States; that they are absolved from all Allegiance to the British Crown, and that all political Connection between them and the State of Great Britain, is and ought to be, totally dissolved; and that as Free and independent states, they have full Power to levy War, conclude Peace, contract Alliances, establish Commerce, and to do all other Acts and Things which Independent States may of right do. And, for the support of this Declaration with Reliance on the Protection of divine Providence, we mutually pledge to each other our Lives, our Fortunes, and our sacred Honor.

SIGNERS OF THE UNANIMOUS DECLARATION: John Hancock

(According to the Authenticated List printed by Order of Congress of January 18, 1777)

New-Hampshire. Josiah Bartlett, Wm. Whipple, Matthew Thorton.

Massachusetts-Bay. Saml. Adams, Jphn Adams, Robt. Tret Paine,Elbridge Gerry

Delaware. Caesar Rodney, Geo. Read, Tho M:Kean

Rhode-Isl & Providence, & C. Step. Hopkins, William Ellery

Connecticut.. Roger Sherman, Saml. Huntington, Wm. Williams, Oliver Wolcott.

New-York. Wm. Floyd, Phil. Livingston, Frans. Lewis, Lewis Morris.

New-Jersey. Richd. Stockton, Jno. Witherspoon, Fras. Hopkinson, John Hart, Abra Clark.

Pennsylvania. Robt. Morris, Benja. Rush, Benja. Franklin, John Morton, Geo. Clymer, Jas. Smith, Geo Taylor, James Wilson, Geo. Ross.

Maryland. Samuel Chase, Wm. Paca, Thos. Stone, Charles Carroll of Carrollton.

Virginia. George Wythe, Richard Henry Lee, Thos Jefferson, Benja. Harrison, Thos. Nelson Jr., Francis Lightfoot Lee, Carter Braxton.

North Carolina. Wm. Hooper. Joseph Hewes, John Penn.

South Carolina. Edward Ruthledge, Thos. Heyward Jr., Thomas Lynch Jr., Arthur Middleton.

Georgia. Button Gwinnett, Lyman Hall, Geo. Walton.

"Whoever has the gold makes the rules." Golden Rule of Money

THE CONSTITUTION OF THE UNITED STATES OF AMERICA

We, The People of the United States, in order to form a more perfect union, establish justice, insure domestic tranquility, provide for the common defence, promote the general welfare, and secure the blessings of liberty to ourselves and our posterity, do ordain and establish this Constitution for the United States of America.

ARTICLE 1

Sect. 1. ALL legislative powers herein granted shall be vested in a Congress of the United States, which shall consist of a Senate and House of Representatives.

Sect.2 The House of Representatives shall be composed of members chosen every second year by the people of the several states, and the electors in each state shall have the qualification requisite for electors of the most numerous branch of the state legislature.

No person shall be a representative who shall not have attained to the age of twenty-five years, and been seven years a citizen of the United States, and who shall not, when elected, be an inhabitant of that state in which he shall be chosen.

Representatives and direct taxes shall be apportioned among the several states which may be included within this Union, according to their respective numbers, which shall be determined by adding to the whole number of free persons, including those bound to service for a term of years, and excluding Indians not taxed, three-fifths of all other persons. The actual enumeration shall be made within three years after the first meeting of the Congress of the United States, and within every subsequent term of ten years, in such manner as they shall by law direct. The number of representatives shall not exceed one for every thirty thousand, but each state shall have at least one representative; and until such enumeration shall be made, the state of Hew-Hampshire shall be entitled to chuse three, Massachusetts eight, Rhode-Island and Providence Plantation one, Connecticut five, New-York six, New-Jersey four, Pennsylvania eight, Delaware one, Maryland six, Virginia ten, North-Carolina five, South-Carolina five, and Georgia three.

When vacancies happen in the representation form any state, the Executive authority thereof shall issue writs of election to fill such vacancies.

The House of Representatives shall chuse their Speaker and other officers; and shall have the sole power of impeachment.

Sect. 3. The Senate of the United States shall be composed of two senators from each state, chosen by the legislature thereof, for six years; and each senator shall have one vote.

Immediately after they shall be assembled in consequence of the first election, they shall be divided as equally as may be into three classes. The seats of the senators of the first class shall be vacated at the expiration of the second year, of the second class at the expiration of the fourth year, and of the third class at the expiration of the sixth year, so that one-third may be chosen every second year; and if vacancies happen by resignation, or otherwise, during the recess of the Legislature of any state, the Executive thereof may make temporary appointments until the next meeting of the Legislature, which shall then fill such vacancies.

No persons shall be a senator who shall not have attained to the age of thirty years, and been nine years a citizen of the United States, and who shall not, when elected, be an inhabitant of that state for which he shall be chosen.

The Vice-President of the United States shall be President of the senate, but shall have not vote, unless they be equally divided.

The Senate shall chuse their other officers, and also a President pro tempore, in the absence of the Vice-President, or when he shall excercise the office of President of the United States.

The Senate shall have the sole power to try all impeachments. When sitting for that purpose, they shall be on oath or affirmation. When the President of the United States is tried, the Chief Justice shall preside: And no person shall be convicted without the concurrence of two thirds of the members present.

Judgement in cases of impeachment shall not extend further than to removal from office, and disqualification to hold and enjoy any office of honor, trust or profit under the United States; but the part convicted shall nevertheless be liable and subject to indictment, trial, judgment and punishment, according to law.

Sect. 4. The times, places and manner of holding elections for senators and representatives, shall be prescribed in each state by the legislature thereof; but the Congress may at any time by law make or alter such regulations, except as to places of chusing Senators.

The Congress shall assemble at least once in every year, and such meeting shall be on the first Monday in December, unless they shall by law appoint a different day.

THE CONSTITUTION

Sect. 5. Each house shall be the judge of the elections, returns and qualifications of its own members, and a majority of each shall constitute a quorum to do business; but a smaller number may adjourn from day to day, and may be authorized to compel the attendance of absent members, in such manner, and under such penalties as each house may provide.

Each house may determine the rules of its proceedings, punish its members for disorderly behavior, and, with the concurrence of two thirds, expel a member.

Each house shall keep a journal of its proceedings, and from time to time publish the same, excepting such parts as may in their judgement require secrecy; and the yeas and nays of the members of either house on any question shall, at the desire of one-fifth of those present, be entered on the journal.

Neither house, during the session of Congress, shall, without the consent of the other, adjourn for more than three days, nor to any other place than that in which the two houses shall be sitting.

Sect. 6. The senators and representatives shall receive a compensation for their services, to be ascertained by law, and paid out of the treasury of the United States. They shall in all cases, except treason, felony and breach of the peace, be privileged from arrest during their attendance at the session to their respective houses, and in going to and returning from the same; and for any speech or debate in either house, they shall not be questioned in any other place.

No senator or representative shall, during the time for which he was elected, be appointed to any civil office under the authority of the United States, which shall have been created, or the emoluments whereof shall have been encreased during such time; and no person holding any office under the United States, shall be a member of either house during his continuance in office.

Sect. 7 All bills for raising revenue shall originate in the house of representatives; but the senate may propose or concur with amendments as on other bills.

Every bill which shall have passed the house of representatives and the senate, shall, before it becomes a law, be presented to the president of the United States; if he approve he shall sign it, but if not he shall return it, with his objections to that house in which it shall have originated, who shall enter the objections at large on their journal, and proceed to reconsider it. If after such reconsideration two-thirds of that house shall agree to pass the bill, it shall be sent, together with the objections, to the other house, by which it shall likewise be reconsidered, and if approved by two-thirds of that house, it shall become a law. But in all such cases the votes of both houses shall be determined by yeas and nays, and the names of the persons voting for and against the bill shall be entered on the journal of each house respectively. If any bill shall not be returned by the President within two days (Sundays excepted) after it shall have been presented to him, the same shall be a law, in like manner as if he had signed it, unless the Congress by their adjournment prevent its return, in which case it shall not be a law.

Every order, resolution, or vote to which the concurrence of the Senate and House of Representatives may be necessary (except on a question of adjournment) shall be presented to the President of the United States; and before the same shall take effect, shall be approved by him, or , being disapproved by him, shall be repassed by two-thirds of the Senate and House of Representatives, according to the rules and limitations prescribed in the case of a bill.

Sect. 8 The Congress shall have power

To lay and collect taxes, duties, imposts and excises, to pay the debts and provide for the common defence and general welfare of the United States; but all duties, imposts and excises shall be uniform throughout the United States;

To borrow money on the credit of the United States;

To regulate commerce with foreign nations, among the several states, and with the Indian tribes;

To establish an uniform rule of naturalization, and uniform laws on the subject of bankruptcies throughout the United States;

To coin money, regulate the value thereof, and of foreign coin, and fix the standard of weights and measures.

To provide for the punishment of counterfeiting the securities and current coin of the United States.

To establish post offices and post roads.

To promote the progress of science and useful arts, by securing for limited times to authors and inventors the exclusive right to their respective writings and discoveries;

To constitute tribunals inferior to the supreme court;

To define and punish piracies and felonies committed on the high seas, and offences against the law of nations;

To declare war, grant letters of marque and reprisal, and make rules concerning captures on land and water;

To raise and support armies, but no appropriation of money to that use shall be for longer term than two years;

To provide and maintain a navy;

To make rules for the government and regulation of the land and naval forces;

To provide for calling forth the militia to execute the laws of the union, suppress insurrections and repel invasions;

To provide for organizing, arming, and disciplining, the militia, and for governing such part of them as may be employed

THE CONSTITUTION

in the service of the United States, reserving to the States respectively, the appointment of the officers, and the authority of training the militia according to the discipline prescribed by Congress;

To exercise exclusive legislation in all cases whatsoever, over such district (not exceeding ten miles square) as may, by cession of particular States, and the acceptance of Congress, become the seat of the government of the United States, and to exercise like authority over all places purchased by the consent of the legislature of the state in which the same shall be, for the erection of forts, magazines, arsenals, dockyards, and other needful buildings;--And

To make all laws which shall be necessary and proper for carrying into execution the foregoing powers, and all other powers vested by this constitution in the government of the United States, or in any department or officer thereof.

Sect. 9. The migration or importation of such persons as any of the states now existing shall think proper to admit, shall not be prohibited by the Congress prior to the year one thousand eight hundred and eight, but a tax or duty may be imposed on such importation, not exceeding ten dollars for each person.

The privilege of the writ of habeas corpus shall not be suspended, unless when in cases of rebellion or invasion the public safety may require it.

No bill of attainder or ex post facto law shall be passed.

No capitation, or other direct, tax shall be laid, unless in proportion to the census or enumeration herein before directed to be taken.

No tax or duty shall be laid on articles exported from any state. No preference shall be given by any regulation of commerce or revenue to the ports of one state over those of another; nor shall vessels bound to, or from, one state, be obliged to enter, clear, or pay duties in another.

No money shall be drawn from the treasury, but in consequence of appropriations made by law; and regular statement and account for the receipts and expenditures of all public money shall be published from time to time.

No title of nobility shall be granted by the United States:- And no person holding any office of profit or trust under them, shall, without the consent of the Congress, accept of any present, emolument, office, or title, of any kind whatever, from any king, prince, or foreign state.

Sect. 10. No state shall enter into any treaty, alliance, or confederation; grant letters of marque and reprisal; coin money; emit bill of credit; make any thing but gold and silver coin a tender in payment of debts; pass any bill of attainder, ex post facto law, or law impairing the obligation of contracts, or grant any title of nobility.

No state shall, without the consent of the Congress, lay any imposts or duties on imports or exports, except what may be absolutely necessary for executing its inspection laws; and the net produce of all duties and imposts, laid by any state on imports or exports, shall be for the use of the Treasury of the United States; and all such laws shall be subject to the revision and controul of the Congress. No state shall, without the consent of Congress, lay any duty of tonnage, keep troops, or ships of war in time of peace, enter into any agreement or compact with another state, or with a foreign power, or engage in war, unless actually invaded, or in such imminent danger as will not admit of delay.

ARTICLE II

Sect. 1. The executive power shall be vested in a president of the United States of America. He shall hold his office during the term of four years, and, together with the vice-president, chosen for the same term, be elected as follows.

Each state shall appoint, in such manner as the legislature thereof may direct, a number of electors, equal to the whole number of senators and representatives to which the state may be entitled in the Congress: but no senator or representative, or person holding an office of trust or profit under the United States, shall be appointed an elector.

The electors shall meet in their respective states, and vote by ballot for two persons, of whom one at least shall not be an inhabitant of the same state with themselves. And they shall make a list of all the persons voted for, and of the number of votes for each; which list they shall sign and certify, and transmit sealed to the seat of the government of the United States, directed to the president of the senate. The president of the senate shall, in the presence of the senate and house of representatives, open all the certificates, and the votes shall then be counted. The person having the greatest number of votes shall be the president, and if there be more than one who have such majority, and have an equal number of votes, then the house of representatives shall immediately chuse by ballot one of them for president; and if no person have a majority, then from the five highest on the list the said house shall in like manner chuse the president. But in chusing the president, the votes shall be taken by states, the representation from each state having one vote; a quorum for purpose shall consist of a member or members from two-thirds of the states, and a majority of all the states shall be necessary to a choice. In every case, after the choice of the president, the person having the greatest number of votes of the electors shall be the vice-president. But if there should remain two or more who have equal votes. The senate shall chuse from them by ballot the vice-president.

The Congress may determine the time of chusing the electors, and the day on which they shall give their votes; which day shall be the same throughout the United States.

THE CONSTITUTION

No person except a natural born citizen, or a citizen of the United States, at the time of the adoption of this constitution, shall be eligible to the office of president; neither shall any person be eligible to that office who shall not have attained the age of thirty-five years, and been fourteen years a resident within the United States.

In case of the removal of the president from office, or of his death, resignation, or inability to discharge the powers and duties of the said office, the same shall devolve on the vice -president, and the Congress may by law provide for the case of removal, death, resignation or inability, both of the president and vice-president, declaring what officer shall then act as president , and such officer shall act accordingly, until the disability be removed, or a president shall be elected.

The president shall, at stated times, receive for his services, a compensation, which shall neither be increased nor diminished during the period for which he shall have been elected, and he shall not receive within that period any other emolument from the United States, or any of them.

Before he enter on the execution of his office, he shall take the following oath or affirmation:

" I do solemnly swear (or affirm) that I will faithfully execute the office of president of the United States, and will to the best of my ability, preserve, protect and defend the constitution of the United States."

Sect. 2 The president shall be commander in chief of the army and navy of the United States, and of the militia of the several States, when called into the actual service of the United States; he may require the opinion, in writing, of the principal officer in each of the executive departments, upon any subject relating to the duties of their respective offices, and he shall have power to grant reprieves and pardons for offences against the United States, except in cases of impeachment.

He shall have power, by and with the advice and consent of the senate, to make treaties, provided two-thirds of the senators present concur; and he shall nominate, and by and with the advice and consent of the senate, shall appoint ambassadors, other public ministers and consuls, judges of the supreme court, and all other officers of the United States, whose appointments are not herein otherwise provided for, and which shall be established by law. But the Congress may by law vest the appointment of such inferior officers, as they think proper, in the president alone, in the courts of law, or in the heads of departments.

The president shall have power to fill up all vacancies that may happen during the recess of the senate, by granting commissions which shall expire at the end of their next session.

Sect. 3. He shall from time to time give to the Congress information of the state of the union, and recommend to their consideration such measures as he shall judge necessary and expedient; he may, on extraordinary occasions, convene both houses, or either of them, and in case of disagreement between them, with respect to the time of adjournment, he may adjourn them to such time as he shall think proper; he shall receive ambassadors and other public ministers; he shall take care that the laws be faithfully executed, and shall commission all the officers of the United States.

Sect. 4 The president, vice-president and all civil officers of the United States, shall be removed from office on impeachment for, and conviction of, treason, bribery, or other high crimes and misdemeanors.

ARTICLE III

Sect. 1. The judicial power of the United States, shall be vested in one supreme court, and in such inferior courts as the Congress may from time to time ordain and establish. The judges, both of the supreme and inferior courts, shall hold their offices during good behavior, and shall, at stated times, receive for their services, a compensation, which shall not be diminished during their continuance in office.

Sect. 2. The judicial power shall extend to all cases, in law and equity, arising under this constitution, the laws of the United States, and treaties made, or which shall be made, under their authority; to all cases affecting ambassadors, other public ministers and consuls; to all cases of admiralty and maritime jurisdiction; to controversies to which the United States shall be a party; to controversies between two or more States, between a state and citizens of another state, between citizens of different States, between citizens of the same state claiming lands under grants of different States, and between a state, or the citizens thereof, and foreign States, citizens or subjects.

In all cases affecting ambassadors, other public ministers and consuls, and those in which a state shall be party, the supreme court shall have original jurisdiction. In all the other cases before mentioned, the supreme court shall have appellate jurisdiction, both as to law and fact, with such exceptions, and under such regulations as the Congress shall make.

The trial of all crimes, except in cases of impeachment, shall be by jury; and such trial shall be held in the state where the said crimes shall have been committed; but when not committed within any state, the trial shall be at such place or places as the Congress may by law have directed.

Sect. 3. Treason against the United States, shall consist only in levying war against them, or in adhering to their enemies, giving them aid and comfort. No person shall be convicted of treason unless on the testimony of two witnesses to the same overt act, or on confession in open court.

The Congress shall have power to declare the punishment of treason, but no attainder of treason shall work corruption of blood, or forfeiture except during the life of the person attained.

"If I told you what I really know it would be very dangerous to the country. Our whole political system could be disrupted."
J. Edgar Hoover

THE CONSTITUTION

ARTICLE IV

Sect. 1. Full faith and credit shall be given in each state to the public acts, records, and judicial proceedings of every other state. And the Congress may by general laws prescribe the manner in which such acts, records and proceedings shall be proved, and the effect thereof.

Sect. 2. The citizens of each state shall be entitled to all privileges and immunities of citizens in the several states.

A person charged in any state with treason, felony, or other crime, who shall flee from justice, and be found in another state, shall, on demand of the executive authority of the state from which he fled, be delivered up, to be removed to the state having jurisdiction of the crime.

No person held to service or labour in one state, under the laws thereof, escaping into another, shall, in consequence of any law or regulation therein, be discharged from such service or labour, but shall be delivered up on claim of the party to whom such service or labour may be due.

Sect. 3. New states may be admitted by the Congress into this union; but no new state shall be formed or erected within the jurisdiction of any other state; nor any state be formed by the junction of two or more states, or parts of states, without the consent of the legislatures or the states concerned as well as of the Congress.

The Congress shall have power to dispose of and make all needful rules and regulations respecting the territory or other property belonging to the United States; and nothing in this Constitution shall be so construed as to prejudice any claims of the United States, or of any particular state.

Sect. 4. The United States shall guarantee to every state in this union a Republican form of government, and shall protect each of them against invasion; and on application of the legislature, or of the executive (when the legislature cannot be convened) against domestic violence.

ARTICLE V

The Congress, whenever two-thirds of both houses shall deem it necessary, shall propose amendments to this constitution, or, on the application of the legislatures of two-thirds of the several states, shall call a convention for proposing amendments, which, in either case, shall be valid to all intents and purposes, as part of this constitution, when ratified by the legislatures of three-fourths of the several states, or by conventions in three-fourths thereof, as the one or the other mode of ratification may be proposed by the Congress; Provided, that no amendment which may be made prior to the year one thousand eight hundred and eight shall in any manner affect the first and fourth clauses in the ninth section of the first article; and that no state, without its consent, shall be deprived of its equal suffrage in the senate.

ARTICLE VI

All debts contracted and engagements entered into, before the adoption of this Constitution, shall be as valid against the United States under this Constitution, as under the confederation.

This constitution, and the laws of the United States which shall be made in pursuance thereof; and all treaties made, or which shall be made, under the authority of the United States, shall be the supreme law of the land; and the judges in every state shall be bound thereby, any thing in the constitution or laws of any state to the contrary notwithstanding.

The senators and representatives beforementioned, and the members of the several state legislatures, and all executive and judicial officers, both of the United States and of the several States, shall be bound by oath or affirmation, to support this constitution; but no religious test shall ever be required as a qualification to any office or public trust under the United States.

ARTICLE VII

The ratification of the conventions of nine States, shall be sufficient for the establishment of this constitution between the States so ratifying the same.

Done in Convention, by the unanimous consent, of the states present, the seventeenth day of September, in the year of our Lord one thousand seven hundred and eighty-seven, and of the Independence of the United States of America the twelfth. In witness whereof we have here unto subscribed our Names.

GEORGE WASHINGTON, President,
And Deputy from Virginia. + (Other signatures)

"If the American people ever allow private banks to control the issue of their currency, first by inflation and then by deflation, the banks and the corporations that will grow up around them, will deprive the people of all property until their children wake up homeless on the continent their fathers conquered." Thomas Jefferson

BILL OF RIGHTS

AMENDMENTS TO THE CONSTITUTION

Articles in addition to, and Amendment of the Constitution of the United States of America, proposed by Congress, and ratifies by the Legislatures of the several States, pursuant to the fifth Article of the original Constitution.

ARTICLE 1

Congress shall make no law respecting an establishment of religion, or prohibiting the free exercise thereof; or abridging the freedom of speech, or of the press; or the right of the people peaceably to assemble, and to petition the Government for a redress of grievances.

ARTICLE II

A well regulated Militia, being necessary to the security of a free State, the right of the people to keep and bear Arms, shall not be infringed.

ARTICLE III

No Soldier shall, in time of peace be quartered in any house, without the consent of the Owner, nor in time of war, but in manner to be prescribed by law.

ARTICLE IV

The right of the people to be secure in their persons, houses, papers, and effects, against unreasonable searches and seizures, shall not be violated, and no Warrants shall issue, but upon probable cause, supported by Oath or affirmation, and particularly describing the place to be searched, and the persons or things to be seized.

ARTICLE V

No person shall be held to answer for a capital, or otherwise infamous crime, unless on a presentment or indictment of a Grand Jury, except in cases arising in the land or naval forces, or in the Militia, when in actual service in time of War or public danger; nor shall any person be subject for the same offence to be twice put in jeopardy of life or limb; nor shall be compelled in any criminal case to be a witness against himself, nor be deprived of life, liberty, or property, without due process of law; nor shall private property be taken for public use, without just compensation.

ARTICLE VI

In all criminal prosecutions, the accused shall enjoy the right to a speedy and public trial, by an impartial jury of the State and district wherein the crime shall have been committed, which district shall have been previously ascertained by law, and to be informed of the nature and cause of the accusation; to be confronted with the witnesses against him; to have compulsory process for obtaining witnesses in his favor, and to have the Assistance of Counsel for his defence.

ARTICLE VII

In Suits at common law, where the value in controversy shall exceed twenty dollars, the right of trial by jury shall be preserved, and no fact tried by a jury, shall be otherwise re-examined in any Court of the United States, than according to the rules of the common law.

ARTICLE VIII

Excessive bail shall not be required, nor excessive fines imposed, nor cruel and unusual punishments inflicted.

ARTICLE IX

The enumeration in the Constitution, of certain rights, shall not be construed to deny or disparage others retained by the people.

ARTICLE X

The powers not delegated to the United States by the Constitution, nor prohibited by it to the States, are reserved to the States respectively, or to the people.

"Have courage to be ignorant of a great number of things, in order to avoid the calamity of being ignorant of everything."

AMENDMENTS TO THE CONSTITUTION

ARTICLE XI

The Judicial power of the United States shall not be construed to extend to any suit in law or equity, commenced or prosecuted against one of the United States by Citizens of another State, or by Citizens or Subjects of any Foreign State.

ARTICLE XII

The Electors shall meet in their respective states, and vote by ballot for President and Vice-President, one of whom, at least, shall not be an inhabitant of the same state with themselves; they shall name in their ballots the person voted for as President, and in distinct ballots the persons voted for as Vice-President, and they shall make distinct lists of all persons voted for as President, and of all persons voted for as Vice-President, and of the number of votes for each, which lists they shall sign and certify, and transmit sealed to the seat of the government of the United States, directed to the President of the Senate;--- The President of the Senate shall, in the presence of the Senate and House of Representatives, open all the certificates and the votes shall then be counted; --- The person having the greatest number of votes for President, shall be the President, if such number be a majority of the whole number of Electors appointed; and if no person have such majority, then from the persons having the highest numbers not exceeding three on the list of those voted for as President, the House of Representatives shall choose immediately, by ballot, the President, But in choosing the President, the votes shall be taken by states, the representation from each state having one vote; a quorum for this purpose shall consist of a member or members from two-thirds of the states, and a majority of all the states shall be necessary to a choice.

And if the House of Representatives shall not choose a President whenever the right of choice shall devolve upon them, before the fourth day of March next following, then the Vice-President shall act as President, as in the case of the death or other constitutional disability of the President. The person having the greatest number of votes as Vice-President, shall be the Vice-President, if such number be a majority of the whole number of Electors appointed, and if no person have a majority, then from the two highest numbers on the list, the Senate shall choose the Vice-President; a quorum for the purpose shall consist of two-thirds of the whole number of Senators, and a majority of the whole number shall be necessary to a choice. But no person constitutionally ineligible to the office of President shall be eligible to that of Vice-President of the United States.

ARTICLE XIII

Sect. 1. Neither slavery nor involuntary servitude, except as a punishment for crime whereof the party shall have been duly convicted, shall exist within the United States, or any place subject to their jurisdiction.

Sect. 2 Congress shall have power to enforce this article by appropriate legislation.

ARTICLE XIV

Sect. 1. All persons born or naturalized in the United States, and subject to the jurisdiction thereof, are citizens of the United States and of the State wherein they reside. No State shall make or enforce any law which shall bridge the privileges or immunities of citizens of the United States; nor shall any State deprive any person of life, liberty, or property, without due process of law; nor deny to any person within its jurisdiction the equal protection of the laws.

Sect. 2. Representatives shall be apportioned among the several States according to their respective numbers, counting the whole number of persons in each State, excluding Indians not taxed. But when the right to vote at any election for the choice of electors for President and Vice President of the United States, Representatives in Congress, the Executive and Judicial officers of a State, or the members of the Legislature thereof, is denied to any of the male inhabitants of such State, being twenty-one years of age, and citizens of the United States, or in any way abridged, except for participation in rebellion, or other crime, the basis of representation therein shall be reduced in the proportion which the number of such male citizens shall bear to the whole number of male citizens twenty-one years of age in such State.

Sect. 3. No person shall be a Senator or Representative in Congress, or elector of President and Vice President, or hold any office, civil or military, under the United States, or under any State, who, having previously taken an oath, as a member of Congress, or as an officer of the United States, or as a member of any State legislature, or as an executive or judicial officer of any State, to support the Constitution of the United States, shall have engaged in insurrection or rebellion against the same, or given aid or comfort to the enemies thereof. But Congress may by a vote of two-thirds of each house, remove such disability.

Sect. 4. The validity of the public debt of the United States, authorized by law, including debts incurred for payment of pensions and bounties for services in suppressing insurrection or rebellion, shall not be questioned. But neither the United States nor any State shall assume or pay any debt or obligation incurred in aid of insurrection or rebellion against the United States, or any claim for the loss or emancipation of any slave; but all such debts, obligations and claims shall be held illegal and void.

Sect. 5. The Congress shall have power to enforce, by appropriate legislation, the provisions of this article.

ARTICLE XV

Sect. 1. The right of citizens of the United States to vote shall not be denied or abridged by the United States or by any State on account of race, color, or previous condition of servitude.

Sect. 2. The Congress shall have power to enforce this article by appropriate legislation.

"Under the Federal Reserve Act panics are scientifically created; the present (1920) is the first scientifically created one ...worked out as we figure a mathematical problem." Charles A. Lindbergh

AMENDMENTS TO THE CONSTITUTION

ARTICLE XVI

The Congress shall have power to lay and collect taxes on incomes, from whatever source derived, without apportionment among the several States, and without regard to any census or enumeration.

ARTICLE XVII

The Senate of the United States shall be composed of two Senators from each State, elected by the people thereof, for six years; and each Senator shall have one vote. The electors in each State shall have the qualifications requisite for electors of the most numerous branch of the State legislatures.

When vacancies happen in the representation of any State in the Senate, the executive authority of such State shall issue writs of election to fill such vacancies: Provided, that the legislature of any State may empower the executive thereof to make temporary appointments until the people fill the vacancies by election as the legislature may direct.

This amendment shall not be so construed as to affect the election or term of any Senator chosen before it becomes valid as part of the Constitution.

ARTICLE XVIII

Sect. 1. After one year from the ratification of this article the manufacture, sale, or transportation of intoxicating liquors within, the importation thereof into, or the exportation thereof from the United States and all territory subject to the jurisdiction thereof for beverage purposes is hereby prohibited.

Sect. 2. The Congress and the several States shall have concurrent power to enforce this article by appropriate legislation.

Sect. 3 This article shall be inoperative unless it shall have been ratified as an amendment to the Constitution by the legislatures of the several States, as provided in the Constitution, within seven years from the date of the submission hereof to the States by the Congress.

ARTICLE XIX

The right of citizens of the United States to vote shall not be denied or abridged by the United States or by any State on account of sex.

Congress shall have power to enforce this article by appropriate legislation.

ARTICLE XX

Sect. 1. The terms of the President and Vice President shall end at noon on the 20th day of January, and the terms of Senators and Representatives at noon on the 3rd day of January, of the years in which such terms would have ended if this article had not been ratified; and the terms of their successors shall then begin.

Sect. 2. The Congress shall assemble at least once in every year, and such meeting shall begin at noon on the 3rd day of January, unless they shall by law appoint a different day.

Sect. 3. If, at the time fixed for the beginning of the term of the President, the President elect shall have died, the Vice President elect shall become President. If a President shall not have been chosen before the time fixed for the beginning of his term, or if the President elect shall have failed to qualify, then the Vice President elect shall act as President until a President shall have qualified; and the Congress may by law provide for the case wherein neither a President elect nor a vice President elect shall have qualified, declaring who shall then act as President, or the manner in which one who is to act shall be selected, and such person shall act accordingly until a President or Vice President shall have qualified.

Sect. 4. The Congress may by law provide for the case of the death of any of the persons from whom the House of Representatives may choose a President whenever the right of choice shall have devolved upon them, and for the case of the death or any of the persons from whom the Senate may choose a Vice President whenever the right of choice shall have devolved upon them.

Sect. 5. Sections 1 and 2 shall take effect on the 15th day of October following the ratification of this article.

Sect. 6. This article shall be inoperative unless it shall have been ratified as an amendment to the Constitution by the legislatures of three-fourths of the several States within seven years from the date of its submission.

ARTICLE XXI

Sect. 1. The eighteenth article of amendment to the Constitution of the United States is hereby repealed.

Sect. 2. The transportation or importation into any State, Territory, or possession of the United States for delivery or use therein of intoxicating liquors, in violation of the laws thereof, is hereby prohibited.

Sect. 3. This article shall be inoperative unless it shall have been ratified as an amendment to the Constitution by conventions in the several States, as provided in the Constitution, within seven years from the date of the submission hereof to the States by the Congress.

"I believe that banking institutions are more dangerous to our liberties than standing armies." *Thomas Jefferson*

AMENDMENTS TO THE CONSTITUTION

ARTICLE XXII

Sect. 1. No person shall be elected to the office of the President more than twice, and no person who has held the office of President, or acted as President, for more than two years of a term to which some other person was elected President shall be elected to the office of the President more than once. But this Article shall not apply to any person holding the office of President when this Article was proposed by the Congress, and shall not prevent any person who may be holding the office of President, or acting a as President, during the term within which this Article becomes operative from holding the office of President or acting as President during the remainder of such term.

Sect. 2 This article shall be inoperative unless it shall have been ratified as an amendment to the Constitution by the legislatures of three-fourths of the several States within seven years from the date of its submission to the States by the Congress.

ARTICLE XXIII

Sect. 1. The District constituting the seat of Government of the United States shall appoint in such manner as the Congress may direct:

A number of electors of President and Vice President equal to the whole number of Senators and Representatives in Congress to which the District would be entitled if it were a State, but in no event more than the least populous State; they shall be in addition to those appointed by the States, but they shall be considered, for the purposes of the election of President and Vice President, to be electors appointed by a State; and they shall meet in the District and perform such duties as provided by the twelfth article of amendment.

Sect. 2. The Congress shall have power to enforce this article by appropriate legislation.

ARTICLE XXIV

Sect. 1. The right of citizens of the United States to vote in any primary or other election for President or Vice President, for electors for President or Vice President, or for Senator or Representative in Congress, shall not be denied or abridged by the United States or any State by reason of failure to pay any poll tax or other tax.

Sect. 2. The Congress shall have power to enforce this article by appropriate legislation.

ARTICLE XXV

Sect. 1. In case of the removal of the President from office or of his death or resignation, the Vice President shall become President.

Sect.. 2. Whenever there is a vacancy in the office of the Vice President, the President shall nominate a Vice President who shall take office upon confirmation by a majority vote of both Houses of Congress.

Sect. 3. Whenever the President transmits to the President pro tempore of the Senate and the Speaker of the House of Representatives his written declaration that he is unable to discharge the powers and duties of his office, and until he transmits to them a written declaration to the contrary, such powers and duties shall be discharged by the Vice President as Acting President.

Sect. 4. Whenever the Vice President and a majority of either the principal officers of the executive departments or of such other body as Congress may by law provide, transmit to the President pro tempore of the Senate and the Speaker of the House of Representatives their written declaration that the President is unable to discharge the powers and duties of his office, The Vice President shall immediately assume the powers and duties of the office as Acting President.

Thereafter, when the President transmits to the President protempore of the Senate and the Speaker of the House of Representatives his written declaration that no inability exists, he shall resume the powers and duties of his office unless the Vice President and a majority of either the principal officers of the executive department or of such other body as Congress may by law provide, transmit within four days to the President pro tempore of the Senate and the Speaker of the House of Representatives their written declaration that the President is unable to discharge the powers and duties of his office. Thereupon Congress shall decide the issue, assembling within forty-eight hours for that purpose if not in session. If the Congress, within twenty-one days after receipt of the latter written declaration, or, if Congress is not in session, within twenty-one days after Congress is required to assemble, determines by two-thirds vote of both Houses that the President is unable to discharge the powers and duties of his office, the Vice President shall continue to discharge the same as Acting President; otherwise, the President shall resume the powers and duties of his office.

ARTICLE XXVI

Sect. 1. The right of citizens of the United States, who are eighteen years of age or older, to vote shall not be denied or abridged by the United States or by any State on account of age.

Sect. 2. The Congress shall have power to enforce this article by appropriate legislation.

"Great Spirit, grant that I may not criticize my neighbor until I have walked a mile in his moccasins."

IRS FORM 4684

This form may be hard to get in the event of a large disaster and the loss may be tax deductible.

Form **4684**	**Casualties and Thefts**	OMB No. 1545-0177
Department of the Treasury Internal Revenue Service	▶ See separate instructions. ▶ Attach to your tax return. ▶ Use a separate Form 4684 for each different casualty or theft.	**1994** Attachment Sequence No. **26**

Name(s) shown on tax return	Identifying number

SECTION A—Personal Use Property (Use this section to report casualties and thefts of property **not** used in a trade or business or for income-producing purposes.)

1 Description of properties (show type, location, and date acquired for each):

Property **A** ...

Property **B** ...

Property **C** ...

Property **D** ...

Properties (Use a separate column for each property lost or damaged from one casualty or theft.)

		A	B	C	D
2	Cost or other basis of each property				
3	Insurance or other reimbursement (whether or not you filed a claim). See instructions. **Note:** If line 2 is **more than** line 3, skip line 4.				
4	Gain from casualty or theft. If line 3 is **more than** line 2, enter the difference here and skip lines 5 through 9 for that column. See instructions if line 3 includes insurance or other reimbursement you did not claim, or you received payment for your loss in a later tax year				
5	Fair market value **before** casualty or theft				
6	Fair market value **after** casualty or theft				
7	Subtract line 6 from line 5				
8	Enter the **smaller** of line 2 or line 7				
9	Subtract line 3 from line 8. If zero or less, enter -0-				

10	Casualty or theft loss. Add the amounts on line 9. Enter the total	10
11	Enter the amount from line 10 or $100, whichever is **smaller**	11
12	Subtract line 11 from line 10	12
	Caution: Use only one Form 4684 for lines 13 through 18.	
13	Add the amounts on line 12 of all Forms 4684	13
14	Combine the amounts from line 4 of all Forms 4684	14
15	• If line 14 is **more than** line 13, enter the difference here and on Schedule D. Do not complete the rest of this section (see instructions). • If line 14 is **less than** line 13, enter -0- here and continue with the form. • If line 14 is **equal to** line 13, enter -0- here. Do not complete the rest of this section.	15
16	If line 14 is **less than** line 13, enter the difference	16
17	Enter 10% of your adjusted gross income (Form 1040, line 32). Estates and trusts, see instructions	17
18	Subtract line 17 from line 16. If zero or less, enter -0-. Also enter result on Schedule A (Form 1040), line 19. Estates and trusts, enter on the "Other deductions" line of your tax return	18

For Paperwork Reduction Act Notice, see page 1 of separate instructions. Cat. No. 129970 Form **4684** (1994)

"Countries that try to regulate and tax too much will be inhabited residually mainly by dummies." Norman Macrae

IRS FORM 4684

Form 4684 (1994) Attachment Sequence No. **26** Page **2**

Name(s) shown on tax return. Do not enter name and identifying number if shown on other side. | Identifying number

SECTION B—Business and Income-Producing Property (Use this section to report casualties and thefts of property used in a trade or business or for income-producing purposes.)

Part I Casualty or Theft Gain or Loss (Use a separate Part I for each casualty or theft.)

19 Description of properties (show type, location, and date acquired for each):

Property **A** ...

Property **B** ...

Property **C** ...

Property **D** ...

		Properties (Use a separate column for each property lost or damaged from one casualty or theft.)			
		A	**B**	**C**	**D**
20 Cost or adjusted basis of each property	**20**				
21 Insurance or other reimbursement (whether or not you filed a claim). See the instructions for line 3 **Note:** *If line 20 is more than line 21, skip line 22.*	**21**				
22 Gain from casualty or theft. If line 21 is **more than** line 20, enter the difference here and on line 29 or line 34, column (c), except as provided in the instructions for line 33. Also, skip lines 23 through 27 for that column. See the instructions for line 4 if line 21 includes insurance or other reimbursement you did not claim, or you received payment for your loss in a later tax year	**22**				
23 Fair market value **before** casualty or theft . . .	**23**				
24 Fair market value **after** casualty or theft	**24**				
25 Subtract line 24 from line 23	**25**				
26 Enter the **smaller** of line 20 or line 25	**26**				
Note: *If the property was totally destroyed by casualty or lost from theft, enter on line 26 the amount from line 20.*					
27 Subtract line 21 from line 26. If zero or less, enter -0-	**27**				
28 Casualty or theft loss. Add the amounts on line 27. Enter the total here and on line 29 or line 34 (see instructions) .	**28**				

Part II Summary of Gains and Losses (from separate Parts I)

(a) Identify casualty or theft		**(b)** Losses from casualties or thefts		**(c)** Gains from casualties or thefts includible in income
		(i) Trade, business, rental or royalty property	*(ii)* Income-producing property	
Casualty or Theft of Property Held One Year or Less				
29		() ()	
		() ()	
30 Totals. Add the amounts on line 29	**30**	() ()	

31 Combine line 30, columns (b)(i) and (c). Enter the net gain or (loss) here and on Form 4797, line 15. If Form 4797 is not otherwise required, see instructions | **31**

32 Enter the amount from line 30, column (b)(ii) here and on Schedule A (Form 1040), line 22. Partnerships, S corporations, estates and trusts, see instructions | **32**

Casualty or Theft of Property Held More Than One Year

33 Casualty or theft gains from Form 4797, line 34	**33**			
34		() ()	
		() ()	
35 Total losses. Add amounts on line 34, columns (b)(i) and (b)(ii) . . .	**35**	() ()	
36 Total gains. Add lines 33 and 34, column (c)				**36**
37 Add amounts on line 35, columns (b)(i) and (b)(ii)				**37**

38 If the loss on line 37 is **more than** the gain on line 36:

 a Combine line 35, column (b)(i) and line 36, and enter the net gain or (loss) here. Partnerships and S corporations see the note below. All others enter this amount on Form 4797, line 15. If Form 4797 is not otherwise required, see instructions | **38a**

 b Enter the amount from line 35, column (b)(ii) here. Partnerships and S corporations see the note below. Individuals enter this amount on Schedule A (Form 1040), line 22. Estates and trusts, enter on the "Other deductions" line of your tax return | **38b**

39 If the loss on line 37 is **equal to** or **less than** the gain on line 36, combine these lines and enter here. Partnerships, see the note below. All others, enter this amount on Form 4797, line 3 | **39**

 Note: *Partnerships, enter the amount from line 38a, 38b, or line 39 on Form 1065, Schedule K, line 7. S corporations, enter the amount from line 38a or 38b on Form 1120S, Schedule K, line 6.*

IRS FORM 4684

Department of the Treasury
Internal Revenue Service

Instructions for Form 4684

Casualties and Thefts
Section references are to the Internal Revenue Code.

Paperwork Reduction Act Notice

We ask for the information on this form to carry out the Internal Revenue laws of the United States. You are required to give us the information. We need it to ensure that you are complying with these laws and to allow us to figure and collect the right amount of tax.

The time needed to complete and file this form will vary depending on individual circumstances. The estimated average time is:

Recordkeeping. . . . 1 hr., 12 min.

Learning about the law or the form 11 min.

Preparing the form . . . 1 hr., 2 min.

Copying, assembling, and sending the form to the IRS . 35 min.

If you have comments concerning the accuracy of these time estimates or suggestions for making this form more simple, we would be happy to hear from you. You can write to both the IRS and the Office of Management and Budget at the addresses listed in the instructions for the tax return with which this form is filed.

General Instructions

Purpose of Form

Use Form 4684 to report gains and losses from casualties and thefts. Attach Form 4684 to your tax return.

Deductible Losses

You may deduct losses from fire, storm, shipwreck, or other casualty, or theft (e.g., larceny, embezzlement, and robbery).

If your property is covered by insurance, you must file a timely insurance claim for reimbursement of your loss. Otherwise, you cannot deduct the loss as a casualty or theft loss. However, the part of the loss that is not covered by insurance is still deductible.

Related expenses.—The related expenses you have due to a casualty or theft, such as expenses for the treatment of personal injuries or for the rental of a car, are not deductible as casualty or theft losses.

Costs for protection against future casualties are not deductible but should be capitalized as permanent improvements. An example would be the cost of a levee to stop flooding.

Gain on Reimbursement

If the amount you receive in insurance or other reimbursement is more than the cost or other basis of the property, you have a gain. If you have a gain, you may have to pay tax on it, or you may be able to postpone reporting the gain.

Do not report the gain on damaged, destroyed, or stolen property if you receive property that is similar or related to it in service or use. Your basis for the new property is the same as your basis for the old property.

Generally, you must report the gain if you receive unlike property or money as reimbursement. But you can choose to postpone all or part of the gain if, within 2 years of the end of the first tax year in which any part of the gain is realized, you purchase:

1. Property similar or related in service or use to the damaged, destroyed, or stolen property, or

2. A controlling interest (at least 80%) in a corporation owning such property.

To postpone all of the gain, the cost of the replacement property must be equal to or more than the reimbursement you received for your property. If the cost of the replacement property is less than the reimbursement received, you must report the gain to the extent the reimbursement exceeds the cost of the replacement property.

For details on how to postpone the gain, get **Pub. 334,** Tax Guide for Small Business.

If your main home was located in a Presidentially declared disaster area, and that home or any of its contents were damaged or destroyed due to the disaster, special rules apply. See **Gains Realized on Homes in Disaster Areas** on page 2.

When To Deduct a Loss

Deduct the part of your casualty or theft loss that is not reimbursable. Deduct it in the tax year the casualty occurred or the theft was discovered. However, a disaster loss and a loss from deposits in insolvent or bankrupt financial

institutions may be treated differently. See **Disaster Losses** below and **Special Treatment for Losses on Deposits in Insolvent or Bankrupt Financial Institutions** on page 2.

If you are not sure whether part of your casualty or theft loss will be reimbursed, do not deduct that part until the tax year when you are reasonably certain that it will not be reimbursed.

If you are reimbursed for a loss you deducted in an earlier year, include the reimbursement in your income in the year you received it, but only to the extent the deduction reduced your tax in an earlier year.

See **Pub. 547,** Nonbusiness Disasters, Casualties, and Thefts, for special rules on when to deduct losses from casualties and thefts to leased property.

Disaster Losses

A disaster loss is a loss that occurred in an area determined by the President of the United States to warrant Federal disaster assistance.

You may elect to deduct a disaster loss in the prior tax year as long as the loss would otherwise be allowed as a deduction in the year it occurred.

This election must be made by filing your return or amended return for the prior year, and claiming your disaster loss on it, by the later of the following two dates:

1. The due date for filing your original return (without extensions) for the tax year in which the disaster actually occurred.

2. The due date for filing your original return (including extensions) for the tax year immediately before the tax year in which the disaster actually occurred.

You may revoke your election within 90 days after making it by returning to the IRS any refund or credit you received from the election. If you revoke your election before receiving a refund, you must repay the refund within 30 days after receiving it.

On the return on which you claim the disaster loss, specify the date(s) of the disaster and the city, town, county, and state in which the damaged or destroyed property was located.

Note: *To determine the amount to deduct for a disaster loss, you must take into account as reimbursements any*

Cat. No. 12998Z

IRS FORM 4684

benefits you received from Federal or state programs to restore your property.

If your home was located in a disaster area and your state or local government ordered you to tear it down or move it because it was no longer safe to use as a home, the loss in value because it is no longer safe is treated as a disaster loss. The order for you to tear down or move the home must have been issued within 120 days after the area was officially declared a disaster area.

Use the value of your home before you moved it or tore it down as its fair market value after the casualty for purposes of figuring the disaster loss.

Gains Realized on Homes in Disaster Areas

If your main home was located in an area declared by the President of the United States to warrant Federal assistance as the result of a disaster, and that home or any of its contents were damaged or destroyed due to the disaster:

• No gain is recognized from receiving any insurance proceeds for unscheduled personal property that was part of the contents of the home.

• Any other insurance proceeds you receive for the home or its contents is treated as received for a single item of property, and any replacement property you purchase that is similar or related in service or use to the home or its contents is treated as similar or related in service or use to that single item of property. Therefore, you can choose to recognize gain only to the extent the insurance proceeds treated as received for that single item of property exceed the cost of the replacement property.

• If you choose to postpone any gain from the receipt of insurance or other reimbursement for your main home or any of its contents, the period in which you must purchase replacement property is extended until 4 years after the end of the first tax year in which any part of the gain is realized.

• Renters receiving insurance proceeds for damaged or destroyed property in a rented home also qualify for relief under these rules if their rented home is their main home.

Example. Your main home and its contents were completely destroyed in 1994 by a tornado in a Presidentially declared disaster area. You received insurance proceeds of $200,000 for the home, $25,000 for unscheduled personal property in your home, $5,000 for jewelry, and $10,000 for a stamp collection. The jewelry and stamp collection were kept in your home and were scheduled property on your insurance policy. No gain is recognized on the $25,000 you received for the unscheduled personal property. If you

reinvest the remaining proceeds of $215,000 in property similar or related in service or use to your home, jewelry, or stamp collection, you can elect to postpone any gain on that home, jewelry, or stamp collection. If you want to reinvest all of the remaining proceeds in a new main home, you can still qualify to postpone all of your gain even if you do not purchase any jewelry or stamps. If you reinvest less than $215,000, any gain is recognized only to the extent $215,000 exceeds the amount you reinvest in property similar or related in service or use to your home, jewelry, or stamp collection. To postpone gain, you must purchase the replacement property before 1999. Your basis in the replacement property equals its cost decreased by the amount of any postponed gain.

For details on how to postpone gain, see Pub. 547.

Special Treatment for Losses on Deposits in Insolvent or Bankrupt Financial Institutions

If you are an individual who incurred a loss from a deposit in a bank, credit union, or other financial institution because it became insolvent or bankrupt, and you can reasonably estimate your loss, you can choose to deduct the loss as:

• A casualty loss to personal use property on Form 4684, or

• An ordinary loss (miscellaneous itemized deduction) on Schedule A (Form 1040), line 22. The maximum amount you can claim is $20,000 ($10,000 if you are married filing separately). Your deduction is reduced by any expected state insurance proceeds and is subject to the 2% limit.

If you choose, you can wait until the year of final determination of the actual loss and treat that amount as a nonbusiness bad debt. A nonbusiness bad debt is deducted on Schedule D (Form 1040) as a short-term capital loss.

If you are a 1% or more owner, an officer of the financial institution, or related to any such owner or officer, you cannot deduct the loss as a casualty loss or as an ordinary loss. See **Pub. 550**, Investment Income and Expenses, for the definition of "related."

You cannot choose the ordinary loss deduction if any part of the deposits related to the loss is federally insured.

If you decide to deduct the loss as a casualty loss or as an ordinary loss and you have more than one account in the same financial institution, you must include all your accounts. Once you make the choice, you cannot change it without permission from the IRS.

To choose to deduct the loss as a casualty loss, complete Form 4684 as

follows: On line 1, show the name of the financial institution and write "Insolvent Financial Institution." Skip lines 2 through 9. Enter the amount of the loss on line 10, and complete the rest of Section A.

If, in a later year, you recover an amount you deducted as a loss, you may have to include in your income the amount recovered for that year. For details, see **Recoveries** in **Pub. 525**, Taxable and Nontaxable Income.

Specific Instructions

Which Sections To Complete

Use **Section A** to figure casualty or theft gains and losses for property that is not used in a trade or business or for income-producing purposes.

Use **Section B** to figure casualty or theft gains and losses for property that is used in a trade or business or for income-producing purposes.

If property is used partly in a trade or business and partly for personal purposes, such as a personal home with a rental unit, figure the personal part in Section A and the business part in Section B.

Section A—Personal Use Property

Use a separate column for lines 1 through 9 to show each item lost or damaged from a single casualty or theft. If more than four items were lost or damaged, use additional sheets following the format of lines 1 through 9.

Use a separate Form 4684 through line 12 for each casualty or theft involving property not used in a trade or business or for income-producing purposes.

Do not include any loss previously deducted on an estate tax return.

If you are liable for casualty or theft losses to property you **lease** from someone else, see Pub. 547.

Line 2.—Cost or other basis usually means original cost plus improvements. Subtract any postponed gain from the sale of a previous main home. Special rules apply to property received as a gift or inheritance.

Line 3.—Enter on this line the amount of insurance or other reimbursement you received or expect to receive for each property. Include your insurance coverage whether or not you are filing a claim for reimbursement. For example, your car worth $2,000 is totally destroyed in a collision. You are insured with a $500 deductible, but decide not to report it to your insurance company because you are afraid the insurance company will cancel your policy. In this case, enter $1,500 on this line.

IRS FORM 4684

If you expect to be reimbursed but have not yet received payment, you must still enter the expected reimbursement from the loss. If, in a later tax year, you determine with reasonable certainty that you will not be reimbursed for all or part of the loss, you can deduct for that year the amount of the loss that is not reimbursed.

Types of reimbursements.—Insurance is the most common way to be reimbursed for a casualty or theft loss, but if:

● Part of a Federal disaster loan under the Disaster Relief Act is forgiven, the part you do not have to pay back is considered a reimbursement.

● The person who leases your property must make repairs or must repay you for any part of a loss, the repayment and the cost of the repairs are considered reimbursements.

● A court awards you damages for a casualty or theft loss, the amount you are able to collect, minus lawyers' fees and other necessary expenses, is a reimbursement.

● You accept repairs, restoration, or cleanup services provided by relief agencies, it is considered a reimbursement.

● A bonding company pays you for a theft loss, the payment is also considered a reimbursement.

Lump-sum reimbursement.—If you have a casualty or theft loss of several assets at the same time and you receive a lump-sum reimbursement, you must divide the amount you receive among the assets according to the fair market value of each asset at the time of the loss.

Grants, gifts, and other payments.—Grants and other payments you receive to help you after a casualty are considered reimbursements only if they must be used specifically to repair or replace your property. Such payments will reduce your casualty loss deduction. If there are no conditions on how you have to use the money you receive, it is not a reimbursement.

Use and occupancy insurance.—If insurance reimburses you for your loss of business income, it does not reduce your casualty or theft loss. The reimbursement is income, however, and is taxed in the same manner as your business income.

Line 4.—If you are entitled to an insurance payment or other reimbursement for any part of a casualty or theft loss but you choose not to file a claim for the loss, you cannot realize a gain from that payment or reimbursement. Therefore, figure the gain on line 4 by subtracting your cost or other basis in the property (line 2) **only** from the amount of reimbursement you actually received. Enter the result on line 4, but do not enter less than zero.

If you filed a claim for reimbursement but did not receive it until after the year of the casualty or theft, see Pub. 547 for information on how to report the reimbursement.

Lines 5 and 6.—Fair market value is the price at which the property would change hands between a willing buyer and a willing seller, each having a knowledge of the relevant facts. The difference between the fair market value immediately before the casualty or theft and the fair market value immediately after represents the decrease in fair market value because of the casualty or theft.

The fair market value of property after a theft is zero if the property is not recovered.

Fair market value is generally determined by competent appraisal. The appraiser's knowledge of sales of comparable property about the same time as the casualty or theft, knowledge of your property before and after the occurrence, and the methods of determining fair market value are important elements in proving your loss.

The appraised value of property immediately after the casualty must be adjusted (increased) for the effects of any general market decline that may occur at the same time as the casualty or theft. For example, the value of all nearby property may become depressed because it is in an area where such occurrences are commonplace. This general decline in market value is not part of the property's decrease in fair market value as a result of the casualty or theft.

Replacement cost or the cost of repairs is not necessarily fair market value. However, you may be able to use the cost of repairs to the damaged property as evidence of loss in value if:

● The repairs are necessary to restore the property to the condition it was in immediately before the casualty;

● The amount spent for repairs is not excessive;

● The repairs only correct the damage caused by the casualty; and

● The value of the property after the repairs is not, as a result of the repairs, more than the value of the property immediately before the casualty.

To figure a casualty loss to real estate not used in a trade, business, or for income-producing purposes, measure the decrease in value of the property as a whole. All improvements, such as buildings, trees, and shrubs, are considered together as one item. Figure the loss separately for other items. For example, figure the loss separately for each piece of furniture.

Line 15.—If there is a net gain on this line, combine your short-term gains with your short-term losses, and enter the net short-term gain or loss on Schedule

D (Form 1040), line 4. Estates and trusts enter this amount on Schedule D (Form 1041), line 2. Combine your long-term gains with your long-term losses and enter the net long-term gain or loss on Schedule D (Form 1040), line 12. Estates and trusts enter this amount on Schedule D (Form 1041), line 8.

The holding period for long-term gains and losses is more than 1 year. For short-term gains and losses it is 1 year or less. To figure the holding period, begin counting on the day after you received the property and include the day the casualty or theft occurred.

Line 17.—Estates and trusts figure adjusted gross income in the same way as individuals, except that the costs of administration are allowed in figuring adjusted gross income.

Section B—Business and Income-Producing Property

Use a separate column of Part I, lines 19 through 27, to show each item lost or damaged from a single casualty or theft. If more than four items were lost or damaged, use additional sheets following the format of Part I, lines 19 through 27.

Use a separate Section B, Part I, of Form 4684 for each casualty or theft involving property used in a trade or business or for income-producing purposes. Use one Section B, Part II, to combine all Sections B, Part I.

For details on the treatment of casualties or thefts to business or income-producing property, including rules on the loss of inventory through casualty or theft, see Pub. 334.

If you had a casualty or theft loss involving a home you used for business or rented out, your deductible loss may be limited. First, complete Form 4684, Section B, lines 19 through 26. If the loss involved a home used for business for which you are filing **Schedule C (Form 1040)**, figure your deductible casualty or theft loss on **Form 8829**, Expenses for Business Use of Your Home. Enter on line 27 of Form 4684 the deductible loss from line 33 of Form 8829, and write "See Form 8829" above line 27. For a home you rented out or used for a business for which you are not filing Schedule C (Form 1040), see section 280A(c)(5) to figure your deductible loss. Attach a statement showing your computation of the deductible loss, enter that amount on line 27, and write "See attached statement" above line 27.

Note: *A gain or loss from a casualty or theft of property used in a passive activity is not taken into account in determining the loss from a passive activity unless losses similar in cause and severity recur regularly in the activity. See* **Form 8582**, *Passive Activity*

Page 3

IRS FORM 4684

Loss Limitations, and its instructions for details.

Line 20.—Cost or adjusted basis usually means original cost plus improvements, minus depreciation allowed or allowable (including any section 179 expense deduction), amortization, depletion, etc. Special rules apply to property received as a gift or inheritance. See **Pub. 551,** Basis of Assets, for details.

Line 21.—See the instructions for line 3.

Line 22.—See the instructions for line 4.

Lines 23 and 24.—See the instructions for lines 5 and 6 for details on determining fair market value.

Loss on each item figured separately.—Unlike a casualty loss to personal use real estate, in which all improvements are considered one item, a casualty loss to business or income-producing property must be figured separately for each item. For example, if casualty damage occurs to both a building and to trees on the same piece of real estate, measure the loss separately for the building and for the trees.

Line 26.—If you have business or income-producing property that is completely lost (becomes totally worthless) because of a casualty or theft, figure your loss without taking into account any decrease in fair market value.

Line 28.—If the amount on line 28 includes losses on property held 1 year or less, and on property held for more than 1 year, you must allocate the amount between lines 29 and 34 according to how long you held each property. Enter on line 29 all gains and losses to property held 1 year or less. Enter on line 34 all gains and losses to property held more than 1 year, except as provided in the instructions for line 33 below.

Part II, Column (a).—Use a separate line for each casualty or theft.

Part II, Column (b)(i).—Enter the part of line 28 from trade, business, rental, or royalty property (other than property you used in performing services as an employee). Enter in column (b)(ii) the part of line 28 from property you used in performing services as an employee.

Part II, Column (b)(ii).—Enter the part of line 28 from income-producing property and from property you used in performing services as an employee. Income-producing property is property held for investment, such as stocks, notes, bonds, gold, silver, vacant lots, and works of art.

Line 31.—If **Form 4797,** Sales of Business Property, is not otherwise required, enter the amount from this line on page 1 of your tax return, on the line identified as from Form 4797. Write "Form 4684."

Line 32.—Estates and trusts, enter on the "Other deductions" line of your tax return. Partnerships, enter on Form 1065, Schedule K, line 11. S corporations, enter on Form 1120S, Schedule K, line 10. Write "Form 4684."

Line 33.—If you had a casualty or theft gain from certain trade, business, or income-producing property held more than 1 year, you may have to recapture part or all of the gain as ordinary income. See the instructions for Form 4797, Part III, for more information on the types of property subject to recapture. If recapture applies, complete Form 4797, Part III, and this line, instead of Form 4684, line 34.

Line 38a.—Taxpayers, other than partnerships and S corporations, if Form 4797 is not otherwise required, enter the amount from this line on page 1 of your tax return, on the line identified as from Form 4797. Write "Form 4684."

"I am the state." Louis XIV

SUMMARY

This book offers a lot of practical advice. Remember to rely on your own common sense for what works best for you. Be as self reliant as possible. In dealing with a disaster or catastrophe take a deep breath and make up your mind that you will be determined to beat the odds and overcome the situation. Your response in the first few hours makes all the difference in the world. Survival is for the prepared, not necessarly the strong. Your world may change and life will go on.

THE FIFTH AND PRESENT SUN
NAHUI OLLIN
Four Movement

On the Aztec Cosmos, the present Sun or age, is represented by the large circle marked at its outer edge by pairs of orange triangles. This circle contains the calendar itself, and the symbols of the Four Past Suns. The Aztec believed that this age would end when earthquakes shook the entire world. The Aztec had several ways to refer to the Sun: Tonatiuh, "The Bright One That Warms," the Sun God; Temoctzin, "The One That Goes Down For Our Sake"; Chimalpopca, "Smoking Shield"; and Tlalchitonatiuh, "The Bright One That Warms Near Earth," the sun just about to set. Huitzilopochtli was also a sun god.

Tonatiuh

"Common sense is instinct. Enough of it is genius." George Bernard Shaw

SOURCES

PAGES	PUBLICATION
6	From **SURVIVAL FM 21-76.**
8-9	Adapted from L-154 **EMERGENCY PREPAREDNESS CHECKLIST.**
11	Adapted from **FIRE FACTS & FIRE SAFETY.**
13	Adapted from **EMERGENCY!!! HOW TO PROTECT YOUR FAMILY.**
20	Avalanches adapted from **THE BOOK OF OF SURVIVAL.**
20-21	Drought & Big Freeze adapted from **THE URBAN SURVIVAL HANDBOOK.**
22-24	Adapted from **FRESNO PACIFIC BELL PHONEBOOK.**
26-27	Adapted from **THE WEATHER ALMANAC.**
29	Adapted from **NATURE ON THE RAMPAGE.**
30-32	Adapted from **THE WEATHER ALMANAC.**
38-64	From **EMERGENCY FIRST AID.**
66-67	From **THE ARMAGEDDON LETTER.**
68	From **SELF RELIANT LIVING.**
69	Adapted from **SURVIVING THE AIDS PLAGUE.**
70,72	Adapted from **THE URBAN SURVIVAL HANDBOOK.**
73	Adapted from **CRIME PREVENTION AND PERSONAL SAFETY.**
76	Adapted from **WHAT CAN I DO ABOUT DOMESTIC VIOLENCE.**
77	Adapted from **MCALVANY INTELLIGENCE ADVISOR & INSIDER REPORT.**
79	Adapted from **FIRE FACTS & FIRE SAFETY.**
80	Adapted from **THE BOOK OF SURVIVAL.**
82	Adapted from **GANGS: A COMMUNITY RESPONSE.**
83	Adapted from **THE URBAN SURVIVAL HANDBOOK.**
85	From **SURVIVAL FM 21-76.**
88	Adapted from **BOMBS BY MAIL.**
89	Adapted from **STRATEGIC INVESTMENT AD.**
90	Adapted from **HOW CAN I GET A NEIGHBORHOOD WATCH STARTED.**
92	Adapted from **UNITED AGAINST CRIME.**
93	Adapted from **WHAT EVERYONE SHOULD KNOW ABOUT ROBBERY.**
95-96	Adapted from **THE URBAN SURVIVAL HANDBOOK& BOOK OF SURVIVAL.**
98	Adapted from **20 WAYS NOT TO BE SWINDLED.**
99	From **THE URBAN SURVIVAL HANDBOOK.**
101	Adapted from **SURVIVING UNEMPLOYMENT.**
103-104	Adapted from **THINKING AND GROWING RICH.**
105	Adapted from **CHANGING DESTINY.**
106	Adapted from **7 HABITS OF HIGHLY EFFECTIVE PEOPLE.**
107	From **THE POWER OF TOTAL PERSPECTIVE.**
108	From **THE FIVE THOUSAND YEAR LEAP.**

"The wicked borroweth, and payeth not again; but the righteous sheweth mercy, and giveth." Psalm 37:21

BIBLIOGRAPHY

1. **Pocket Guide To Emergency First Aid**, American Medical Association, 1993, Random House, NYC.
2. **FM 21-76 Survival**, Department of the Army, 1970, Washington DC.
3. **Wright's Complete Disaster Survival Manual**, Ted Wright, 1993, Hampton Roads, Norfolk, VA.
4. **Emergency!!! How To Protect Your Family**, William E. Dewey, 1994, Dewey Research Center, Rochester, NY.
5. **The Key of Kings: How To Determine Your Own Destiny**, Guy Finley, 1993, Four Star Books, Grant's Pass, OR.
6. **Pearls of Wisdom,** Jerome Agel & Walter D. Glanze, 1987, Harper & Row, NY.
7. **Mobile Home Safety,** Channing L. Bete, 1988, South Deerfield, MA.
8. **The Pessemist's Guide To History,** Stuart Flexner, 1992, Avon Books, NY.
9. **Social Science Quotations,** Sills Merton, 1991, Macmillan, NY.
10. **The Urban Survival Handbook**, John Wiseman, 1991, Harvill/ Harper Collins, London.
11. **Principal Threats Facing Communities and Local Emergency Management Coordinators,** Federal Emergency Management Agency, 1992, Washington DC.
12. **Self-Reliant Living,** Carl E. Krupp, 1993, Merlin, OR.
13. **Surviving The AIDS Plague**, Taki N. Anagnoston, 1989, USA.
14. **Crime Prevention**, Channing L. Bete, 1987, South Deerfield, MA.
15. **The Book of Survival,** Anthony Greenback, 1967, Harper & Row, NY & Evanston.
16. **Gangs: A Community Response**, Daniel E. Lungren, 1994, CA Attorney General's Office, CA.
17. **Earth Changes Survival Handbook,** Page Bryant ,1983, Sun Books, Albuquerque, NM.
18. **Surviving a Japanese P.O.W. Camp,** Peter R. Wygle, 1991, Pathfinder, Ventura CA.
19. **Your Family Disaster Plan**, FEMA & American Red Cross, 1991, Washington DC.
20. **Emergency Food & Water**, FEMA, 1992, Washington DC.
21. **Emergency Preparedness Checklist**, FEMA & American Red Cross, 1991, Washington DC.
22. **Surviving Unemployment: a Family Handbook for Weathering Hard Times**, Cathy Beyer, Doris Pike, & Loretta McGovern, 1993, Holt, NY.
23. **The Armageddon Letter**, Julian M. Snyder, Nov/Dec. 1994, St. Moritz, Switzerland.
24. **Burglary Prevention,** California Crime Watch, 1979, Office of the Attorney General, CA.
25. **Home Security**, National Crime Prevention Council, 1979, Office of Criminal Justice Planning, CA.
26. **What Everyone Should Know About Gangs,** Channing L. Bete, 1992, South Deerfield, MA.
27. **Think and Grow Rich**, Napoleon Hill, 1960, Ballantine, NY.
28. **20 Ways Not To Be Swindled**, Fresno Police Department, 1969, Fresno CA.
29. **Bombs By Mail,** US Postal Inspector, 1990, Washington DC.
30. **What Everyone Should Know About Robbery**, Fresno Police Department, 1992, Fresno, CA.
31. **The Law and You,** Fresno Police Department, 1982 , Fresno, CA.
32. **What Can I Do About Domestic Violence,** National Crime Prevention Council,1994, Tandy.
33. **Crime Prevention & Personal Safety**, Fresno Police Department, 1994, Fresno, CA.
34. **How Can I Get A Neighborhood Watch Started**, National Crime Prevention Council, 1994, Tandy.
35. **United Against Crime**, National Crime Prevention Council & National Sheriff's Association, 1994, Tandy.
36. **Insider Report**, Larry Abraham, January 1994, Publishers Management, Phoenix, AZ.
37. **McAlvany Intellignce Advisor**, Donald S. McAlvany, 1994, Phoenix, AZ.
38. **Fire Facts,** National Fire Protection Association, 1993, Quincy, MA.
39. **Fire Safety,** Aetna Public Service Library, 1994, Hartford, CT.

"To think is easy. To act is difficult. To act as one thinks is the most difficult of all ." Johann Wolfang von Goethe

BIBLIOGRAPHY

40. **Family Earthquake Safety Home Hazard Hunt & Drill,** FEMA & American Red Cross, 1986, Washington DC.
41. **Safety Tips For Earthquakes,** FEMA, 1993, US Government Printing Office, Washington DC.
42. **Safety and Survival in an Earthquake**, FEMA, 1991, US Government Printing Office, Washington DC.
43. **Earthquake Safety**, Ellen Jackson, 1991, Horizon, Bountiful UT.
44. **Earthquake Safety Checklist**, FEMA, 1985, US Government Printing Office, Washington DC.
45. **Fresno Pacific Bell Phone Book,** Pacific Bell, 1992
46. **Strategic Investment Ad,** Douglass Cooke, 1994, Agora, Baltimore MD.
47. **The Seven Habits of Highly Effective People**, Steven R. Covey, 1989, Simon & Schuster, NY.
48. **Hydrogen Peroxide Medical Miracle**, William Campbell Douglass, 1992, Second Opinion, Atlanta, GA.
49. **The Five Thousand Year Leap**, W. Cleon Skousen, 1981, National Center for Constitutional Studies, Washington DC.
50. **The Master Key To Riches,** Napolean Hill, 1965, Fawcett Crest, New York.
51. **The Urban Survival Handbook**, John Wiseman, 1991, Harvill, London.
52. **The Weather Almanac**, James A. Ruffner & Frank E. Bair, 1977, Book Tower, Detroit MI.
53. **Political Quotations**, Daniel B. Baker, 1990, Gales Research, Detroit MI.
54. **The Power Of Total Perspective**, R. E. McMaster Jr., 1994, A.N. International, Phoenix AZ.
55. **Chinese Proverbs From Olden Times**, Peter Pauper Press, 1956, Mount Vernon, New York.
56. **Selections From Poor Richard's Almanac By Benjamin Franklin**, George Oehl, 1982, Crown, New York.
57. **Nature On The Rampage**, Ann & Myron Sutton, 1962, Lippincott, Philadelphia & New York.

FURTHER INFORMATION

Newsletters-Information

The Reaper, R.E. McMaster Jr., 6 months for $ 110, Finacial newsletter,
P. O. Box 84901, Phoenix AZ 85071, #1- 800-528-0559.
Self-Reliant Living, Carl E. Krupp, Self sufficiency and survival thoughts,
Box 910, Merlin OR 97532, # 1-503-476-4721.
The McAlvany Intelligence Advisor, Donald S. McAlvany, 12 months for $115, monetary, economic,
geopolitical and precious metals analysis, P.O. Box 84904, Phoenix AZ 85071 #1-800-528-0559.
The International Hary Schultz Letter, Harry Schultz, 12 months for $275, A financial & liberty
loving newsletter, P.O. Box 622, CH-1001 Lausanne, Switzerland, #3216533684, Fax#3216535777.
The Earth Changes Report, Gordon-Michael Scallion, Survival guide for the Nineties,
P.O. Box 336, Chesterfield NH 03443 # 1-603-363-4916 Fax # 1-603-363-4169.
Siesmo-Watch Newsletter, Advanced Geological Exploration, P.O. Box 18012, Reno NV 89511
1-800-852-2960 or 1-702-852-0992
Federal Emergency Management Authority(FEMA), booklets on preparedness, earthquakes, etc.
500 C. ST. SW, Washington DC, 20472 # 1-202-646-2650

Products: Equipment , Food and Information

Bailey's, first aid kits, 44650 Hwy. 101 P.O. Box 550, Laytonville, CA 95454
 # 707-984-6133 fax# 707 984-8115
Recreational Equipment Inc. 1700 45th Street East Sumner, WA 98390 Phone # 1-800-426-4840
Campmor, Outdoor products, P.O. Box 700-D, Saddle River, New Jersey 07458-0700
 # 1-800-226-7667
Alpine Distributors, Mathew Walker, Box 3100, Central Point, OR 97502 info# 1-503-826-9279
 orders: 1-800-453-7453, fax# 1-503-826-1023
Country Harvest Preparedness Products, 325 W. 600 S., Dept 101, Heber City, UT 84032
 # 1-800-322-2245, fax# 1-801-322-2245
Nitro-Pak Preparedness center, 13309 Rosecrans Ave., Suite 50, Santa Fe, CA 90670-4940
 # 1-800-866-4876, fax# 1-310-802-2635
Safe-Trek Outfitters, Stephen Quale, 1716 W. Main, Bozeman, M, 59715
 # 1-800-424-7870, 1-406-587-5571 fax# 1-406-586-4842
Walton's Food Inc., 135 No. 10th st., Box 307, Mt. Pelier, ID 83254
 # 1-208-847-0465 or 1-800-847-0465, fax # 1-208-847-0467
Delta Press LTD., P.O. Box 1625 Dept. V34C, 215 S. Washington St., El Dorado, AR 71731
 # 1-800-852-4445 or 1-501 -862-4984 fax# 1-501-8622-9671
Phoenix Systems Inc., P.O. Box 3339, Evergreen, CO 80439
 # 1-303-277-0305 fax# 1-303-278-8101
Sierra Supply, P.O. Box 1390, Durango, CO 81302
 # 1-303-259-1822

*** If you have any ideas related to the topics in this book please send them in care of this editor to:
AU Specialty Publications, P.O. Box 687, Elko, NV 89803.

THE ANTI-GRAVITY HANDBOOK

Revised/Expanded Edition
Edited by David Hatcher Childress

*With Arthur C. Clark, Nikola Tesla, T.B. Paulicki,
Bruce Cathie, Leonard G. Cramp and Albert Einstein*

The book that blew minds and had engineers using their calculators is back in print in a new expanded compilation of material on Anti-Gravity, Free Energy, Flying Saucer propulsion, UFOs, Suppressed Technology, NASA Coverups and more.

Highly illustrated with patents, technical illustrations, photos and more, this revised and expanded edition has more material, including photos of Area 51, Nevada, the government's secret testing facility, Australian Secret Fascilities, plus a rare reprint of Space, Gravity & the Flying Saucer by Leonard G. Cramp. This classic on weird science is back in a 90s format!

- How to build a flying saucer.
- Read about Arthur C. Clark on Anti-Gravity.
- learn about crystals and their role in levitation.
- Secret government research and developement.
- Nikola Tesla on how anti-gravity airships could draw power from the atmosphere.
- Bruce Cathie's Anti-Gravity Equation.
- NASA, the Moon and Anti-Gravity. Plus more.

230 pages, 7x10 tradepaper, Bibliography/Index/Appendix
Highly illustrated with 100's of patents illustrations and photos,
$14.95. **code: AGH**

ANTI-GRAVITY & THE UNIFIED FIELD

Edited by David Hatcher Childress

Is Einstein's Unified Field the answer to all of our energy problems? Explored in this compilation of material is how gravity, electricity and magnetism manifest from a unified field around us. Why artificial gravity is possible; Secrets of UFO propulsion; free energy; Nikola Tesla and anti-gravity airships of the 20's and 30's; Flying saucers as superconducting whirls of plasma; anti-mass generators; vortex propulsion; suppressed technology; government cover-ups; gravitational pulse drive, spacecraft & more.
240 pages, 7x10 tradepaper, 130 rare photographs, diagrams and drawings, $14.95. **code: AGU**

ANTI-GRAVITY & THE WORLD GRID

Edited by David Hatcher Childress

Is the earth surrounded by an intricate electromagnetic grid network offering free energy? This compilation of material on the earth grid, ley lines, and world power points contains chapters on the geography, mathematics, and light harmonics of the earth grid. Learn the purpose of ley lines and ancient megalithic structures located on the grid. Discover how the grid made the Philadelphia Experiment possible. Explore Coral Castle and many other mysteries; Including, acoustic levitation, Tesla Shields and Scalar Wave weaponry. Browse through the section on anti-gravity patents, and research resources.
274 pages, 150 rare photographs, diagrams and drawings, 7x10 paperback, $14.95. **code: AGW**

ANTI-GRAVITY & THE WORLD GRID

Edited By
David Hatcher Childress

LOST CITIES OF ATLANTIS, ANCIENT EUROPE & THE MEDITERRANEAN

by David Hatcher Childress

Atlantis! The legendary lost continent comes under the close scrutiny of maverick archaeologist David Hatcher Childress in this sixth book in the internationally popular Lost Cities series. Childress takes the reader on a quest for the lost continent of Atlantis in search of sunken cities in the Mediterranean; across the Atlas Mountains in search of Atlantean ruins; and to remote islands in search of megalithic ruins, living legends, and secret societies. From Ireland to Turkey, Morocco to Eastern Europe, or remote islands of the Mediterranean and Atlantic, Childress takes the reader on an astonishing quest for mankind's past. Ancient technology, cataclysms, megalithic construction, lost civilizations, and devastating wars of the past are all explored in this amazing book. Childress challenges the skeptics and proves that great civilizations not only existed in the past but that the modern world and its problems are reflections of the ancient world of Atlantis. Join David on an unforgettable tale in search of the solutions to the mysteries of the past.

524 pp. ♦ 6x9 paperback ♦ Illustrated with hundreds of maps, photos & diagrams ♦ Footnotes & bibliography $16.95 ♦ code: MED (September '95 publication)

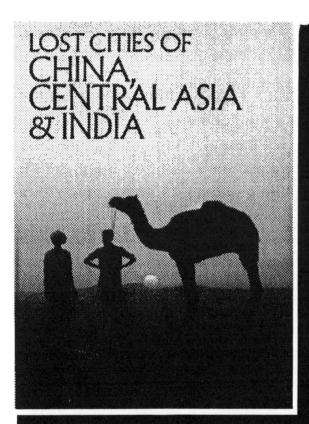

LOST CITIES OF
CHINA,
CENTRAL ASIA
& INDIA

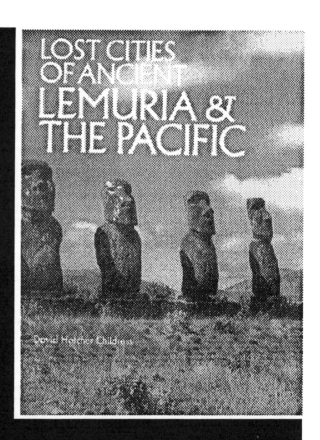

LOST CITIES
OF ANCIENT
LEMURIA &
THE PACIFIC

David Hatcher Childress

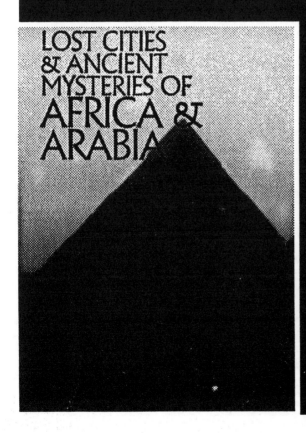

LOST CITIES
& ANCIENT
MYSTERIES OF
AFRICA &
ARABIA

LOST CITIES
& ANCIENT
MYSTERIES OF
SOUTH
AMERICA

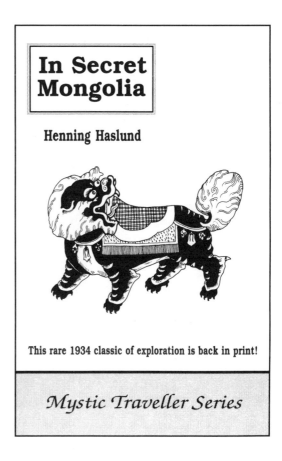

DANGER MY ALLY
The Amazing Life Story of the Discoverer of the Crystal Skull
by F.A. "Mike" Mitchell-Hedges

The incredible life story of F.A. "Mike" Mitchell-Hedges, the British adventurer whose discovery of the Crystal Skull in the lost Mayan city of Lubaantun in Belize was just one episode in an exciting life of exploration and discovery: gambling everything on a trip to the Americas as a young man, riding with Pancho Villa, going on a personal quest for Atlantis, fighting bandits in the Caribbean, and discovering the famous Crystal Skull.

374 pp. ♦ 6x9 paperback ♦ Illustrated with maps, photos & diagrams ♦ Bibliography & index ♦ $16.95 ♦ code: **DMA**

IN SECRET MONGOLIA
Sequel to Men & Gods In Mongolia
by Henning Haslund

The latest addition to Adventures Unlimited's *Mystic Traveller Series*. Danish-Swedish explorer Haslund's first book on his exciting explorations in Mongolia and Central Asia. Haslund takes us via camel caravan to the medieval world of Mongolia, a country still barely known today. First published by Kegan Paul of London in 1934, this rare travel adventure is back in print after 50 years. Haslund and his camel caravan journey across the Gobi Desert where he meets with renegade generals and warlords, god-kings and shamans. Haslund is captured, held for ransom, thrown into prison, battles black magic, and portrays in vivid detail the birth of new nation. Haslund's second book *Men & Gods In Mongolia* is also available from Adventures Unlimited Press.

374 pp. ♦ 6x9 paperback ♦ Illustrated with maps, photos & diagrams ♦ Bibliography & index ♦ $16.95 ♦ code: **ISM**

MEN & GODS
IN MONGOLIA
by Henning Haslund

First published in 1935 by Kegan Paul of London, this rare and unusual travel book takes us into the virtually unknown world of Mongolia, a country that only now, after seventy years, is finally opening up to the west. Haslund, a Swedish explorer, takes us to the lost city of Karakota in the Gobi desert. We meet the Bodgo Gegen, a God-king in Mongolia similar to the Dalai Lama of Tibet. We meet Dambin Jansang, the dreaded warlord of the "Black Gobi." There is even material in this incredible book on the Hi-mori, an "airhorse" that flies through the air (similar to a Vimana) and carries with it the sacred stone of Chintamani. Aside from the esoteric and mystical material, there is plenty of just plain adventure: caravans across the Gobi desert, kidnapped and held for ransom, initiation into Shamanic societies, warlords, and the violent birth of a new nation.
358 pages, 6x9 paperback, 57 photos, illustrations and maps. $15.95.
code: MGM

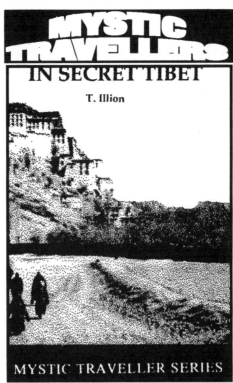

MYSTIC TRAVELLER SERIES

IN SECRET TIBET
Theodore Illion.

Reprint of a rare 30's travel book. Illion was a German traveller who not only spoke fluent Tibetan, but travelled in disguise through forbidden Tibet when it was off-limits to all outsiders. His incredible adventures make this one of the most exciting travel books ever published. Includes illustrations of Tibetan monks levitating stones by acoustics.
210 pages, 6x9 paperback, illustrated, $15.95. **code: IST**

VIMANA AIRCRAFT OF
ANCIENT INDIA
& ATLANTIS
David Hatcher Childress
Introduction by Ivan T. Sanderson

Did the ancients have the technology of flight? In this incredible volume on ancient India, authentic Indian texts such as the Ramayana and the Mahabharata, are used to prove that ancient aircraft were in use more than four thousand years ago. Included in this book is the entire Fourth Century BC manuscript Vimaanika Shastra by the ancient author Maharishi Bharadwaaja, translated into English by the Mysore Sanskrit professor G.R. Josyer. Also included are chapters on Atlantean technology, the incredible Rama Empire of India and the devastating wars that destroyed it. Also an entire chapter on mercury vortex propulsion and mercury gyros, the power source described in the ancient Indian texts. Not to be missed by those interested in ancient civilizations or the UFO enigma.
334 pages, 6x9 paperback, 104 rare photographs, maps and drawings. $15.95.
code: VAA

DARKNESS OVER TIBET
Theodore Illion.

In this second reprint of the rare 30's travel books by Illion, the German traveller continues his travels through Tibet and is given the directions to a strange underground city. As the original publisher's remarks said, this is a rare account of an underground city in Tibet by the only Westerner ever to enter it and escape alive!
210 pages, 6x9 paperback, illustrated, $15.95. **code: DOT**

ATLANTIS IN SPAIN
A Study of the Ancient Sun Kingdoms of Spain
E.M. Whishaw

First published by Rider & Co. of London in 1928, this classic book is a study of the megaliths of Spain, ancient writing, cyclopean walls, Sun Worshipping Empires, hydraulic engineering, and sunken cities is now back in print after sixty years. An extremely rare book until this reprint, learn about the Biblical Tartessus; an Atlantean city at Niebla; the Temple of Hercules and the Sun Temple of Seville; Libyans and the Copper Age; more. Profusely illustrated with photos, maps and illustrations.
284 pages, 6 x9, paperback. Epilog with tables of ancient scripts. $15.95. **code: AIS** •November Publication

IN SECRET MONGOLIA
Henning Haslund

First published by Rider & Co. of London in 1934 as *Tents In Mongolia*, this rare travel book takes us via camel caravan to inner-most Central Asia in search of magic and mystery Mongolia, a country still today largely unknown. Profusely illustrated with photos, maps and illustrations.
284 pages, 6 x9, paperback. Index. $16.95
code: ISM •December Publication

THE FANTASTIC INVENTIONS OF NIKOLA TESLA
by Nikola Tesla
with additional material by David Hatcher Childress

This book is a virtual compendium of patents, diagrams, photos, and explanations of the many incredible inventions of the originator of the modern era of electrification. The book is a readable and affordable collection of his patents, inventions, and thoughts on free energy, anti-gravity, and other futuristic inventions. Covered in depth, often in Tesla's own words, are such topics as:
• His Plan to Transmit Free Electricity into the Atmosphere;
• How Anti-Gravity Airships could Draw Power from the Towers he was Building;
• Tesla's Death Rays, Ozone Generators, and more…

342 pp. ♦ 6x9 paperback ♦ Highly illustrated ♦ Bibliography & appendix ♦ $16.95
code: FINT

LOST CITIES OF ANCIENT LEMURIA & THE PACIFIC
by David Hatcher Childress

Was there once a continent in the Pacific? Called Lemuria or Pacifica by geologists, and Mu or Pan by the mystics, there is now ample mythological, geological and archaeological evidence to "prove" that an advanced and ancient civilization once lived in the central Pacific. Maverick archaeologist and explorer David Hatcher Childress combs the Indian Ocean, Australia, and the Pacific in search of the astonishing truth about mankind's past. Contains photos of the underwater city on Pohnpei, explanations on how the statues were levitated around Easter Island in a clockwise vortex movement, disappearing islands, Egyptians in Australia, and more.

379 pp. ♦ 6x9 paperback ♦ Photos, maps, & illustrations ♦ Footnotes & bibliography ♦ $14.95 ♦ code: LEM

THE FREE-ENERGY DEVICE HANDBOOK
A Compilation of Patents & Reports by David Hatcher Childress

Large format compilation of various patents, papers, descriptions, and diagrams concerning free-energy devices and systems. The Free-Energy Device Handbook is a visual tool for experimenters and researchers into magnetic motors and other "over-unity" devices with chapters on the Adams Motor, the Hans Coler Generator, cold fusion, superconductors, "N" machines, space-energy generators, Nikola Tesla, T. Townsend Brown, the Bedini motor, and the latest in free-energy devices. Packed with photos, technical diagrams, patents, and fascinating information, this book belongs on every science shelf. With energy and profit a major political reason for fighting various wars, free-energy devices, if ever allowed to be mass-distributed to consumers, could change the world. Get your copy now before the Department of Energy bans this book!

306 pp. ♦ 7x10 paperback ♦ Profusely illustrated ♦ Bibliography & appendix ♦ $16.95 ♦ code: FEH

EXTRATERRESTRIAL ARCHAEOLOGY
by David Hatcher Childress

With hundreds of photos and illustrations, Extraterrestrial Archaeology takes the reader to the strange and fascinating worlds of Mars, the Moon, Mercury, Venus, Saturn, and other planets for a look at the alien structures that appear there. This book is non-fiction! Whether skeptic or believer, this book allows you to view for yourself the amazing pyramids, domes, spaceports, obelisks, and other anomalies that are profiled in photograph after photograph. Using official NASA and Soviet photos, as well as other photos taken via telescope, this book seeks to prove that many of the planets (and moons) of our solar system are in some way inhabited by intelligent life. The book includes many blowups of NASA photos and detailed diagrams of structures—particularly on the Moon. Extraterrestrial Archaeology will change the way you think.

224 pp. ♦ 8¹/2x11 paperback ♦ Highly illustrated with photos, diagrams & maps! ♦ Bibliography, index, appendix ♦ $18.95
code: ETA

MAN-MADE UFOS: 1944-1994
50 Years of Suppression
by Renato Vesco & David Hatcher Childress

A comprehensive and in-depth look at the early "flying saucer technology" of Nazi Germany and the genesis of early man-made UFOs. From captured German scientists, escaped battalions of German soldiers, secret communities in South America and Antarctica to today's state-of-the-art "Dreamland" flying machines, this astonishing book blows the lid off the "Government UFO Conspiracy." Examined in detail are secret underground airfields and factories; German secret weapons; "suction" aircraft; the origin of NASA; gyroscopic stabilizers and engines; the secret Marconi aircraft factory in South America, and other secret societies, both ancient and modern, that have kept this craft a secret, and much more. Not to be missed by students of technology suppression, UFOs, anti-gravity, free-energy conspiracy, and World War II. Introduction by W.A. Harbinson, author of the Dell novels Genesis and Revelation.

440 pp. ♦ 6x9 paperback ♦ Packed with photos & diagrams Index & footnotes $18.95 ♦ code: MMU

THE HISTORY OF ATLANTIS
by Lewis Spence
Lewis Spence's classic book on Atlantis is now back in print. Lewis Spence was a Scottish historian (1874-1955) who is best known for his volumes on world mythology and his five Atlantis books. The History of Atlantis (1926) is considered his best. Spence does his scholarly best in such chapters as The Sources of Atlantean History, The Geography of Atlantis, The Races of Atlantis, The Kings of Atlantis, The Religion of Atlantis, The Colonies of Atlantis, more. Sixteen chapters in all.
240 pp. ♦ 6x9 paperback ♦ Illustrated with maps, photos & diagrams ♦ $16.95
code: HOA *(Autumn '95)*

Adventures Unlimited Press
One Adventure Place
Kempton, Illinois
60946
24 Hour Telephone
Order Line
815 253 6390
24 Hour Fax Order Line
815 253 6300
EMail orders
adventures_unlimited
@mcimail.com

Renato Vesco
David Hatcher Childress

303 Main Street
P.O. Box 74
Kempton, Illinois 60946
USA
Tel.: 815-253-6390 ♦ Fax: 815-253-6300
Email: adventures_unlimited@mcimail.com

ORDERING INSTRUCTIONS

➤ Please Write Clearly
➤ Remit by USD$ Check or Money Order
➤ Visa/MasterCard Accepted
➤ Call ♦ Fax ♦ Email Any Time

SHIPPING CHARGES

United States

➤ Postal Book Rate { $2.00 First Item
 50¢ Each Additional Item

➤ Priority Mail { $3.50 First Item
 $1.50 Each Additional Item

➤ UPS { $3.50 First Item
 $1.00 Each Additional Item

NOTE: UPS Delivery Available to Mainland USA Only

Canada

➤ Postal Book Rate { $3.00 First Item
 $1.00 Each Additional Item

➤ Postal Air Mail { $4.00 First Item
 $2.00 Each Additional Item

➤ Personal Checks or Bank Drafts MUST BE USD$ and Drawn on a US Bank
➤ Canadian Postal Money Orders OK
➤ Payment MUST BE USD$

All Other Countries

➤ Surface Delivery { $5.00 First Item
 $2.00 Each Additional Item

➤ Postal Air Mail { $10.00 First Item
 $8.00 Each Additional Item

➤ Payment MUST BE USD$
➤ Personal Checks MUST BE USD$ and Drawn on a US Bank
➤ Add $5.00 for Air Mail Subscription to Future *Adventures Unlimited* Catalogs

SPECIAL NOTES

➤ RETAILERS: Standard Discounts Available
➤ BACKORDERS: We Backorder all Out-of-Stock Items Unless Otherwise Requested
➤ PRO FORMA INVOICES: Available on Request
➤ VIDEOS: NTSC Mode Only
 PAL & SECAM Mode Videos Are Not Available

Thank you for your order
We appreciate your business

Please check: ☑

☐ This is my first order ☐ I have ordered before ☐ This is a new address

Name	
Address	
City	
State/Province	Postal Code
Country	
Phone day	Evening
Fax	

Item Code	Item Description	Price	Qty	Total
CAT	Adventures Unlimited Catalog	N/C		N/C

Please check: ☑

☐ Postal-Surface

☐ Postal-Air Mail (Priority in USA)

☐ UPS (Mainland USA only)

Please Use Item Codes!

Subtotal ➤	
Less Discount-10% for 3 or more items ➤	
Balance ➤	
Illinois Residents 7% Sales Tax ➤	
Previous Credit ➤	
Shipping ➤	
Total (check/MO in USD$ only) ➤	

☐ Visa ☐ MasterCard

#_____ Exp. _____

Comments & Suggestions	Share Our Catalog with a Friend